The Essential
DUANE MICHALS

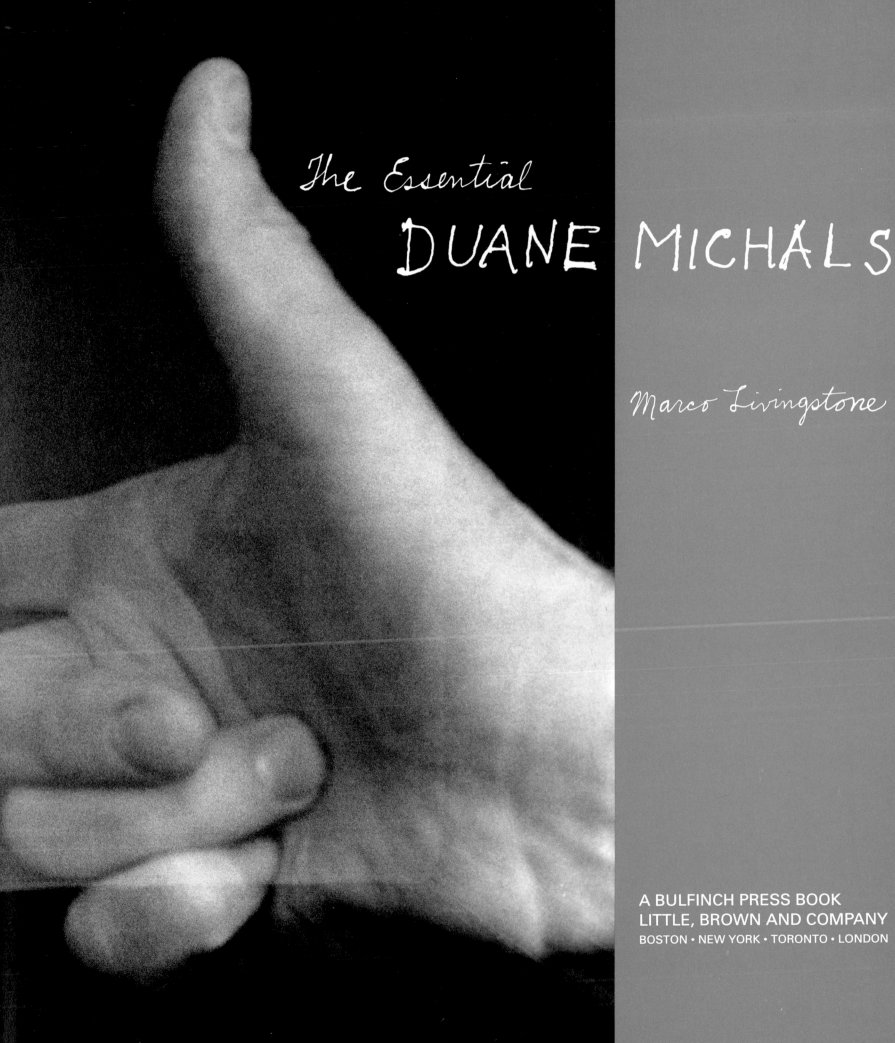

The Essential
DUANE MICHALS

Marco Livingstone

A BULFINCH PRESS BOOK
LITTLE, BROWN AND COMPANY
BOSTON · NEW YORK · TORONTO · LONDON

The author wishes to acknowledge the assistance of the Sidney Janis Gallery, New York, who represent the artist, in providing the material on which the bibliography and lists of awards, collections and exhibitions were based. In particular he would like to offer his thanks to Jeffrey Figley.

Duane Michals himself was helpful beyond all reasonable expectations in responding to the selection of works and in gathering together all the material reproduced in the book.

The biography is adapted from the note by Marco Livingstone in the exhibition catalogue *Duane Michals: Photographs/Sequences/Texts 1958–1984*, published by the Museum of Modern Art, Oxford, England in 1984.

First North American Edition
ISBN 0-8212-2463-8

Library of Congress Catalog Card Number 97-71946

Bulfinch Press is an imprint and trademark of Little, Brown and Company (Inc.)
Published simultaneously in Canada by Little, Brown & Company (Canada) Limited

PRINTED IN SINGAPORE

Contents

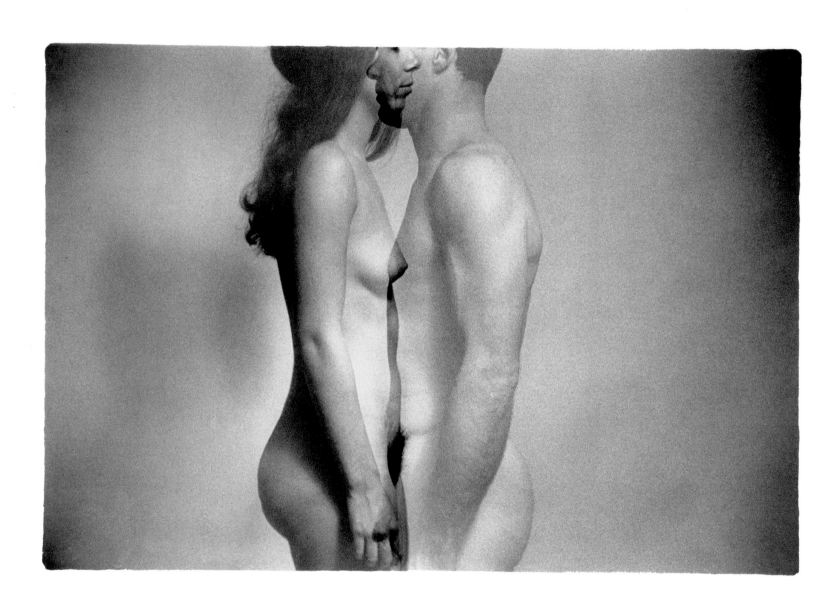

6

For forty years Duane Michals has been making demands on photography that far exceed the expectations for the medium when it was first invented in the 1830s as a way of recording appearances. From the first beautifully composed and acutely observed snapshots that he took as a tourist in 1958, which revealed an unsuspected natural affinity with the camera, through to the poetic elaborations of his maturity, the unfolding of his work could be described as a history of his efforts to overcome the limitations of what the medium was meant to do.

'Photographers deal with reality exquisitely', as Michals acknowledged to me when I first interviewed him in September 1984. 'There's no other art form which reproduces reality with that kind of fidelity. But to me that is to say that appearances are the only things which we consider to be real. What about dreams, what about fear, what about lust, what about all those intimidations which we perform on each other? These experiences, to me, constitute reality.' It is that wider definition of reality, as the accumulation of things felt or experienced rather than just seen, that he has sought to capture in his work, and which has necessitated his redefinition of photography as a form through which such themes can be given not just adequate, but memorable, expression.

Outstanding photographers have always sought to convey something of the aura of their subjects, rather than just their appearance, and have consistently maintained the transcendence of their vision over the purely mechanical operation of their medium. But there has been a surprising conformity of opinion about what can be expressed through the photograph, and how. For more than a century before Michals first taught himself the rudiments of photography, the camera had continued to be used primarily as a tool for capturing 'reality' as a condition that could be witnessed through the eyes. As far as most people are concerned, in the images they produce themselves within this most democratically accessible of forms, it is this documentary function that continues to be its primary purpose. The radical assessment made by Michals, and on which his highly original work has been built, is that one could conceive of the event to be photographed not as some existing external scene or thing but as the visualization of aspects of oneself. As he explained to Tom Evans in an interview published in *Art & Artists* in August 1985, he became disaffected with most of the conventions of photography because they did not equip him to deal with the things that concerned him as a human being:

'The things that interested me were all invisible, metaphysical questions: life after death, the aura of sex – its atmosphere rather than the mechanics – these are things you never see on the street. So I had to invent and make these situations to express and explore these things.'

In emulation of evocatively silent pictures of Paris by the turn-of-the-century French photographer Eugène Atget, in 1964 Michals produced a series of mysterious *Empty New York* interiors glimpsed through windows after hours. The emotive power of these images made him realize that it was possible to project an atmosphere of expectation even when working with the most prosaic of found situations, but that, more tantalizingly still, one could imagine these as theatrical settings within which the dramas of human life were enacted. In 1966 he produced the first of his photographic sequences (or 'photo stories' as he called them in the subtitle to his book *Real Dreams*), a five-part image called *The Woman is Frightened by the Door*. In works such as these – invariably shot 'on location', to use the cinematic term for the use of actual places as backdrops – he records the unfolding of a narrative which he himself has devised and for which friends or other models act out roles sometimes heavily laden with metaphorical import.

The sequential format of such early works as *A Man Going to Heaven* (1967), *The Spirit Leaves the Body* (1968) and *I Remember the Argument* (1969) was quickly compared by critics to the cinema, but the reliance on real time and naturalism in most film making was of no more interest to him than the concern with pure observation in most photography. Michals's sequences stand in a similar relation to movies as poems do to novels: they act on the imagination not through the accumulated evidence of description and explanation, but through the compression of single images rich in metaphorical allusion. The separate images are not like frames extracted from a filmed reel; while they lead one through a progression of events, they do so explicitly in terms of separate stills each of which has far more in common with the language of painting than with the cinema. As in the paintings he admired by Balthus or Magritte, the viewer is presented with a moment of dramatic impact or dreamlike inexplicability: a situation that strikes us as rich in possible explanations, but which remains forever unresolved.

Even in those works by Michals which are most explicit in their narrative, the viewer is presented not with a self-contained story with a single moral or

explanation but with a succession of events each of which is subject to interpretation according to one's own experience or point of view. A conventionally religious person, for example, is likely to impose a much more literal reading on a work such as *The Spirit Leaves the Body* than a non-believer or agnostic; what to one person may seem to be the visualization of the survival of the soul in the afterlife will make sense to another only in much more abstract or metaphorical terms. Although Michals's tender responses to the beauty of the male body are undisguised expressions of his sexual orientation, and as such are likely to strike a particular chord with gay men, each of us – including women and heterosexual men – will also react spontaneously according to his or her own outlook. Only the most repressed or preconditioned viewer will be so antagonistic as to be immune to the effects of these and other images of desire, but even in these extreme cases the viewer will be acting, by definition, entirely within character. One of the most remarkable aspects of Michals's refusal to impose any one view is that the work ends up telling us as much about ourselves as about his own character, imagination or opinions. What we can discover in the process about what motivates or defines us as human beings can be by turns illuminating, funny, disturbing or moving.

If Michals in his photo-sequences broke with one of the cardinal rules of photography, that of the autonomy of the single isolated image, he committed a further and (in the view of purists) more serious blasphemy when he began in the late 1960s to write short texts by hand on the surface of his prints as a counterpoint or supplement to the picture. This act not only violated the virginal self-sufficiency of the print as an aesthetic object in itself, but dared moreover to suggest that a photograph alone might not be up to the task of conveying the intricacies of the artist's thoughts. By the mid-1970s he was producing texts, such as *A Failed Attempt to Photograph Reality* (1975), that stood on their own, dispensing altogether with the photographic image. Revealingly, however, these continued to be written on photographic paper – a surface that was familiar to him and with which he still identified – and to be framed and hung alongside his other works. Only later in the 1980s did such texts begin to be conceived explicitly for publication in the books that have become one of his prime and most appropriate forms of expression.

However unconventional his solutions, Michals no more set out to agitate against the conventions of photography than he did to devise formal strategies for

the mere purpose of innovation. His urge to expand the possibilities of his medium has always been motivated by the need to find the most vivid way of expressing his concerns and changing moods, from the serious to the sensual to the just plain silly. It is these wide-ranging themes – concerning the nature of such abstract notions as time, the imagination and the spirit, as well as the reality of sexual desire, human dependency and an acceptance of mortality – that invariably act as the catalyst for the making of a particular work. The form in which it is eventually expressed is the one to which that subject seems most suited on that particular occasion: a single captioned image, a single image with appended text, a sequence of photographs with or without texts, a photograph covered in paint or paired with a drawing, or (with increasing frequency) a poem or short piece of prose on its own.

An autodidact in everything he does, Michals inevitably plays off the advantages of sincerity, emotional directness and a naive charm against a variety of risks that others would not countenance: the dangers of 'clumsiness', 'awkwardness' of expression, lack of 'polish'. Just as his photographs sometimes look casual and blissfully unconcerned about such basic matters as depth of field or clarity of definition, so his poems do not always scan properly or rhyme with the greatest subtlety. Even his spelling lets him down, and if he makes a mistake in writing a text in ink, he simply crosses out the unwanted words and carries on. The childlike, spidery scrawl of his handwriting, which establishes an intimacy of tone for the messages he is conveying, is itself so revealing in its 'imperfections' that one has no need to call upon the services of a graphologist in search of evidence of his personality.

Michals has little respect for 'professionalism' as its own reward, or for other social conventions that often serve no purpose other than to provide a surface sheen behind which there is nothing but hollowness or a failure of nerve. I do not mean to suggest by this that there is anything amateurish about his work, or to downgrade the importance of his command of photography – his superb compositional sense, his subtle use of natural light, his expressive treatment of the human figure – in conveying his ideas. These are all necessary, but only as means to an end. He has remarked that it is important to give oneself the freedom to fail. One might say that it is all very well for him to take advantage of his fame as a photographer to publish what some literary people might consider to be bad poems, but in revealing himself to us with all his imperfections he is doing something far more

important than demonstrating his ambition or versatility: he is encouraging each of us to reveal ourselves in our own vulnerability and to dare to try things of which we might think ourselves incapable, rather than passing through life on the narrowest and most self-restricting of paths through fear that our limitations or weaknesses will be discovered and made apparent to the rest of the world. Michals's art provides a constant and healthy reminder that our time on this earth is limited, and that – to misapply Marx – we have nothing to lose but our self-imposed chains.

In the purely photographic component of his work, far from setting himself the task of revolutionizing the conventions of the medium, Michals reveals great affection and respect for the work of his antecedents and a profound understanding of the function of the camera as a mechanical aid. This goes far deeper than the discovery of kindred spirits, such as the late-nineteenth-century painter and photographer Thomas Eakins or the mid-twentieth-century photographer George Platt Lynes, for both of whom he has openly declared his admiration. The first photographers thought of their work as 'drawing with light'; W.H. Fox Talbot's publication of 1844 – 46, which can lay claim to be the first photographic book, was given the evocative title *The Pencil of Nature*. For Michals, too, light remains the all-important element, the agent of disclosure, the surrogate means of conveying the sensation of touch, a metaphor for intellectual or spiritual illumination, and the very substance of life itself: the energy animating the universe.

These days it may be fashionable to be cool, ironic, aloof, cynical, unfeeling and indifferent, as a mere glance at most art forms will confirm. By contrast to be sincere, open and emotional, to reveal and acknowledge one's vulnerability, as Michals does in his art, is to risk accusations of sentimentality and worse. Yet the potential rewards of daring to expose oneself in this way are enormous, for they make it possible to establish an intimacy and intensity of communication between artist and audience. It is a situation of which Michals has taken full advantage.

Messages

Sacrificing the purity and autonomy of the isolated photographic image, Michals began writing on the surface of his photographs in the late 1960s out of a conviction that what counted most in his art was its potential for communicating ideas about life and experience. Since appearances can be deceptive, or at best informative only of the surface of what passes for 'reality', he preferred instead to direct the viewer's attention much more concretely to a train of thought for which there might not even be a visual equivalent. If this meant that he could no longer lay claim to the title of photographer, in the generally accepted sense, so be it. Why should he worry about conforming to other people's expectations for the sake of terminology, when he was using photography to create for himself the possibility of addressing the big questions that artists in other fields, such as novelists, poets or film makers, saw as their right and even their duty to consider?

The presence of an accompanying text, or the unfolding of a text within a sequence of images, immediately acknowledges the primacy of an idea being communicated from one person to another. By writing down his plain-speaking words in his own hand, Michals emphasizes the intimacy of the encounter. It is not an abstract, collective audience to whom he speaks, but to each of us in turn. In *Someone Left a Message for You* he acknowledges that the process by which the author enters into our thoughts is by nature an insidious transference of brain waves, but (as he points out in a separate text) there is nothing sinister about this because the very fact that we are reading the text demonstrates that the encounter was meant to be. It is not the possibility of being influenced that should worry us, but the all too common failure to give voice to the thoughts and emotions that we keep bottled up for fear of self-exposure. Always risking the embarrassment of frankness, Michals advises us in no uncertain terms not to let our lives pass in silence, but to say what we have to say now before it is too late.

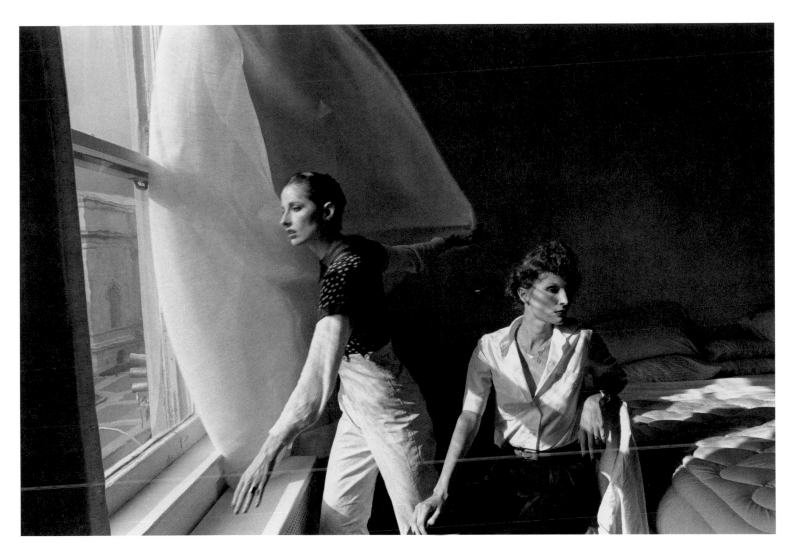

CERTAIN WORDS MUST BE SAID

Things had become impossible between them, and nothing
could be salvaged. Certain words must be said.
And although each one had said those words silently
to herself a hundred times, neither had the courage
to say them out loud to one another. So they began to hope
that someone else might say the necessary words for them.
Perhaps a letter might arrive or a telegram delivered
that would say what they could not. Now they spent
their days waiting. What else could they do?

IT IS NO ACCIDENT THAT YOU ARE READING THIS

I am making black marks on white paper.
These marks are my thoughts.
and although I do not know who you are reading
this now, in some way the lines of our lives
have intersected here on this paper.
for the length of these few sentences.
We meet here.
It is no accident that you are reading this
This moment has been waiting for you.
I have been waiting for you.
Remember me!

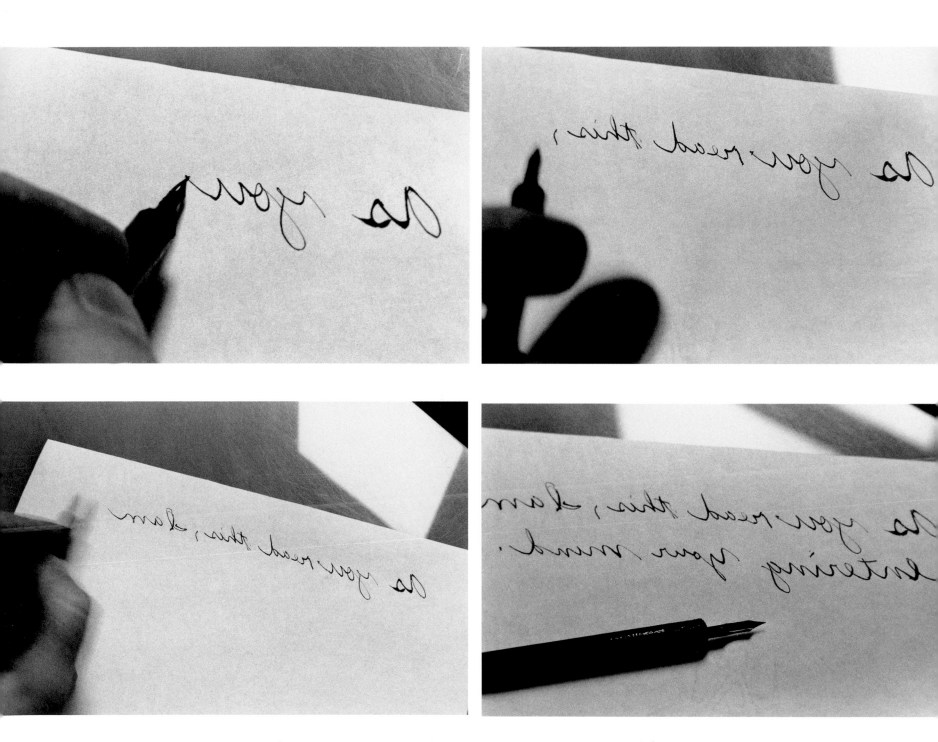

SOMEONE LEFT A MESSAGE FOR YOU

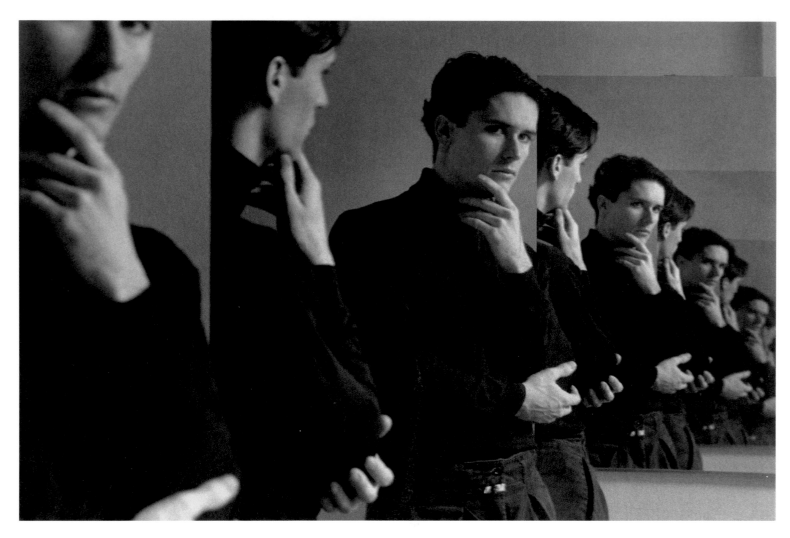

A STORY ABOUT A STORY

This is a story about a man telling a story
about a man telling a story. He looks into
a mirror and tells his tale to the man
he sees in his mirror. And the man in the
mirror thinks that he is telling his story
to the man he sees in his mirror.
He finds a box and when he opens it,
he finds another box inside. And inside that
box is an even smaller one and yet an even
smaller one inside of it. When at last
he finds the tiniest box of all, he takes
a magnifying glass to see what he can see.
But all he sees is a giant eye looking
back at him.
He falls asleep and dreams of a man who
is dreaming about a man who is dreaming
And as you are reading this story, I am
writing a story about you reading this story.
Did you tell me this story, or did I tell it to you?

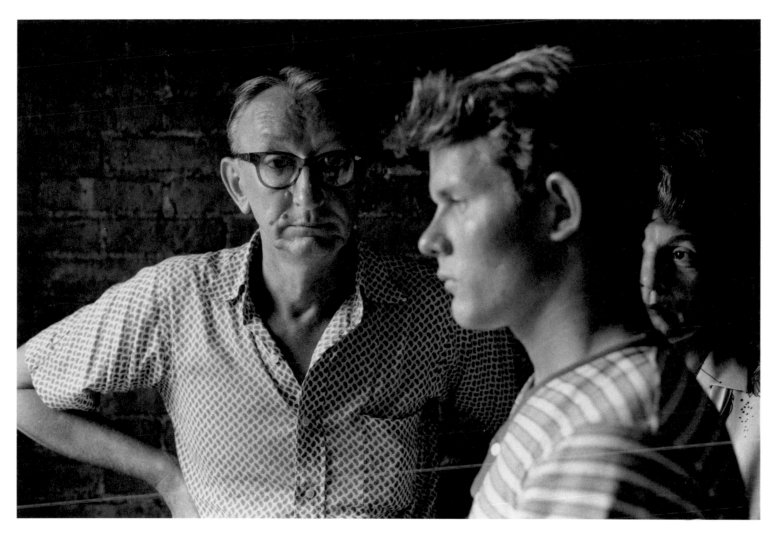

A LETTER FROM MY FATHER

As long as I can remember, my father always said that one day he would write me a very special letter. But he never told me what the letter might be about. I used to try to guess what intimacy the two of us would at last share, what mystery, what family secret would be revealed. I know what I hoped to read in the letter. I wanted him to tell me where he had hidden his affection. But then he died, and the letter never did arrive. And I never found that place where he had hidden his love.

Encounters

From the moment of conception, each person's very existence is subject to random factors and unplanned events that irrevocably alter the course of his or her life. The intersection of our paths, and even the failure to connect when possibilities have been presented to us, may have consequences out of all proportion to the apparent casualness of the occurrence itself. *Chance Meeting* may have particular resonance for gay men who have experienced the Russian roulette pleasures and disasters of 'cruising', but who can fail to have wondered, after catching someone's eye on the street, what might have been had one only had the courage to make contact?

In *The Moments before the Tragedy* Michals presents a sequence of images that are like stills from a filmed narrative pregnant with tense expectation. Even without the benefit of an ominous soundtrack, there is a *frisson* of impending violence and the ever-present threat of unknown dangers and misfortunes that can deprive one forever of health, happiness and one's very existence. In Michals's early work, violent situations abound, suggesting that his idealism as a young man was being eroded by the cruelty he had seen inflicted by people on each other. Later sequences demonstrate a more philosophical acceptance of human nature, as in *The Old Man Kills the Minotaur*, a metaphorical re-enactment through classical imagery of the struggle for supremacy between father and son. The broad comedy of *Burlesque* reveals the playful and childlike aspects of Michals's temperament, but the fun and games take a dark turn, ending on a note of sexual aggression that brings one back with an unexpected jolt to the violent encounters conveyed in his earliest sequences.

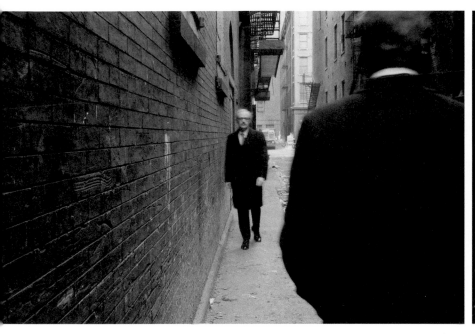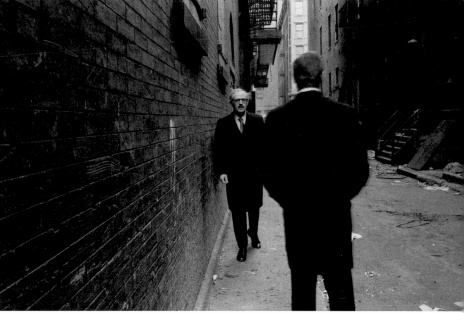

CHANCE MEETING

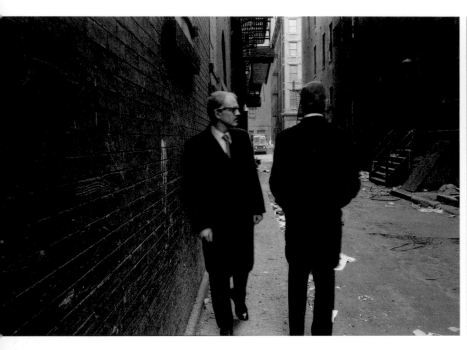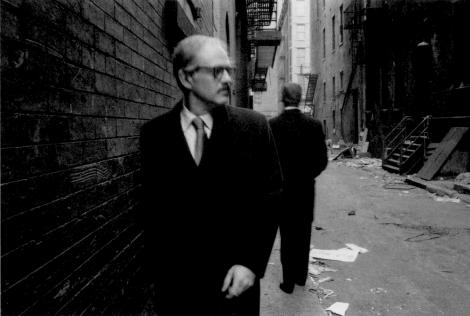

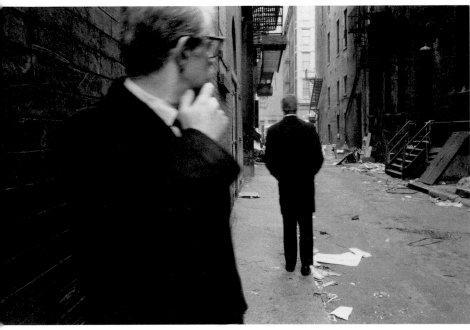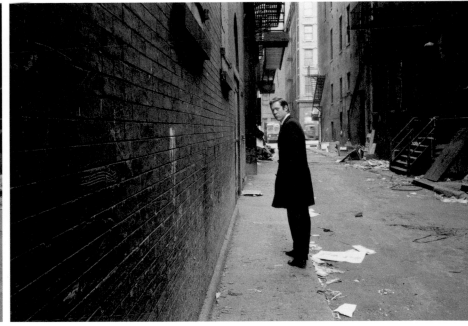

I REMEMBER
THE ARGUMENT

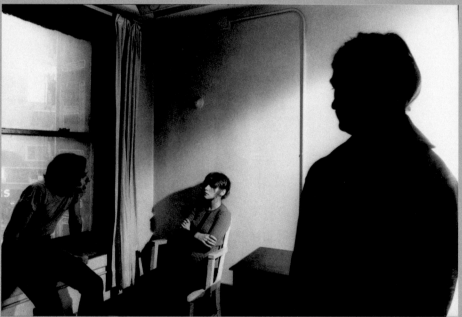

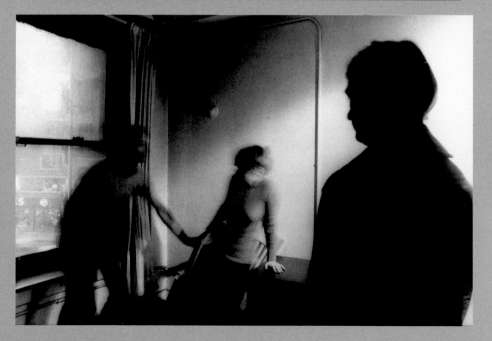

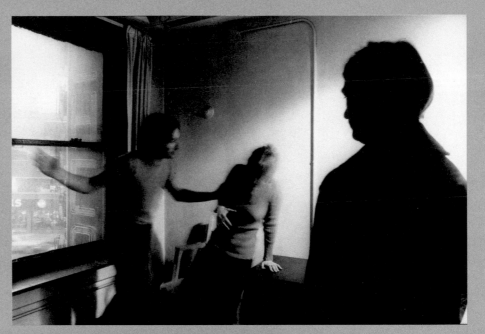

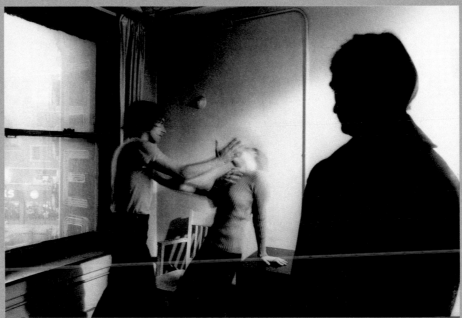

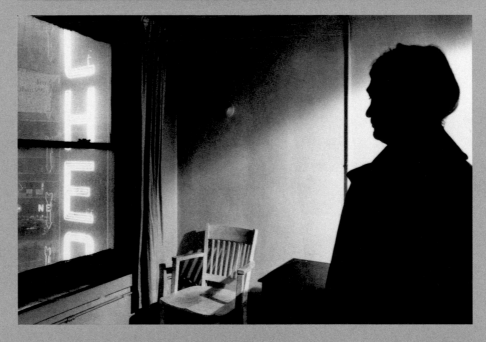

23

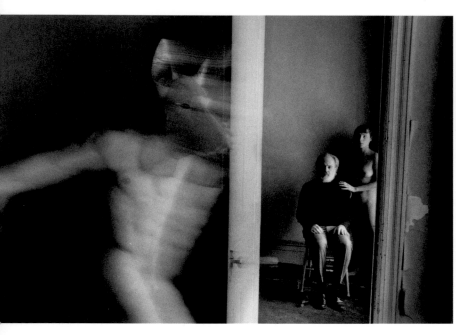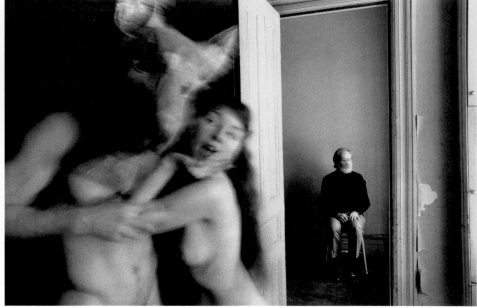

THE OLD MAN KILLS THE MINOTAUR

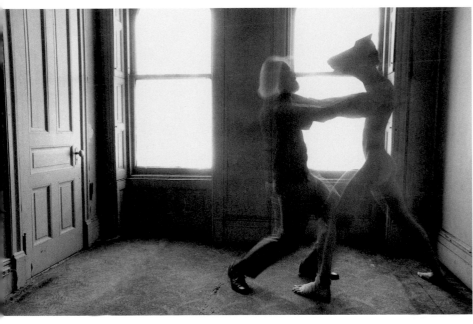
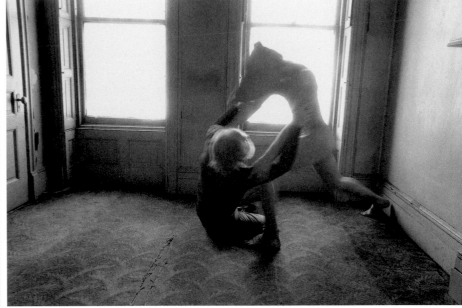

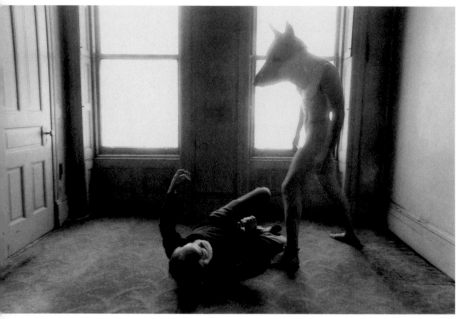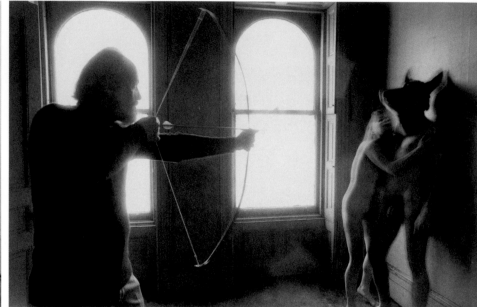

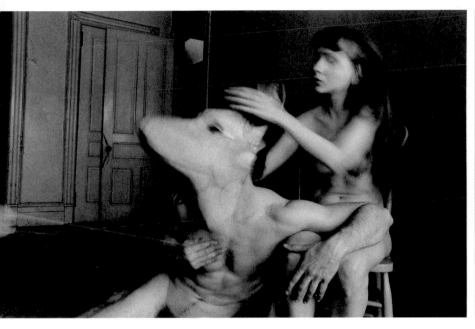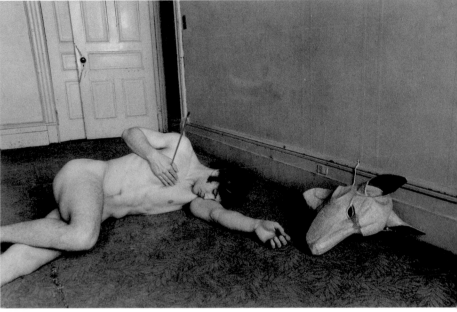

THE MOMENTS BEFORE THE TRAGEDY

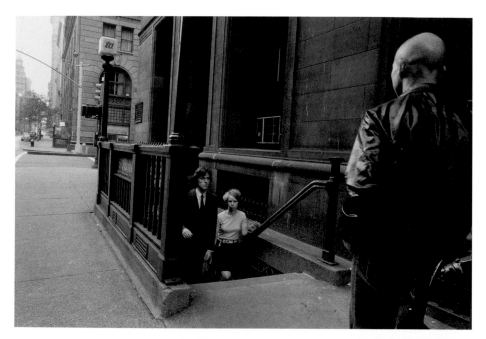

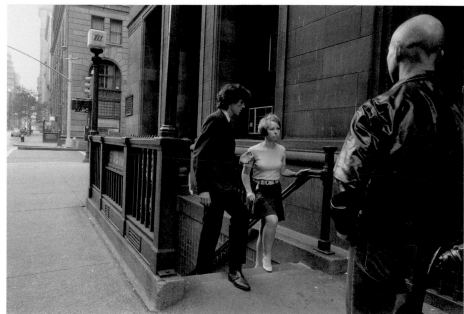

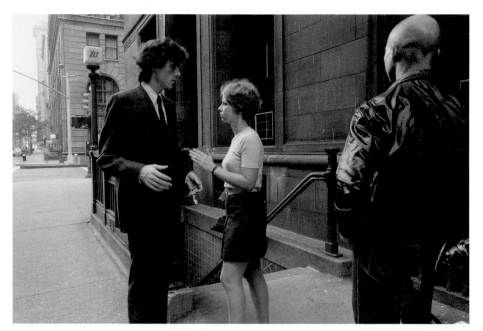

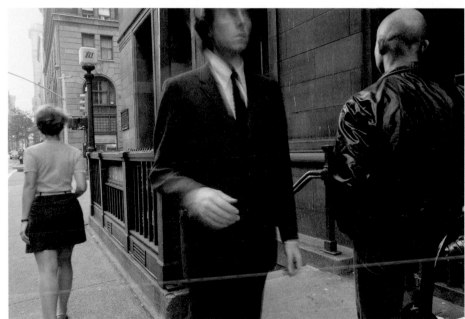

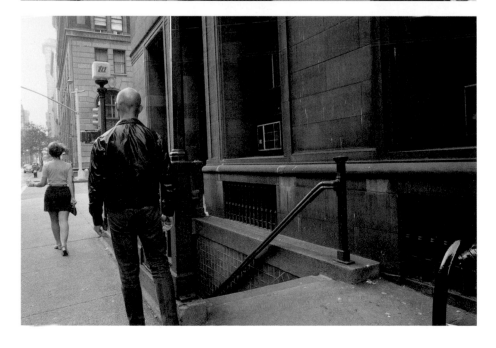

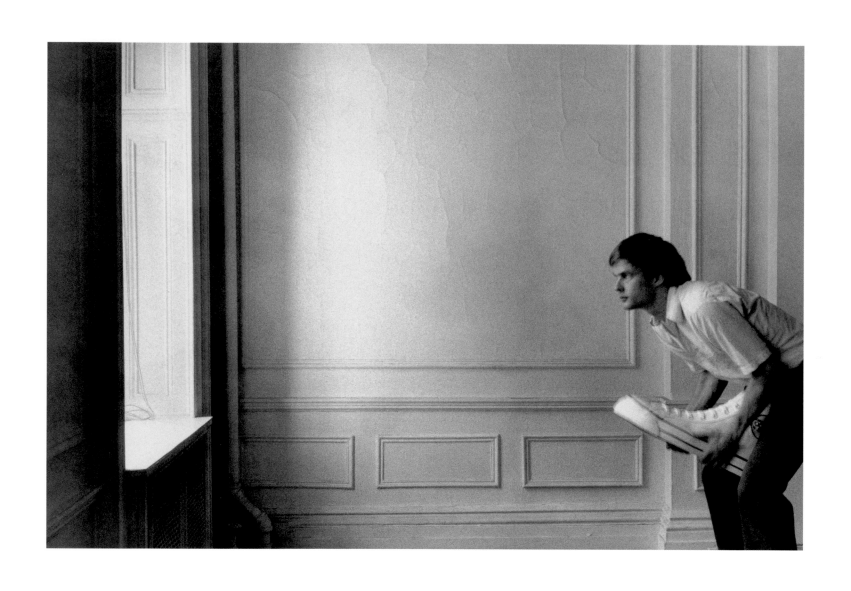

BURLESQUE

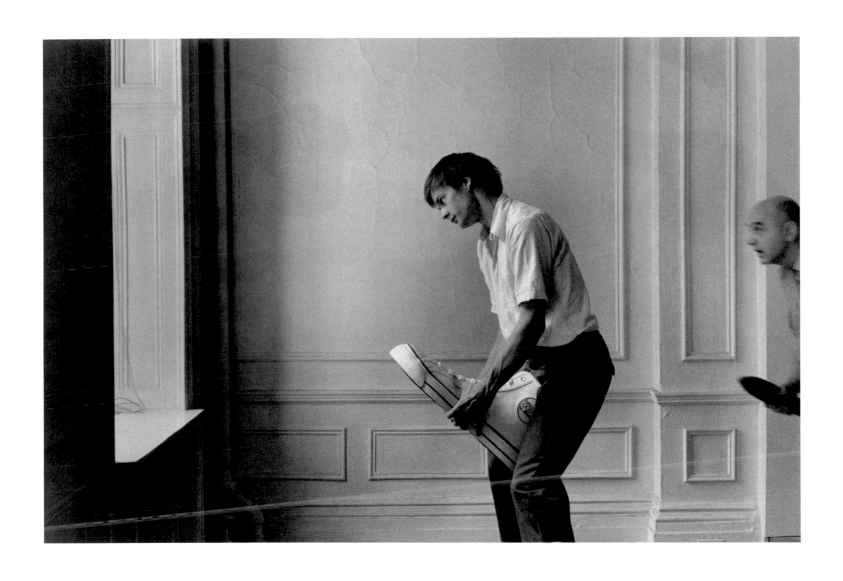

31

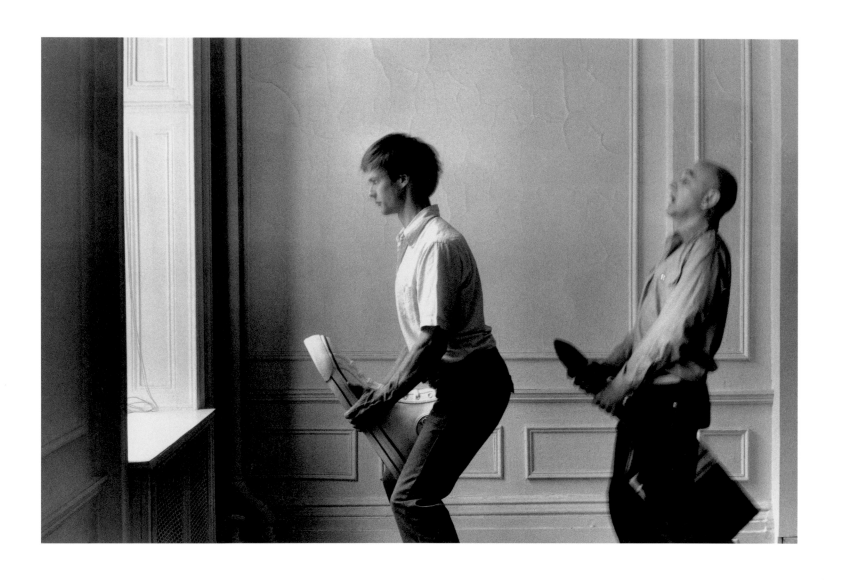

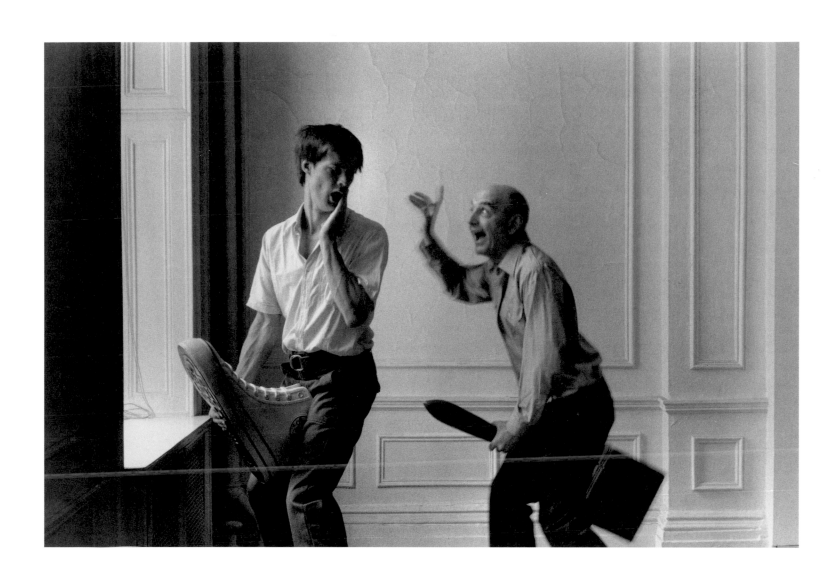

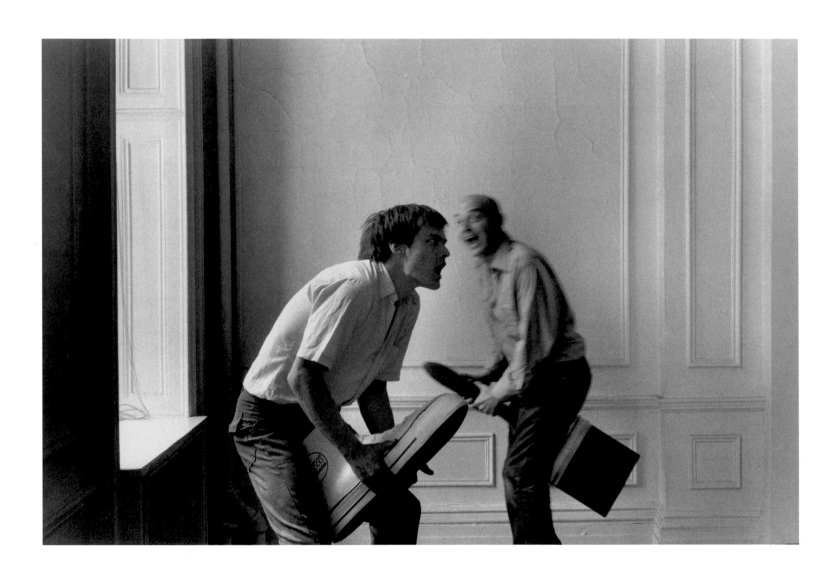

34

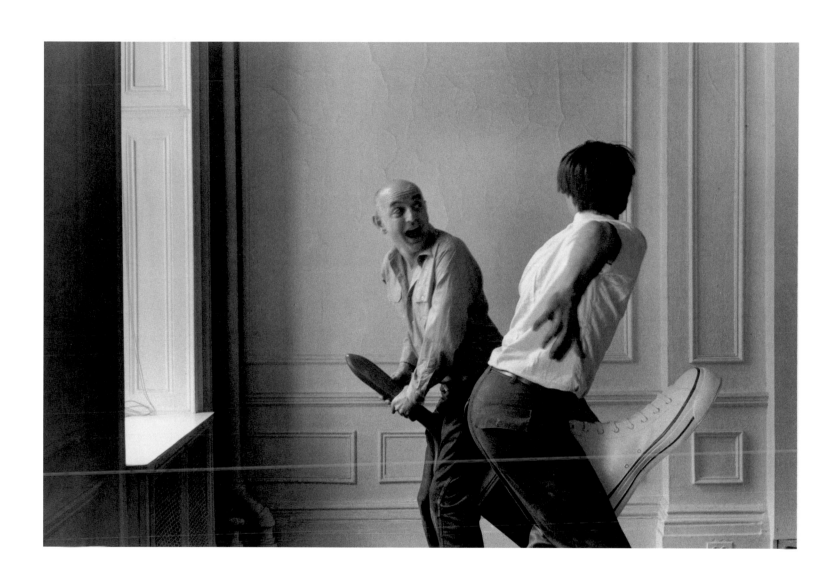

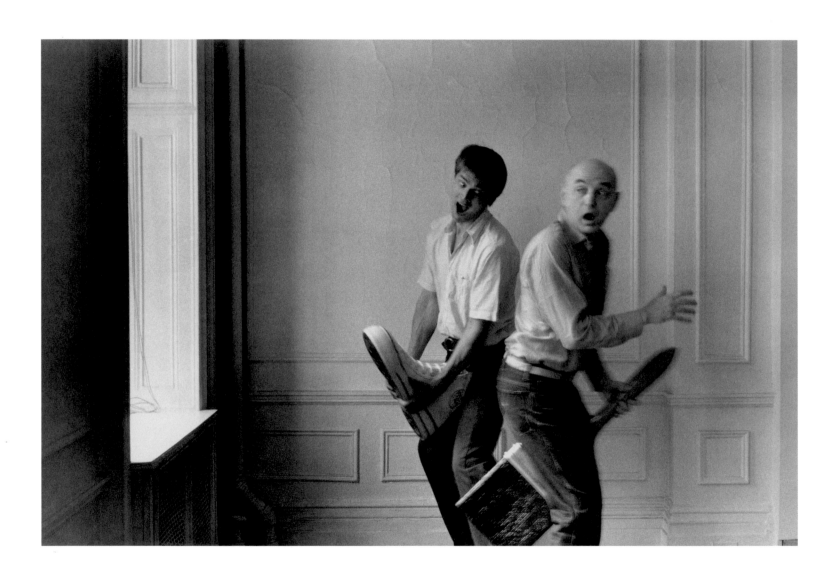

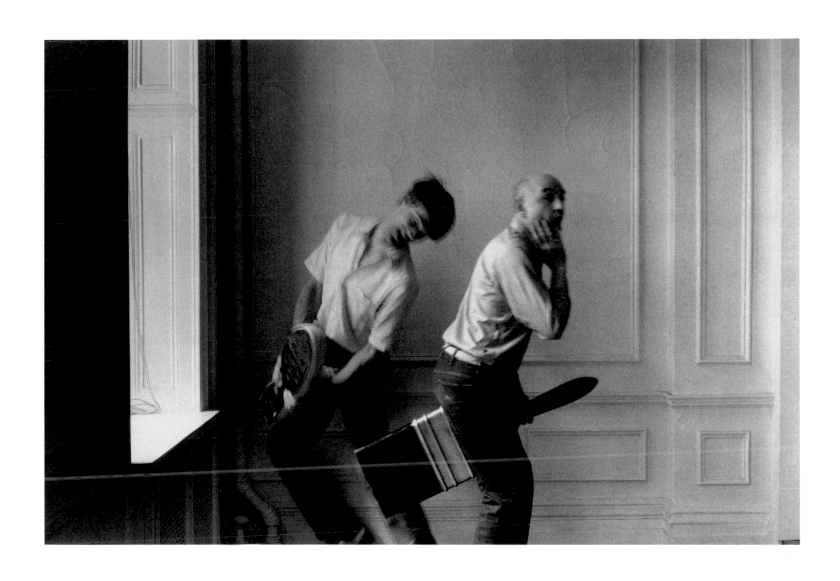

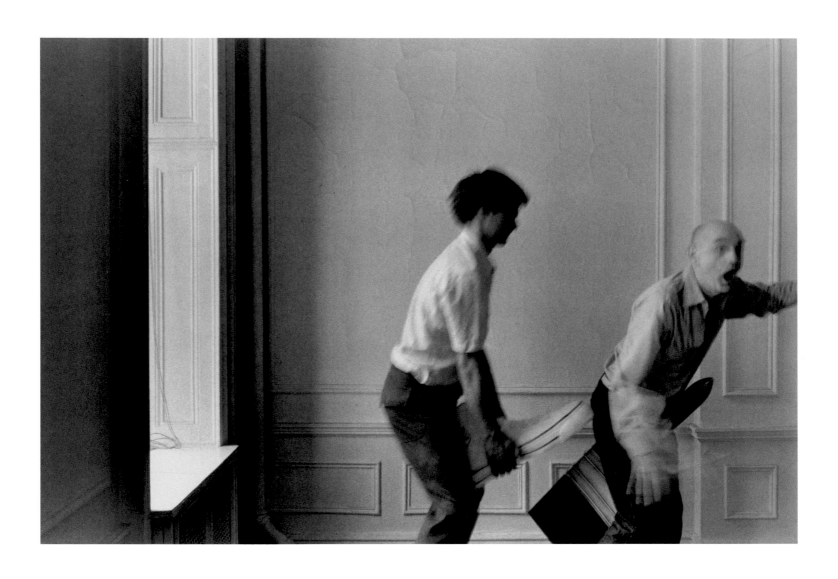

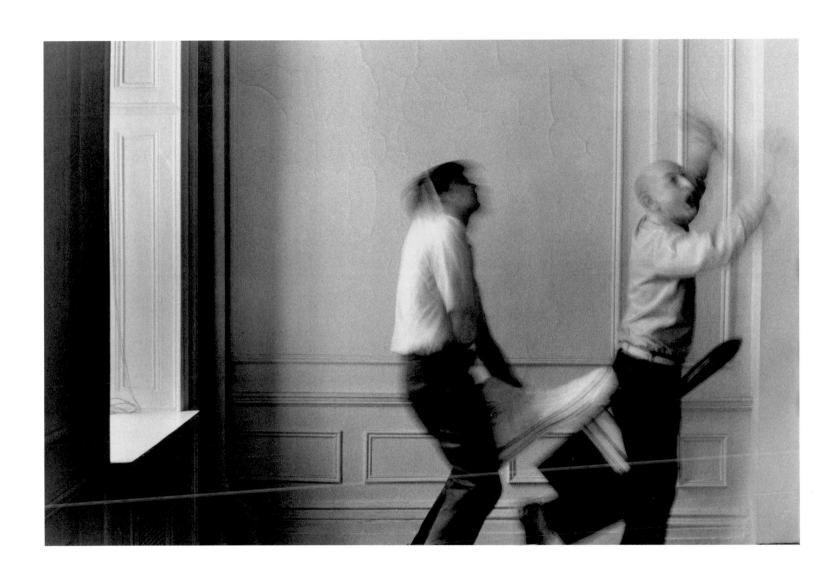

Human Dependency

Children, inexperienced in the ways of the world, are at the mercy of their parents. Adults may begin to live their lives through their children. In old age, when they become too frail to look after themselves, they can expect to return to a childhood state of dependence on others, most probably their own offspring. Our roles are in a constant state of flux, but marked always by a need for mutual support. These themes have been addressed by Michals most often through the father/son relationship, specifically by recourse to his own experience first with his father (with whom he regrets never having had the closeness he craved) and latterly, as a middle-aged childless man, with younger men to whom he has become a kind of surrogate parent. Taking a Biblical tale as his cue for a photo-sequence entitled *The Return of the Prodigal Son*, Michals presents himself in the role of the father welcoming back a son who has returned in a spirit of repentance from his first brush with the outside world. It is not so much a question of forgiveness as of empathy with another person's suffering and vulnerability, as signified by the young man's nakedness. Through the very act of removing his own clothes in order to shield and give comfort to the son, the father in turn makes himself vulnerable, exposing the compassionate instincts of his own humanity.

Other works by Michals suggest that romantic entanglements are subject to similarly confused struggles for dominance and reassurance. In *Person to Person*, the pictorial conceit of metamorphosis on which the tale hinges draws attention vividly to the ways in which we subconsciously take on the attributes of those whom we have loved as a way of holding them in memory. Long after they have died or left us, as a result either of a failed relationship or of circumstances beyond our control, we find that our lives and our very personalities have been irrevocably changed as a result of having known them.

PERSON TO PERSON

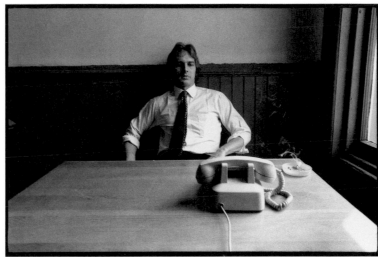

Tom had no idea how long he had been sitting there. It did not matter. She would never call. Yet, deep inside, he still believed in his power over her.

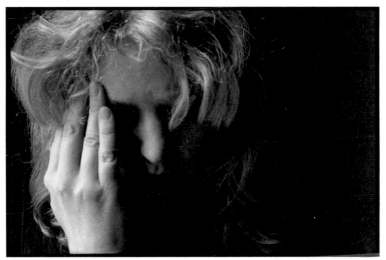

He always had power over her. He knew what words could make her cry.

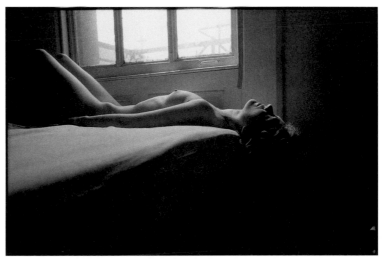

Even now, when he thought of her, it was her body that he missed. He wanted to touch her.

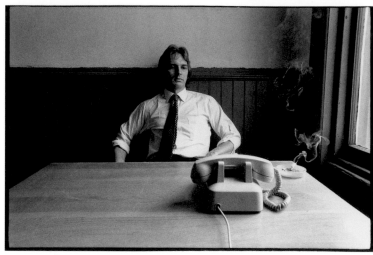

By leaving him, her absence gave her a power over him that she had never had when they were together. Tom was filled with an anxiety he could not understand.

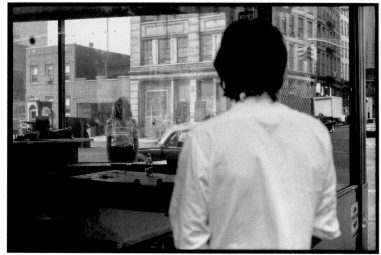

He began to think that he saw her everywhere

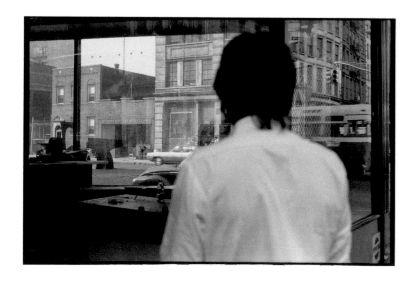

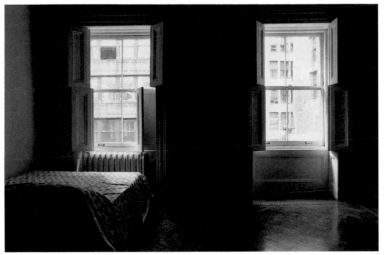

Without her, his room was filled with an enormous melancholy.

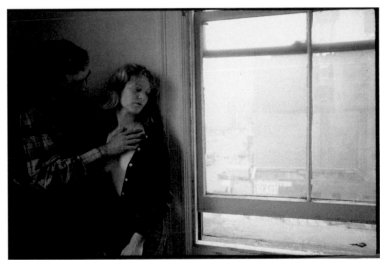

T wondered if she would let a stranger touch her the way he had. He wondered if she had permitted strangers to touch her when they were together, secretly.

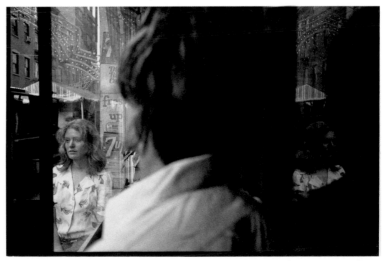

Leaving a shop one afternoon, he saw her, unobserved. Tom was paralyzed and could not move or speak. Later he realized that he was relieved that she had not seen him.

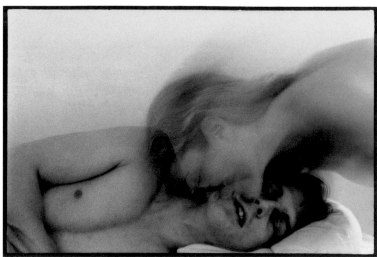

One night he dreamt that she came and kissed him, and with that kiss, she entered his body. ~~She~~ She was looking ~~the~~ through his eyes and listening with his ears.

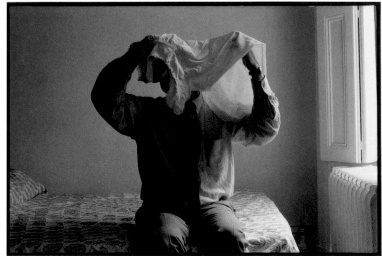

T. found an old night gown of hers in the bottom of his closet. He liked to drape it over his head. It still smelled of her.

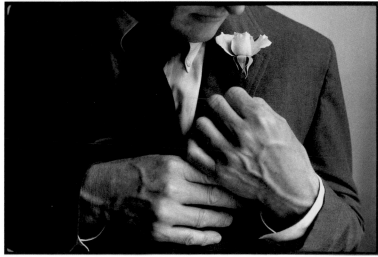

Soon he began to wear a rose in his lapel because it was her favorite flower. Her favorite things became his favorite things.

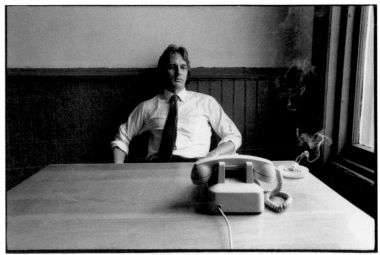

He hated himself # for sitting there. He hated her for making him sit there. T began to believe that he could will her to call. His need for her could make her call him.

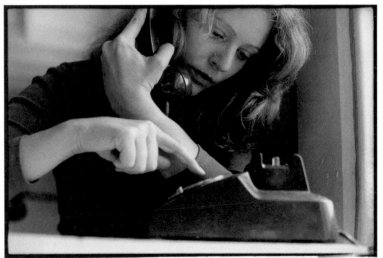

He suddenly knew that at that very moment she was dialing him. It was true! He had made her call. His power could make her call. The telephone would ring.

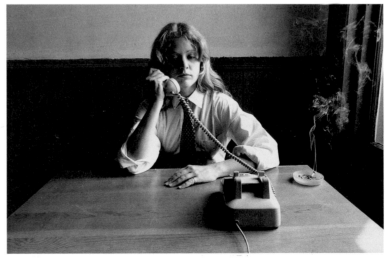

"Hello, no, Tom isn't here anymore. Yes Cathy I'll tell him you called if I see him."

THE RETURN OF THE PRODIGAL SON

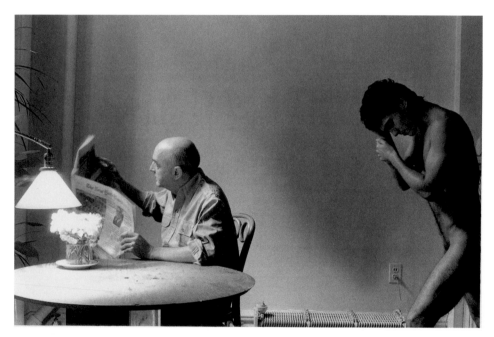

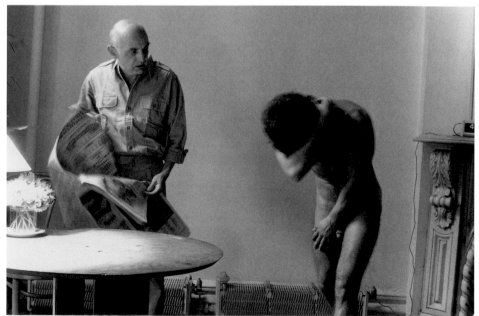

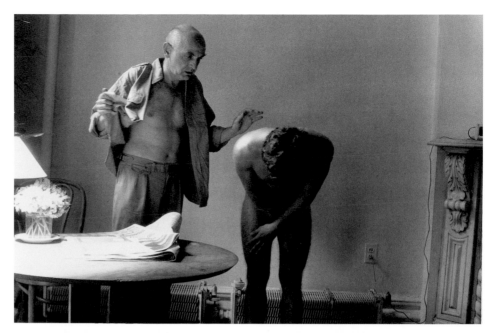

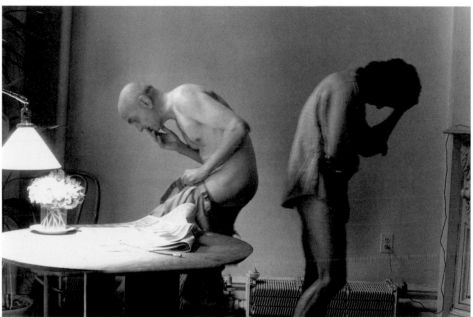

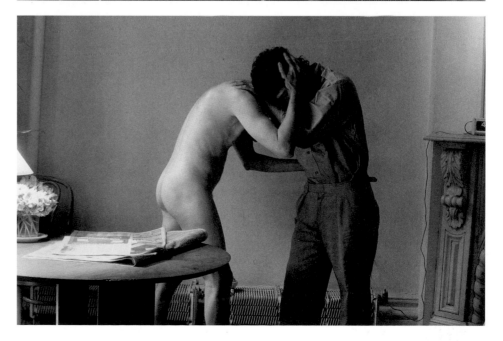

Carry me daddy,
All the way home.
I'll lean on your shoulder,
 Even after I've grown.
And when we get there,
 Tuck me in bed,
 I'll still be your son,
 Even after you're dead.
While I am dreaming,
 Sing me a tune,
A song of my birthright,
 The sun and the moon.

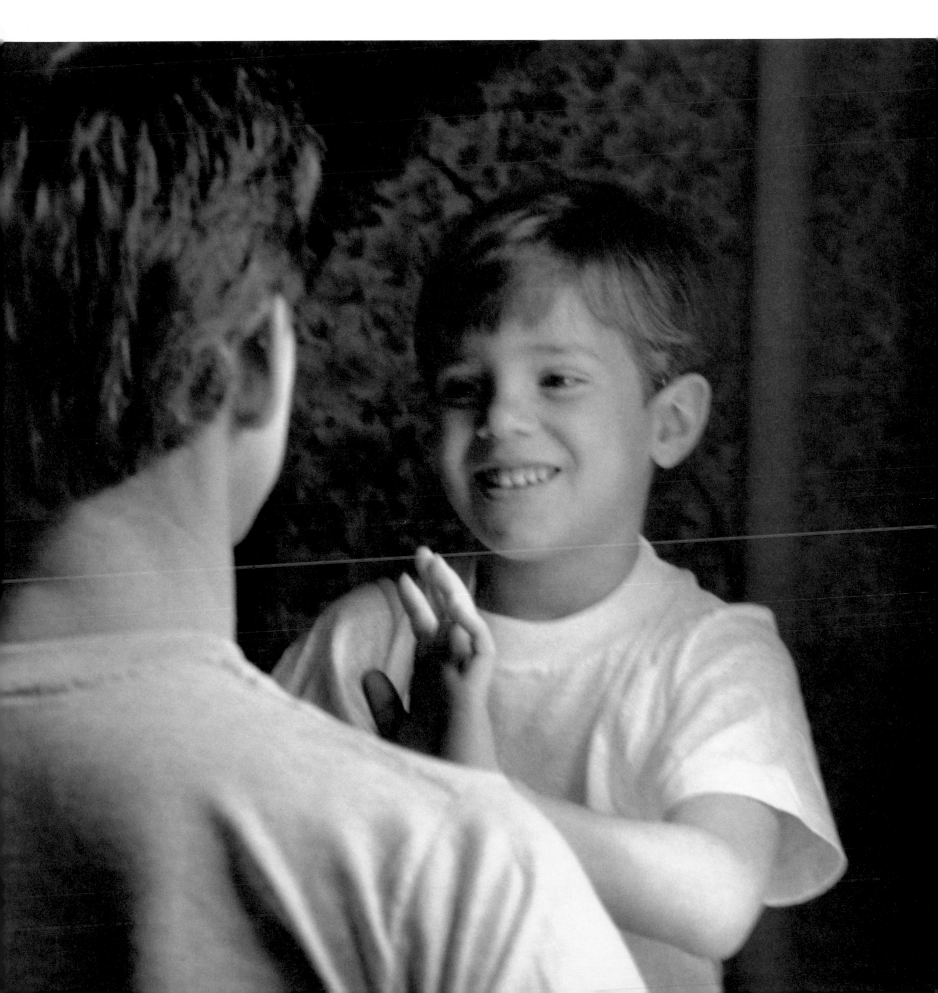

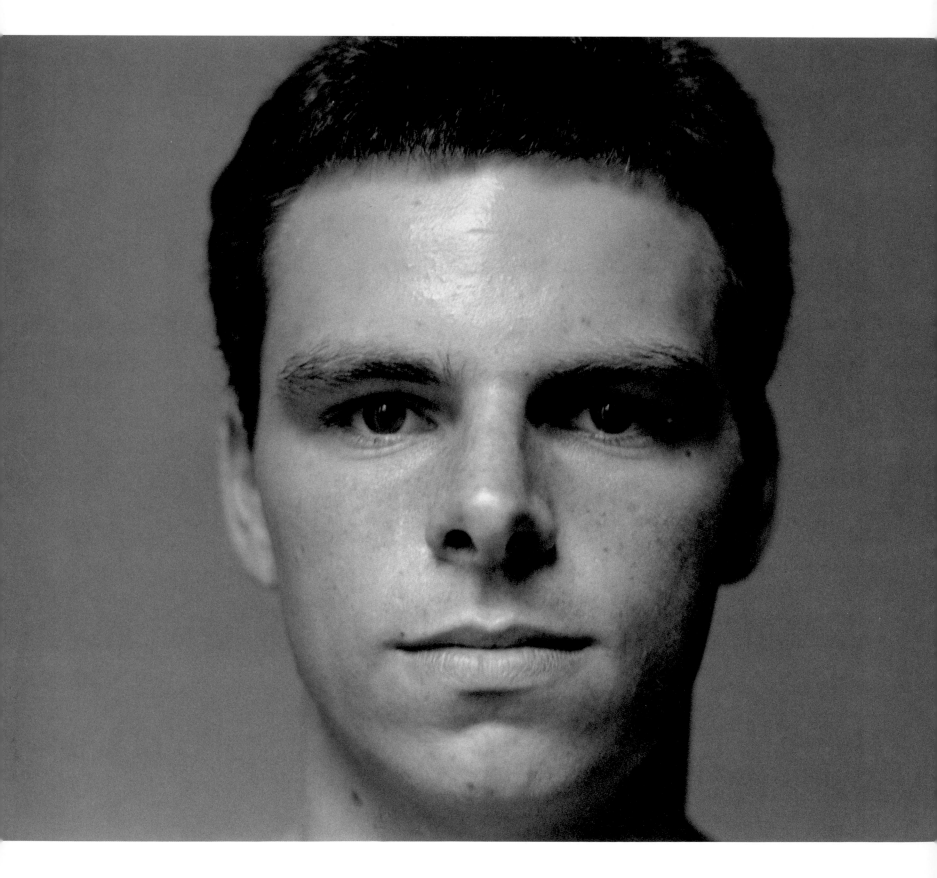

To Some other father's son.

I wish that I had been your mother's lover.
and that we had slept with one another
 on some summer's night.
 so that I might claim of you, the natural father's right

And the blood that pulses through your veins,
 I wish were mine, the very same.
And your strength that I can plainly see,
 I wish had also come from me
Would that you had issued from my fountain's joy,
 you sweet and sturdy smiling boy

But this is the harsh, reality, that like some phantom limb
 you cast no shadow from my tree
Still we had shared what you never had,
 with him whom you had first called dad.
And at the point of this brief now. it seems correct,
that I somehow be at your side
 So I can point and show and guide.
 What I need to give, you do need to take
 We share this living gift,
 for both our loving sakes.

The Imagination

Contrary to most photographers, who direct attention to things as they supposedly are, Michals is far more stimulated by what could be. Consequently he depends not so much on his eyes as on his imagination, and he asks his audience to take a leap of faith and do the same. In the text accompanying an image of an empty bar-room interior, he draws attention to the fact that *There are Things Here not Seen in this Photograph*. By informing us of some of the circumstances and unseen events circulating around that single snapshot of a frozen moment, Michals not only voices his frustration with the expressive limitations of the isolated photograph, but makes us realize that it is in our power as viewers to bring alive – through the application of fantasy – an image that would otherwise remain mute and incomplete.

Borrowing from devices common to Surrealism and Lewis Carroll's Alice stories, including plays on scale and on pictures within pictures, Michals disrupts expectations in sequences such as *Things are Queer*, leading us on a merry chase through the wanderings of his own mind. It is like being taken on a tour of the universe only to be dropped off at the original point of departure, none the wiser. Here and in other works conveying an explicit narrative devised by him, as in *I Dream the Perfect Day in New York City*, it is not enough that we should content ourselves with being entertained by his fertile invention. Each work prompts us to dream our own dreams, as an escape from prosaic circumstances, and in turn to spur us towards our own awakening. Like the events and other works of the imagination that have shaped the artist's own consciousness, Michals's art constitutes an invitation to step into another dimension that offers a release from the insipid reality of the everyday. 'When I'm asleep', as Billy concludes at the end of a sequence in which he dreams 'funny things' from illustrations in old children's books, 'I don't miss being awake!'

THINGS ARE QUEER

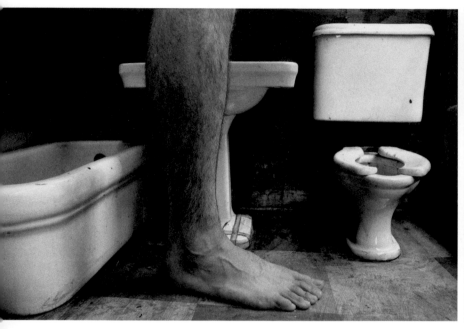
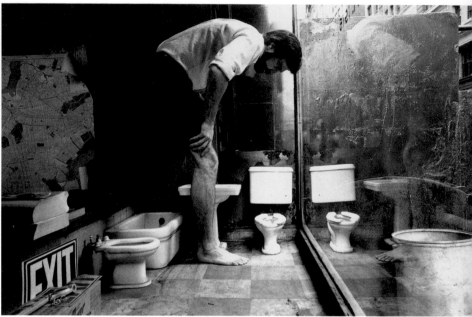

where the giant unlocked a cellar door and showed him
gold: 'One is for the poor, the second for the King, a
yours.' Just then the clock struck twelve and the giant v
the boy in total darkness. Next morning the King came
had happened. 'My dead cousin came to see me and a
fellow showed me three treasure chests in the cellar; but
me to shudder.' The King was overjoyed: 'You have sav
he cried, 'now you may marry my daughter.'

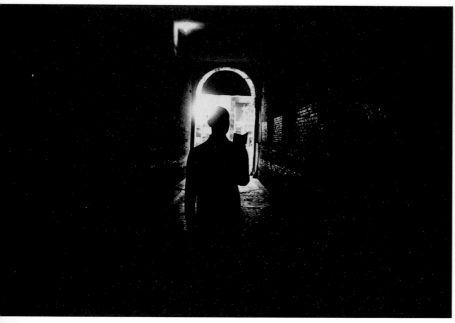

THERE ARE THINGS HERE NOT SEEN IN THIS PHOTOGRAPH

My shirt was wet with perspiration. The beer tasted good but I was still thirsty. Some drunk was talking loudly to another drunk about Nixon. I watched a roach walk slowly along the edge of a bar stool. On the juke box Glen Campbell began to sing about "Southern Nights." I had to go to the men's room. A derelict began to walk towards me to ask for money. It was time to leave.

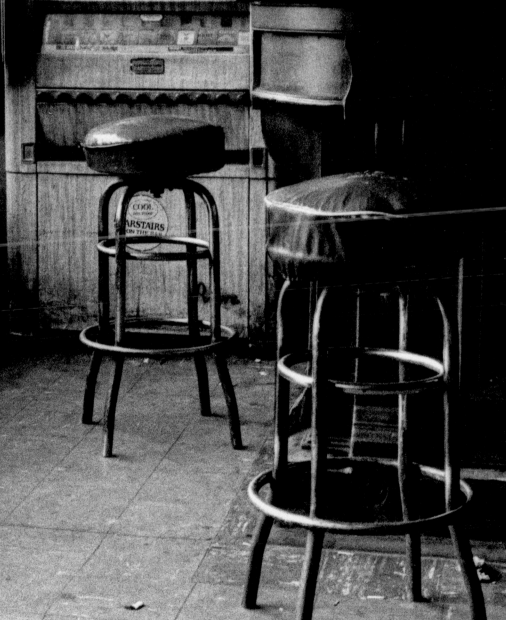

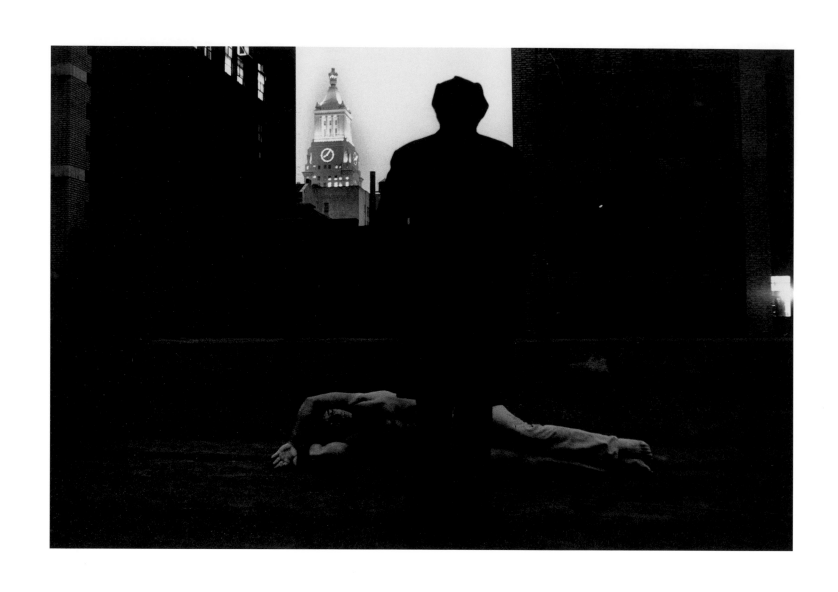

A MAN DREAMING IN THE CITY

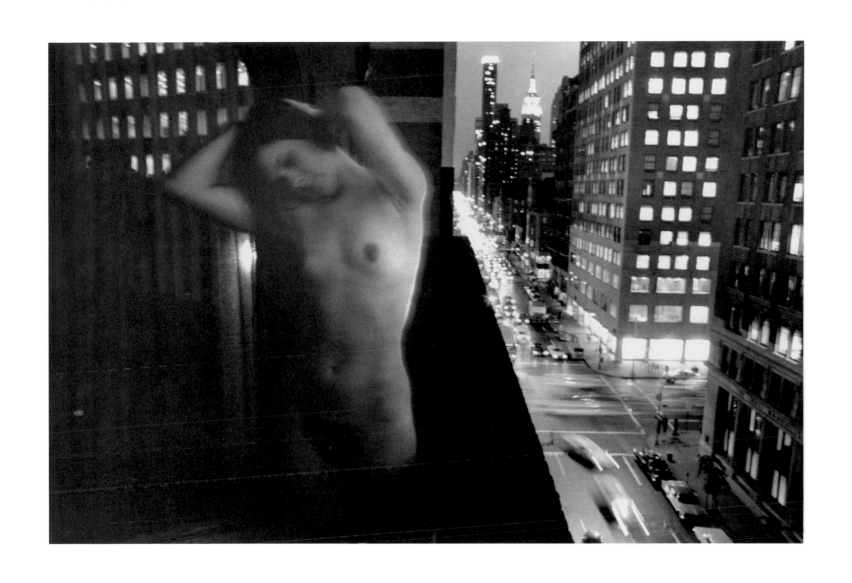

A WOMAN DREAMING IN THE CITY

I DREAM THE PERFECT DAY IN NEW YORK CITY
It was early in the morning of February 18, 1977, in
that certain place of consciousness where one is not

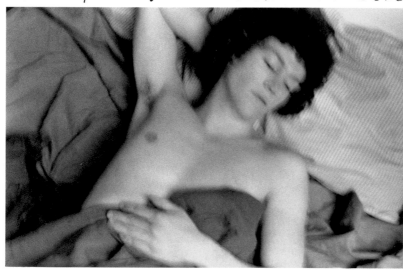

asleep or awake, that I saw myself as a young man
again, and I dreamed the perfect day in New York.

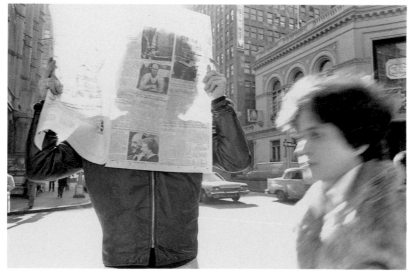

At once I was on the street reading my paper. I was
surprised to that my name had been mentioned in the
capitol by the president, and a great honor would be mine.

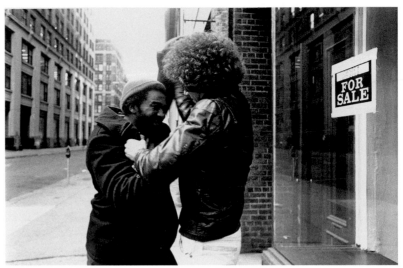

I am attacked by a thief, but I defeat him and he flees.

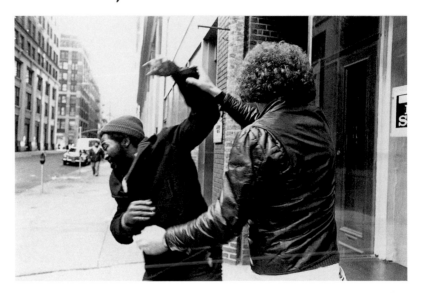

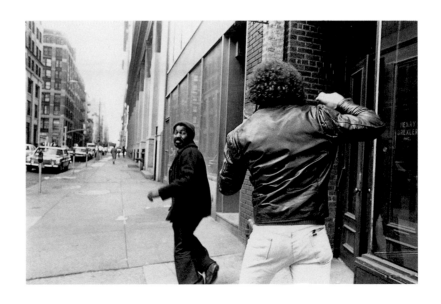

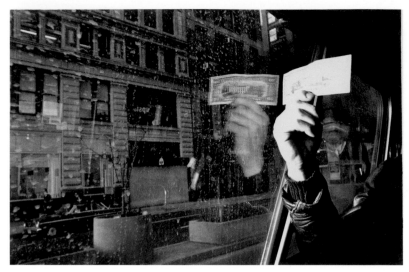

On the bus I find money

A book arrives in the mail from someone unknown.
The first words I read are "Tat tvam asi."

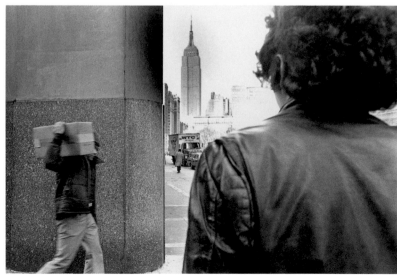

Walking down Broadway, I stop for a moment
to glance at the Empire State Building.

In a moment the building vanishes into light.
I understand. I am awakened.

In the circle of all things

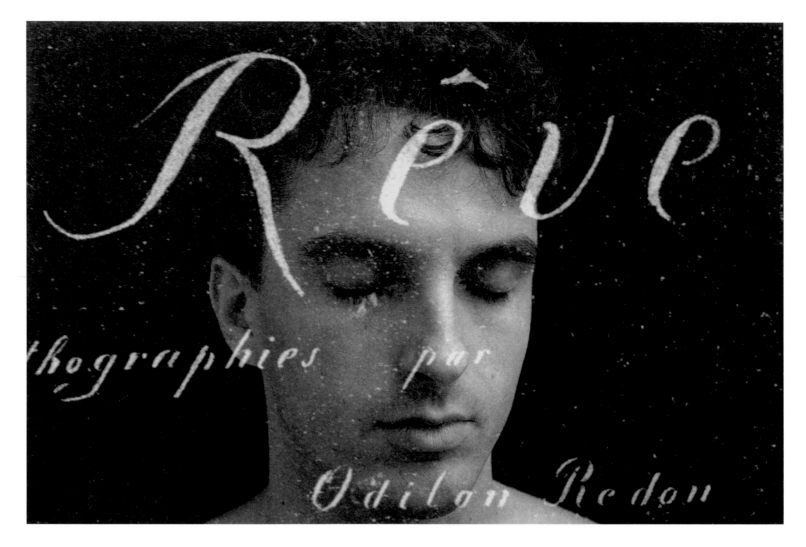

Imagine this then if you can,
Before time became a thought,
 When everything was not,
And the conjurer had yet to play his hand.

 In this repose, centered, still,
A clearness chose itself to will,
Then with a kaleidoscope's quick turn,
 All became from star to worm.

And you who read, and I who write,
 Are conscious seeds of this delight.

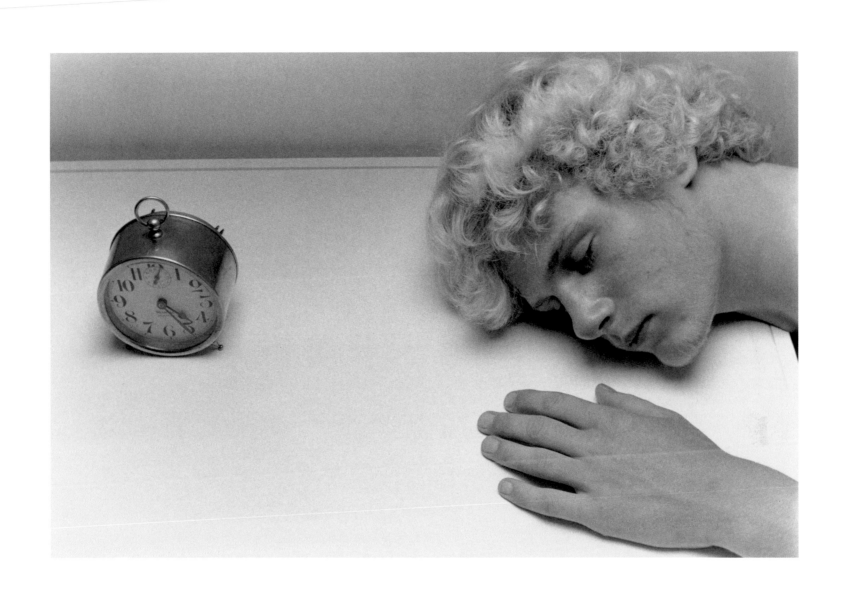

AH DREAMS

THOSE LUMINOUS METEORS
THAT LIGHT THE NIGHT SKIES
OF OUR CONSCIOUSNESS,
THEIR OWN REALITY!

WHAT FUNNY THINGS

BILLY DREAMS

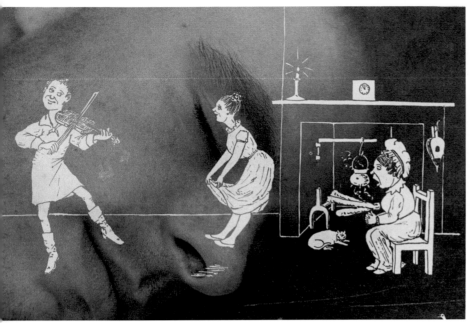

Overpainted Photographs

By painting over photographs that he or others have taken, Michals gleefully commits several sins at once. First of all, as with other devices on which he has relied – including the use of handwritten captions on the print, the production of sequences and the pairing of a photograph with a drawn rendering of the same subject – the act signals what he believes to be the inadequacy of the single photograph to survive as an autonomous object. In the process he demonstrates, moreover, a disrespect for the image thus obscured, particularly in those cases where he has desecrated an expensive print by a photographer normally the object of unquestioned veneration, such as Ansel Adams or André Kertész. Finally, he offends the apologists for painting just as surely as he does the defenders of photography by daring to try his hand at a medium in which he has no training or conventional expertise. As with his poetry, he courts accusations not only of amateurism but of being a dilettantish interloper into territory that is meant to be the sole preserve of the specialists. But this kind of professionalism is not a status to which he aspires in any medium. Better in his view to risk clumsiness and even failure, while expressing himself with directness and sincerity, than to pervert his energies in pursuit of an empty technical polish for its own sake.

There is more to Michals's overpainted photographs than a naive charm. They have also become a vital outlet for both his sense of humour and for inventions which could not have been given visual form as readily even in his most manipulated photographs. The paint, applied as lovingly as in a Vuillard or with the brisk matter-of-factness of a Magritte, in effect becomes a screen for the projection of his imagination. While he does not pretend to wield the brush with quite the subtlety of the artists he admires, such as Chardin or Balthus, it is through this common sense of purpose with them that he legitimately proclaims his right to trespass into the territory of painting.

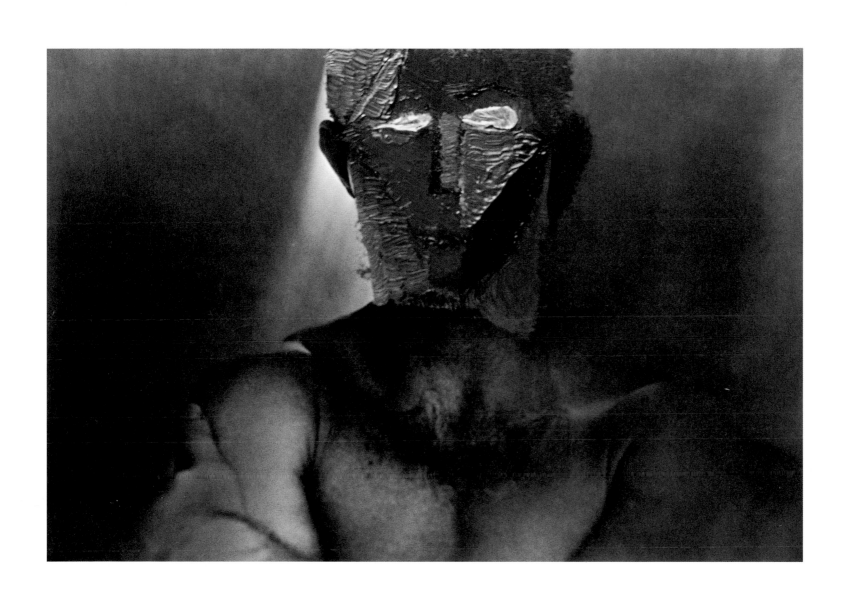

Portrait of Stefan Mihal

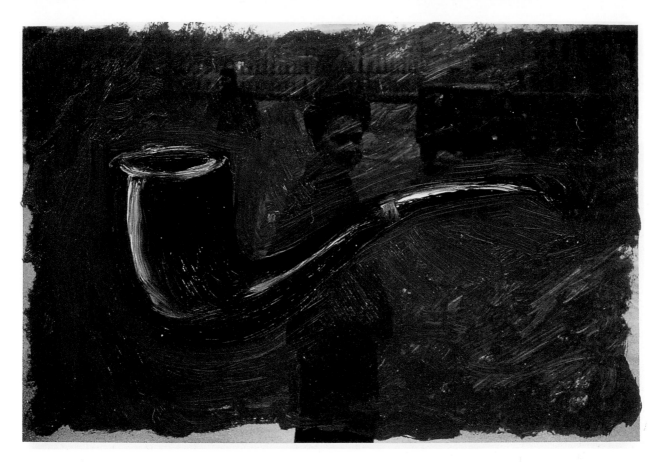

Ceci n'est pas une photo d'une pipe

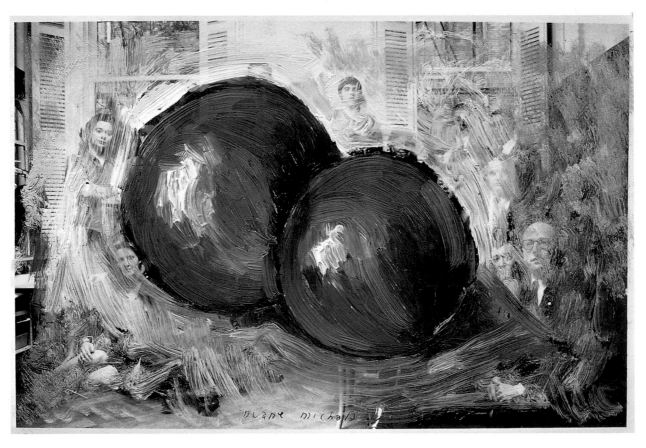

Two Oranges

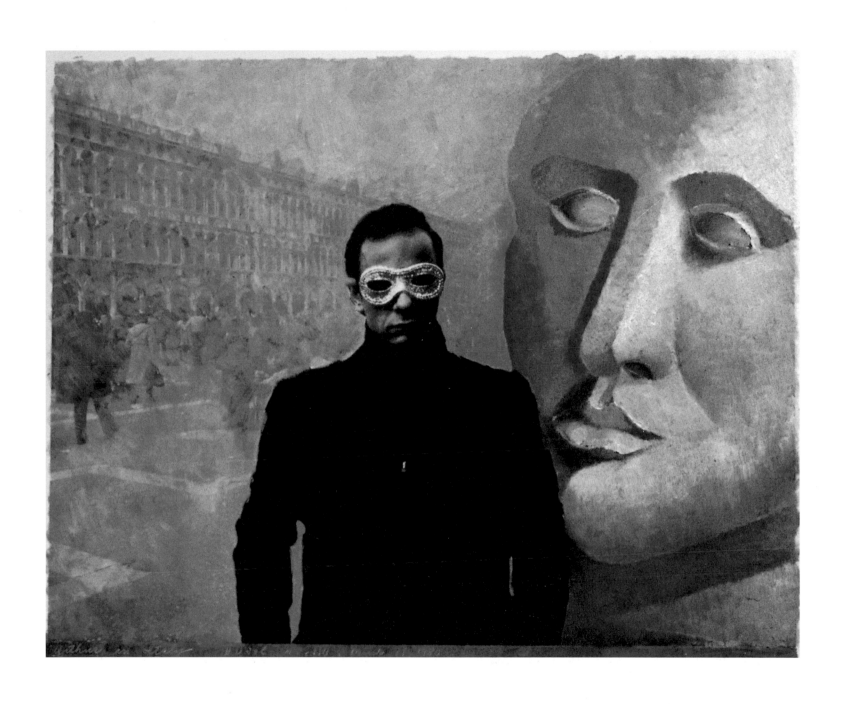

Arthur in Venice

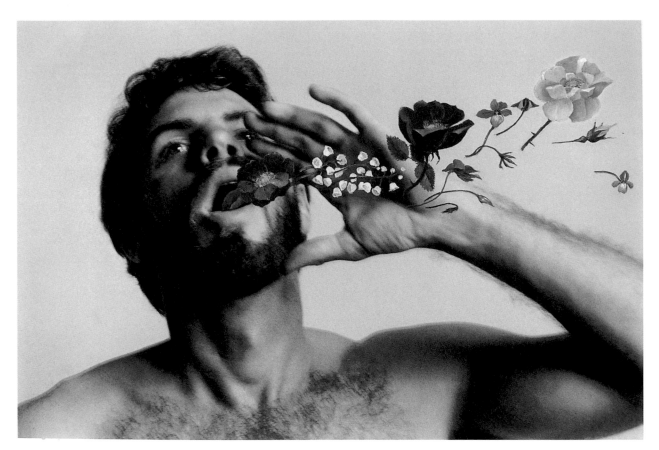

Primavera

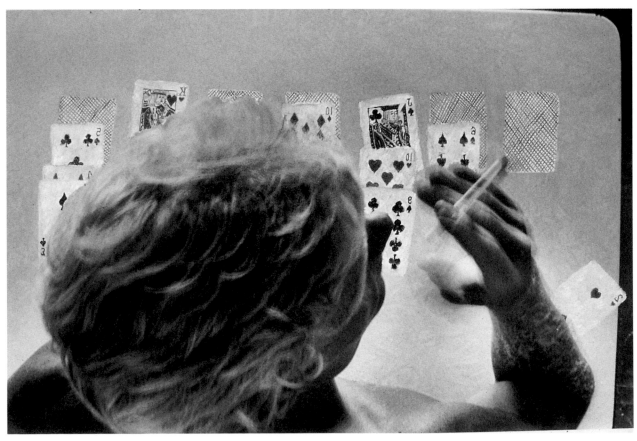

Cheating at Solitaire

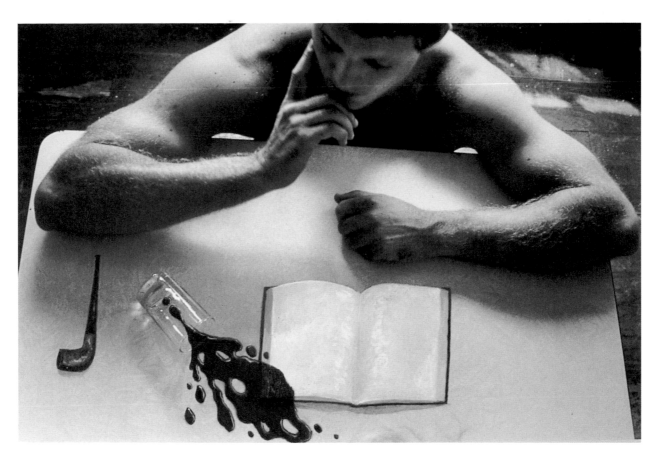

Crying over spilt wine

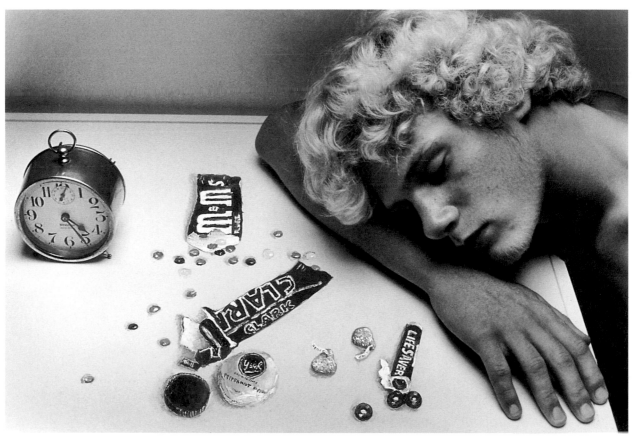

Portrait of Roy Headwell.

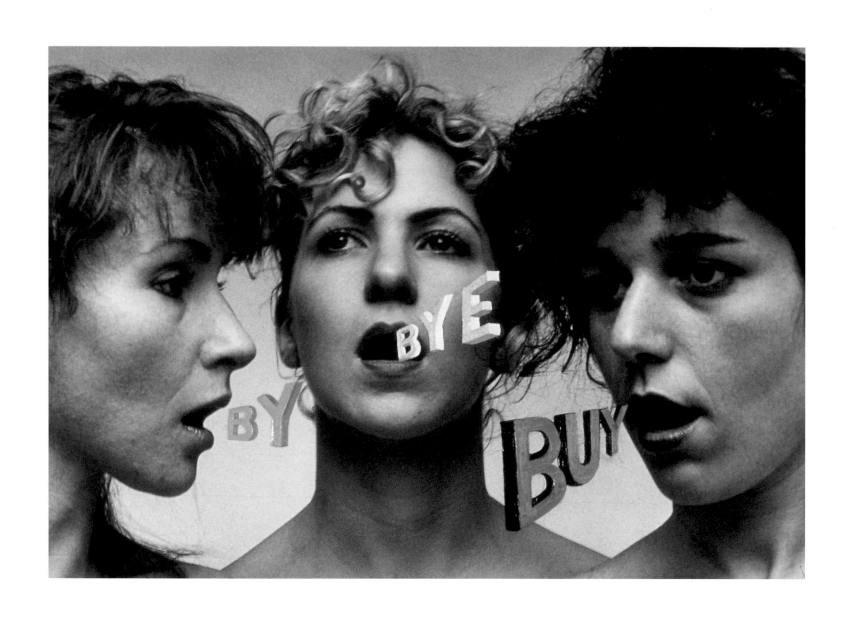

By, Buy, Bye

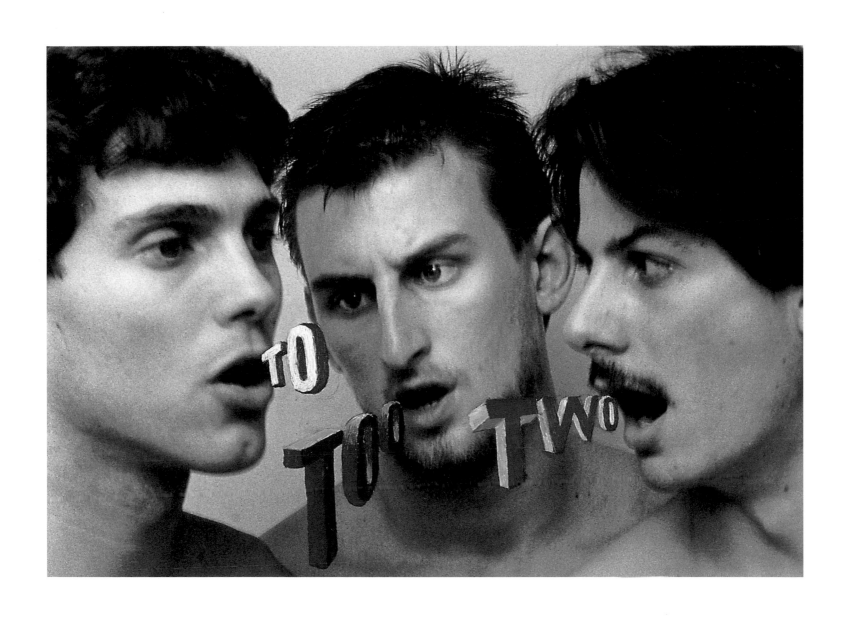

To, Two, Too

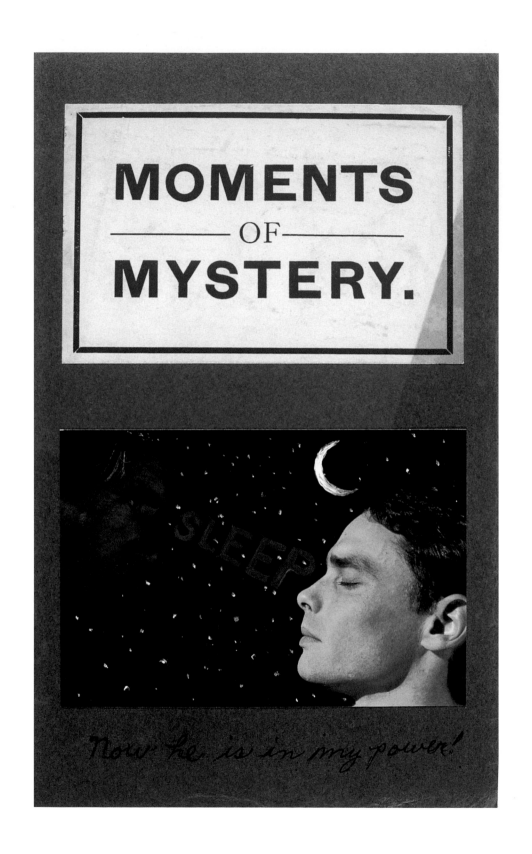

Moments of Mystery

The capacity of the camera to produce a permanent imprint of light on objects was greeted with wonder in the mid-nineteenth century, and audiences were even more entranced by the appearance half a century later of the first moving images. Several generations later, viewers have become rather inured to the magic of these media, tending to take them for granted as neutral recorders of reality. While the surface appearances of 'objective' photography and the naturalism of Hollywood movies (special effects notwithstanding) have become the norm, this was not always so. Early photographers and cinematographers alike delighted in the fabrication of illusions: think, for instance, of the composite prints by Henry Peach Robinson and Oscar Rejlander, the 'fairy pictures' concocted by Victorian girls that were celebrated at the time with such astonishing credulity, or the playful tampering of evidence in the silent films of Georges Méliès.

Self-taught, Michals has felt free to avail himself of even the most basic photographic tricks, such as long and double exposures, sandwiching of negatives, blurring or the use of props to construct an alternative reality. Far from being frightened by the primitive look of some of these devices, he revels in their simplicity, in their surprising capacity to astonish and in their frank admission of his intervention and manipulation of the evidence. Even without the handmade look of his written annotations, there is never any doubt that his photographs are the work of a person, not the mere product of a machine. As with a clumsily demonstrated conjuror's trick, there is not only humour and pathos, and an all too human vulnerability, in the self-evident devices relied upon by Michals, but also a good-natured collusion with an audience willing to suspend its disbelief for the pleasure of returning to a childlike state of trust. The photographs in which Michals addresses himself explicitly to magic and illusion are among his most playful and mysterious. To be serious, as he says, one also has to know how to be silly.

ALICE'S MIRROR

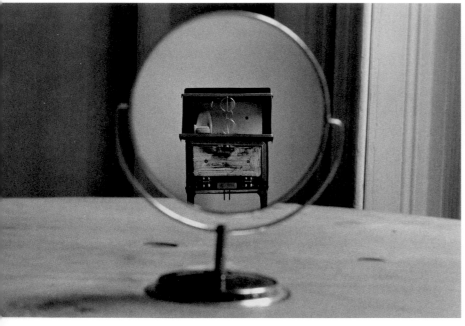 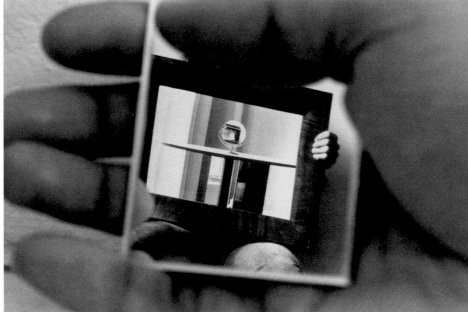

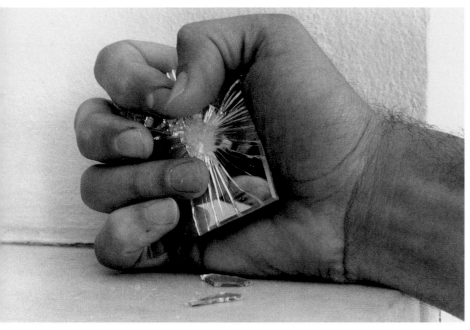 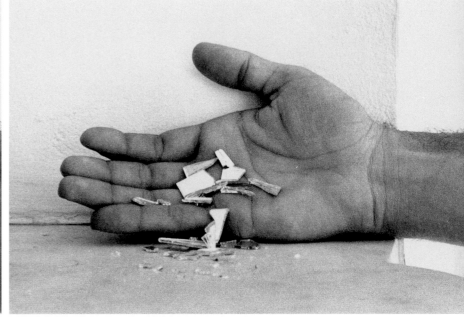

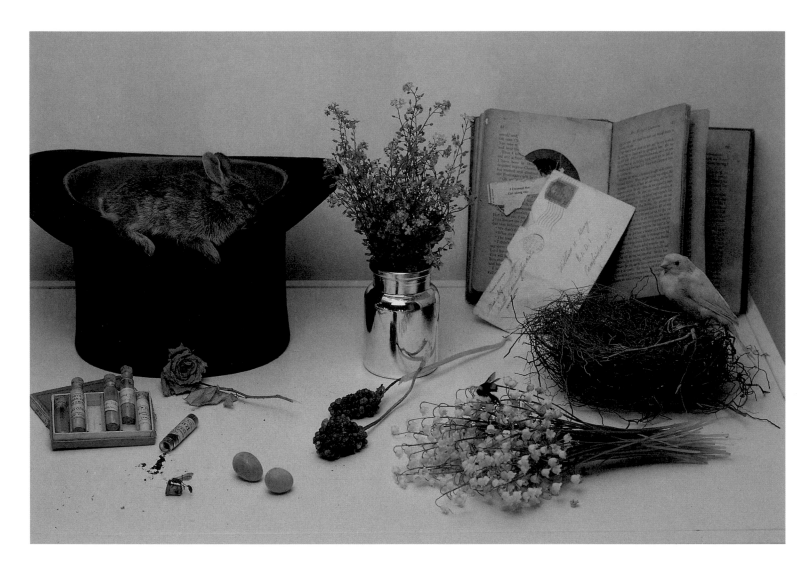

NECESSARY THINGS FOR MAKING MAGIC

1. A baby rabbit and a top hat.
2. The scent of lilies of the valley.
3. The last rose of summer
4. Last years jack in the pulpit seeds.
5. A wasp's sting.
6. Amethist dust.
7. An old love letter found in a lost book.
8 The blue of forget me nots.
10. A wild canary's song.

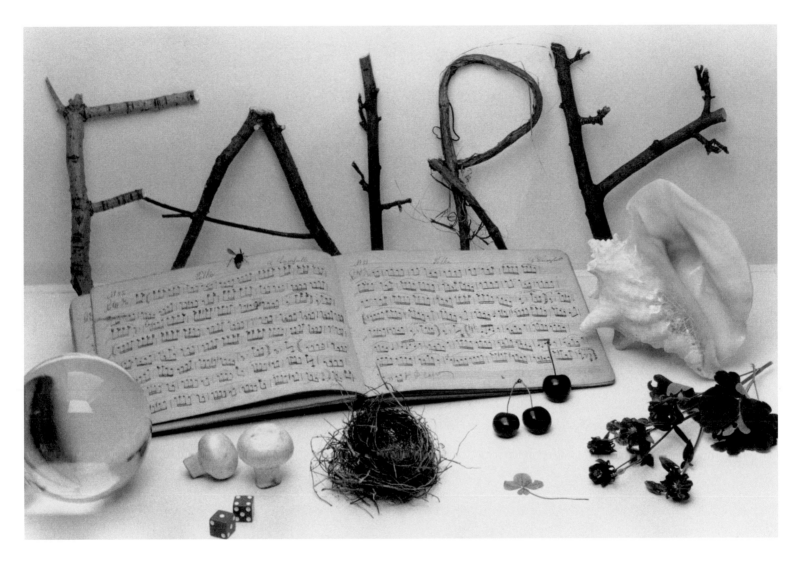

NECESSARY THINGS FOR WRITING FAIRY TUNES

1. The hum from a humming bird's nest.
2. The silence of mushrooms.
3. The sound of wild columbines growing.
4. The roar of the ocean in a sea shell.
5. The buzz of a yellow jacket.
6. Dice for chance.
7. Cherry juice to write the notes.
8. A four leaf clover for good luck.
9. A crystal ball to see the notes.

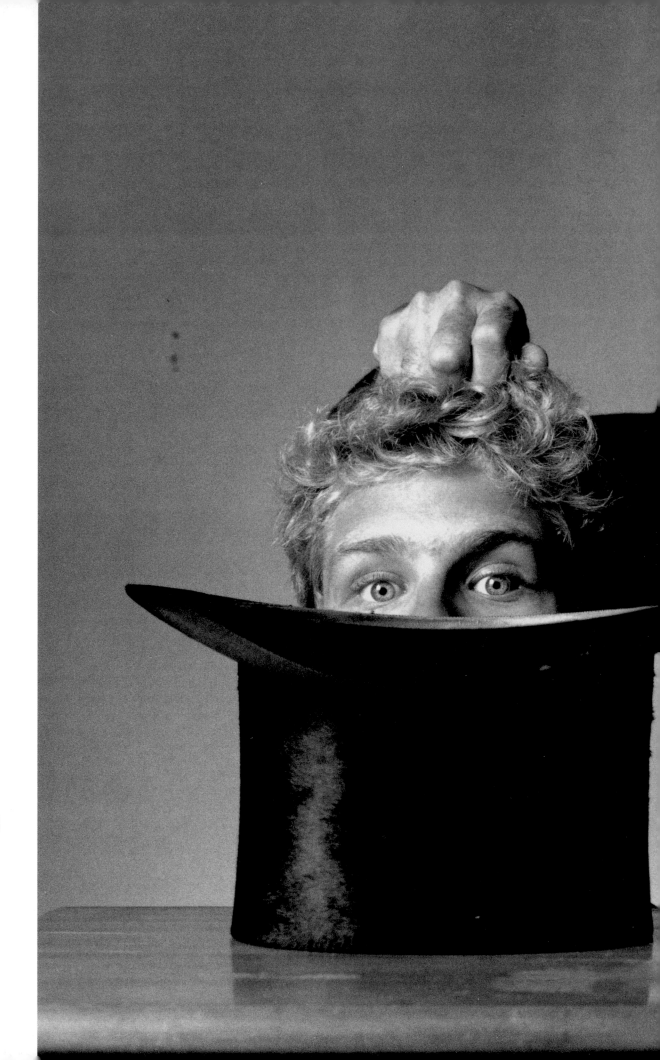

DR. DUANUS' FAMOUS
MAGIC ACT

Time and Memory

Much of the wistfulness that permeates Michals's art originates from his consciousness of passing time and the ephemerality of every moment, when it is precisely the moment that the photograph records. People age and die, things disappear: eventually everything survives only through memory. Yet his work suggests that in planning for the future and reassessing the repercussions of the past, one should not neglect to savour the present. A heightened awareness of time, and an acknowledgment of mortality, should serve not to drag people down into an endlessly replayed re-enactment of the turning points in their lives nor into self-pity about growing old, but on the contrary to intensify the pleasure of the here-and-now. This is not a call for a vacuous, living-for-the-moment hedonism. Remembering is not only essential to understanding the person one has become, through the accumulation of experience, but is also a means of developing a perspective of one's place within the larger scheme of things and of empathizing with the experience of others. Can there be a sadder spectacle than an embittered old person begrudging the optimism of youth, having forgotten what it is like to be young?

The sense of timelessness that Michals experienced when he made his first visit to Egypt in 1978 (in response to a commission for a book) was so overwhelming that his immediate impulse was to photograph himself with a note of the exact time of his arrival. Feeling there the weight of both time and death, he also produced a photo-sequence showing him at work on the construction of his own personal pyramid, a sadly inadequate and temporary-looking memorial to himself. The clever angle and proximity with which his pile of rocks is viewed in the final frame, after he has walked away, makes his monument appear boastfully larger than those of the Ancient Egyptians in the background, but we know its days are numbered. We arrive on this earth, make what we can of our lives and then depart, hoping to have left a mark and something by which to be remembered. That Michals has done so with his art there can be no doubt.

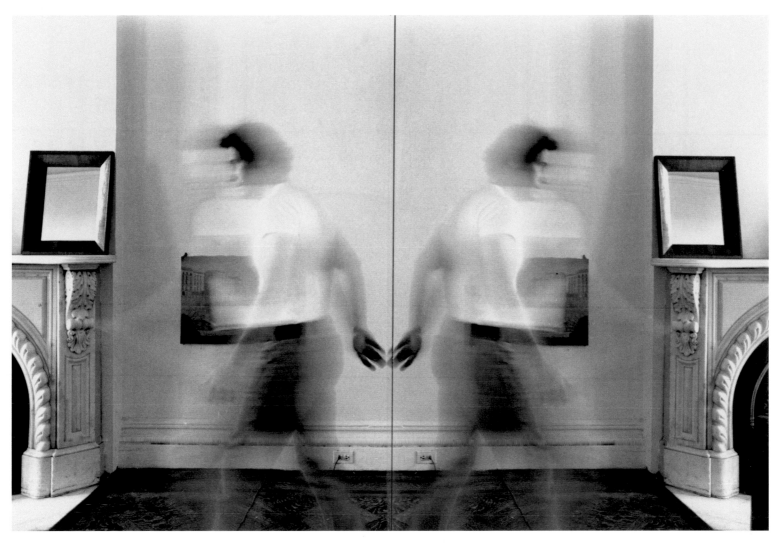

Now becoming Then

When I say, "This is now.", it becomes then.
There is no now. It appears to us as a moment,
 but the moment itself is an illusion.
It is and isn't. And this illusion is a series
 of about-to-bes and has-beens, that put together
~~Put together they seem an event. It is a construction,~~
 seem an event. It is a construction, an invention
 of our minds. It's familiarity makes it invisible.
 Our lives are real dreams that have been
 just one moment, all at once, now.

I build a pyramid

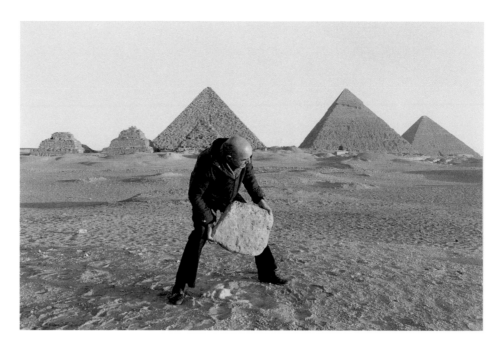

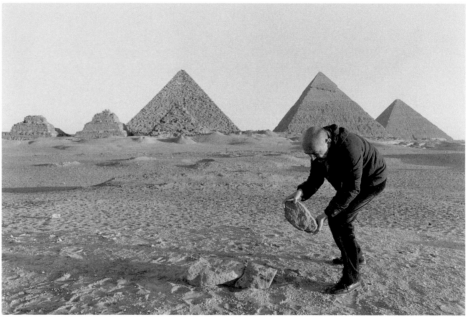

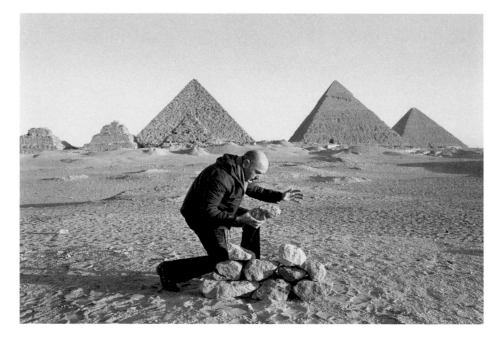

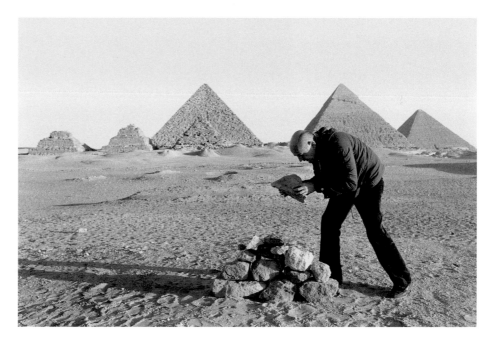

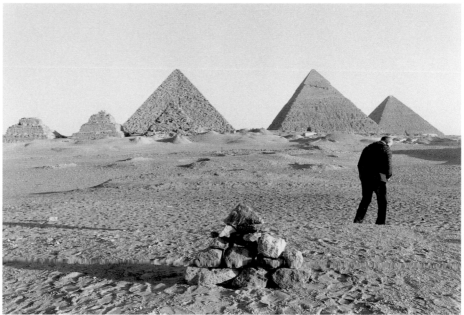

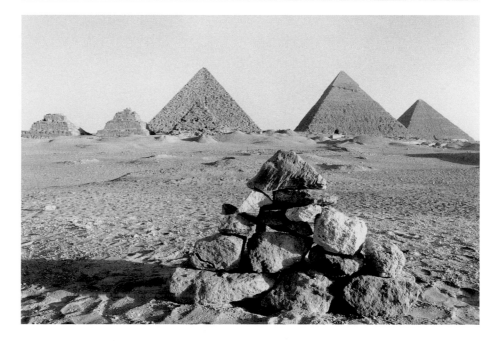

If you should die before me,
~~Dear friend, if you should die before me,~~
I would build you a pyramid.
And each stone would be a memory
Of a moment we had shared,
and I would think of you.
When you awaken from your dream of death,
should you chance to find this pyramid
in your travels, remember me,
and how I once loved you long ago.

IF YOU SHOULD DIE BEFORE ME

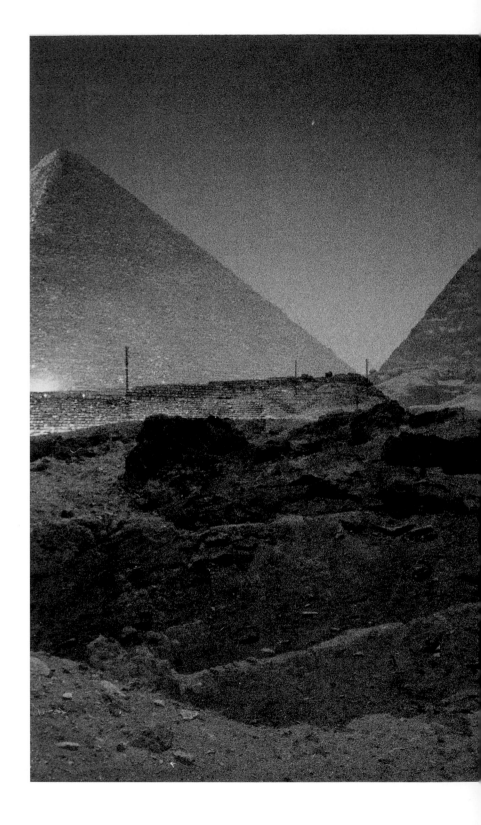

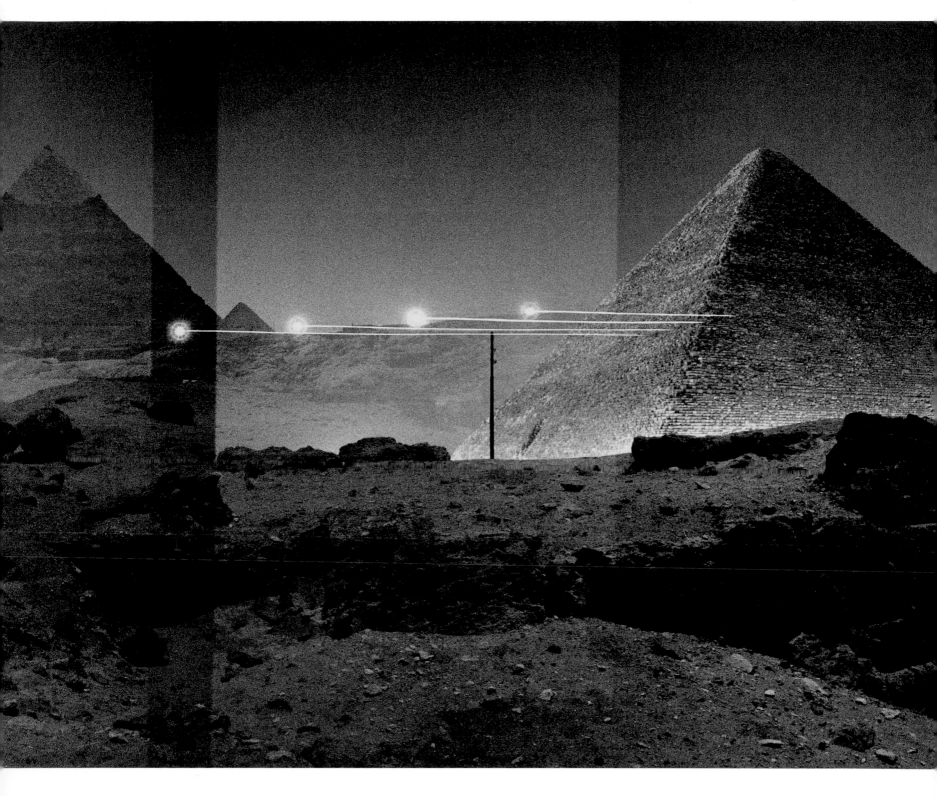

Time is such a funny thing,
It's like the hole inside a ring,
It's always now and never then,
But when I saw it's now again
It's never now but always then.
We're always here but never there,
But when I go from here to there,
Then there is here and here is there.
Should you think you're very tall
Next to a tree you're not at all,
And if you think you're very small
Next to a bee you're ten feet tall.
When we dream we seem awake,
But all along the dream was fake,
To me I'm "I" and never you.
You say you're "I" and also me,
I know that's true, How can that be
Since I'm not you, and you're not me
Time is not what you might think
It is and isn't in a wink.

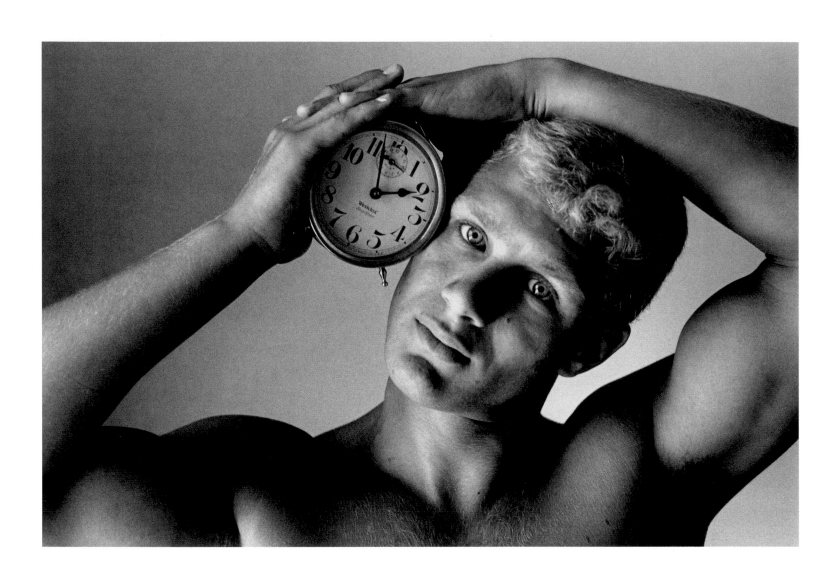

WHAT IS TIME ?

Time is the duration of everything. Its measure is the essential dimension; the moment is the interval between now and then and then again. Time is a thought, and we are clocks whose heart beat is its tick and tock. Time is vacant and depending on the where, it is both tortoise and the hare. Since nothing ever happens twice each moment is a toss of dice.

Time is always now, there is no past except what lasts in the flickering of our memories doubt. There is no future except in the anticipation of salvation of the devout. Now is a contradiction of fact and fiction. Genessis erupts into a cornucopian extravagance of life. The secret key to the arcane mystery of all things imaginable and unimaginable is in the brevity of now, a timeless flash in perpetual continuum.

Here language fails, and we are confined within the mind's capacity for comprehension bound within our three dimensions. Our illusions float on waves of time like concentric circles in a pond.

Time recedes in ripples from the moment's splash, and the ripples widen into waves of stillness where time becomes nothing Clock's lie; now is empty.

WHAT IS MEMORY ?

Memory is the cemetery of our histories spent days.
It is the prologue to this moment's scene in our lives
only play, where ghosts perform their turns upon recall,
and we the author and audience of it all
Memory is our evidence of ever having been, where re-
collection lies and often wears a mantel of disguise
when viewed through times pale shadowed scrim.
It's echoes are a silent din. For some their memories
are more real than what they now do touch and feel.
They rehearse again the scenes they performed in a
once happier then.

In the library of our minds, all the scenarios of our
acts are found. Among our memories' dusty props ~~and~~
are the lists of our hits and flops. Even memory
forgets its plots in the wisp of that haunted ground
And when we write upon our diary's last page, life will
have been one great memory of when we once had been,
which is then forgotten ~~then~~ as we leave the stage.

~~If~~ I indulge myself in memory, it takes me to that
place long ago in Germany where I somehow still
remain. What was his name? Ah yes, Dieter in
the rain.

104

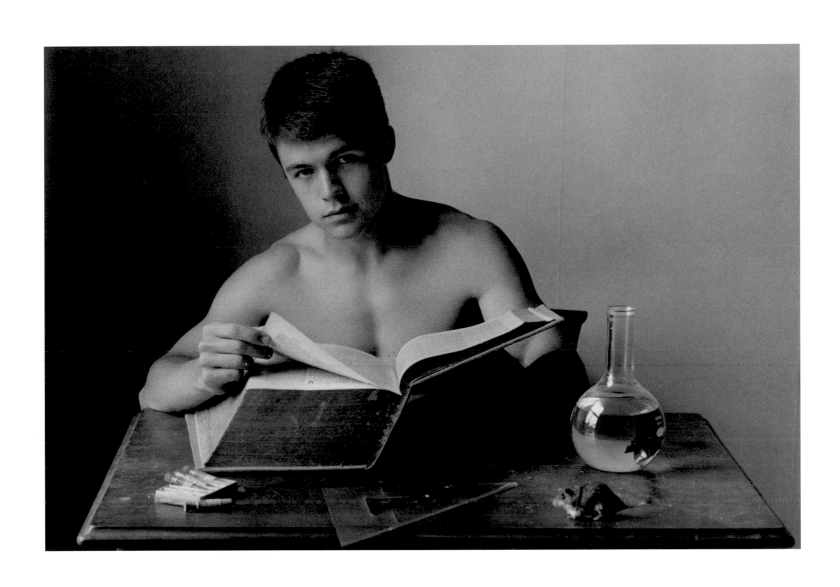

Innocence and Experience

An inordinate value is placed on innocence, as a state of not-knowing untainted by sexual desire or worldly vices, while its opposite is conceived of as corruption. The conception of innocence as the prelude to experience in William Blake's poetry is much closer to Michals's understanding of human nature. Sequences such as *The Fallen Angel* and *The Enormous Mistake* allude compassionately to the despair and guilt to which everyone is subject when coming to terms with his sexual self, but reject these responses as wasteful emotions that prevent us from accepting our true natures and from enjoying the pleasures of life. What are the options? To remain unnaturally 'innocent' by sheer force of will, well into adulthood, like the woman represented in *He Thought that She was Kind*? Or to seek to divest oneself of the knowledge acquired in the hope of returning to a state of grace? The expression of such a reversal in *Paradise Regained* through the removal of clothes and discarding of material possessions has a wilfully comic illogicality.

Michals suggests with pointed humour, in his portrayal of *Little Sylvester the Adult Molester*, that the innocence ascribed to childhood may in any case be a fiction constructed to reassure ourselves that we begin our lives in a state of purity and are corrupted only through contact with others. Common sense – especially when applied to our own experience, if we are truthful to ourselves in recapturing our earliest impulses – tells us that human nature is more complicated than that. In reinterpreting the traditional theme of *The Seven Ages of Man*, Michals reminds us matter-of-factly of perhaps the only incontrovertible truths about life, innocence and experience. We are born, we live and we die. What we make of our allotted time is up to us.

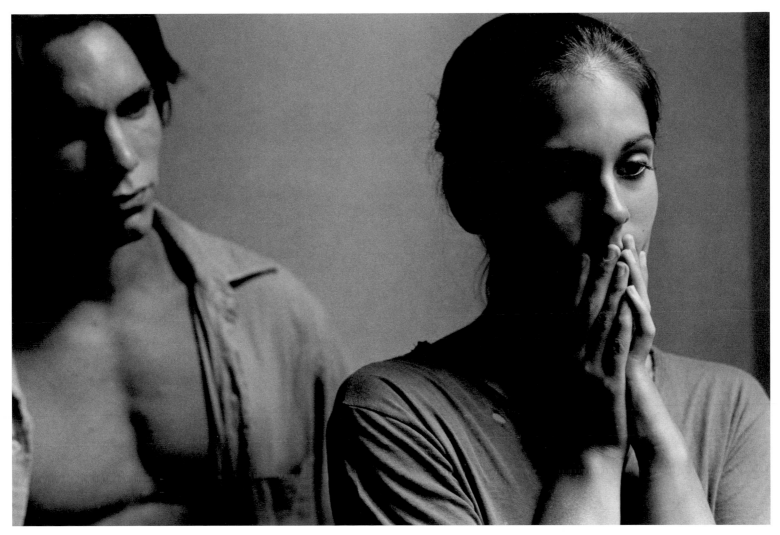

He thought that she was kind and beautiful and innocent
and in fact she was kind and beautiful, but she had been
innocent too long. Her innocence was growing hard inside her
like a stone, and one day she would be crushed
by the weight of that stone.

PARADISE

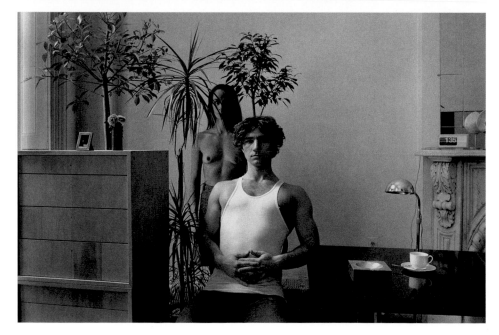

REGAINED

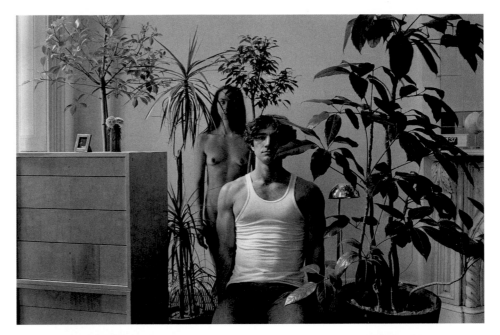

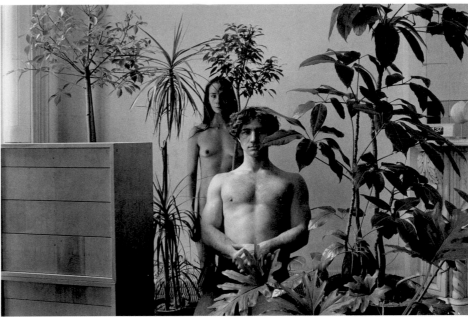

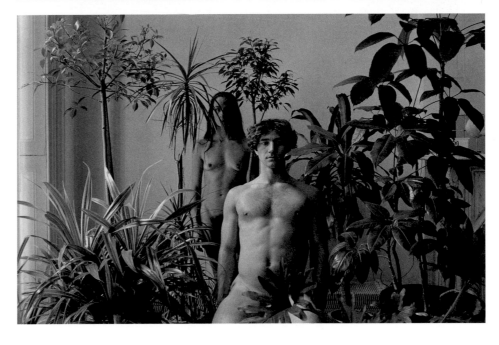

THE FALLEN ANGEL

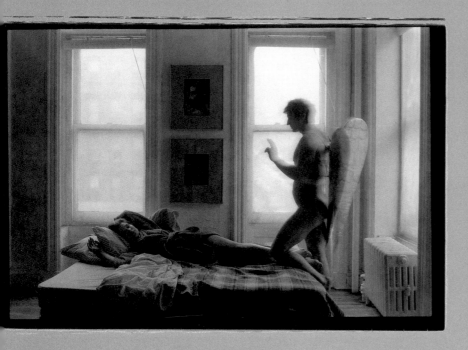 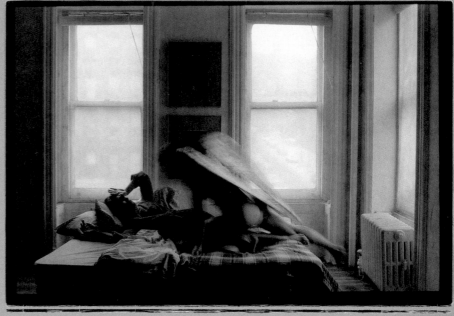

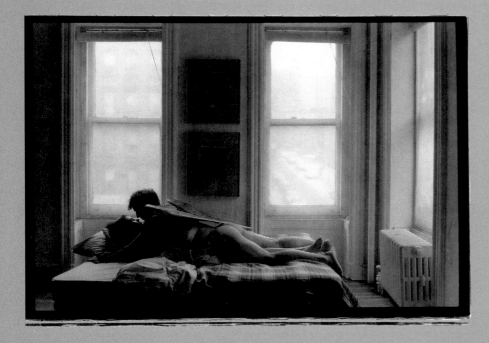 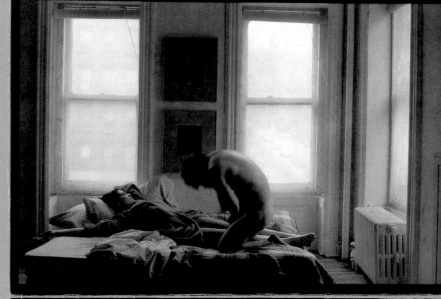

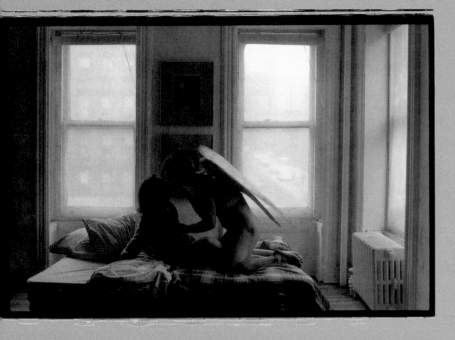
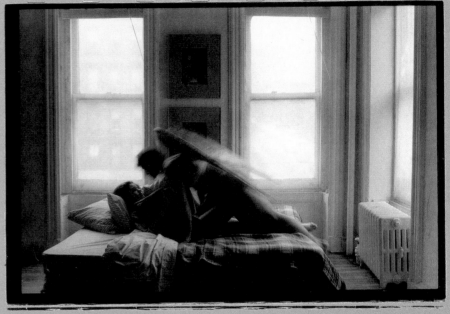
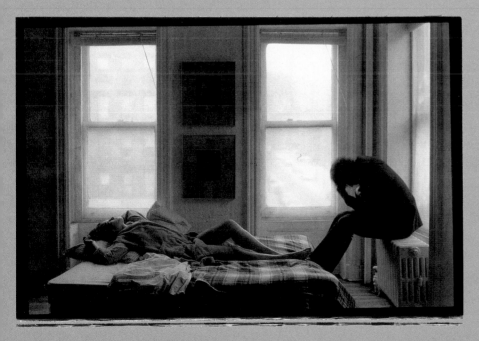
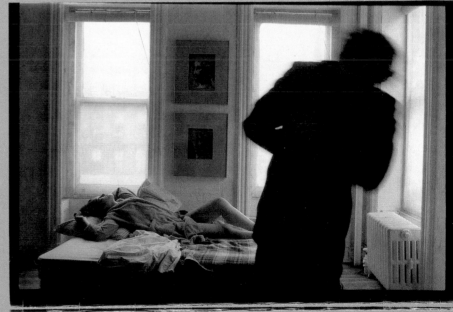

THE SEVEN AGES OF MAN

Infancy
The dark sea journey to dawn's light,
All is pee and sucking appetite.
Everything he sees is he,
Baby cries and in his sleep he dreams
of falling from the sky.
Now hush, hush and lullaby

Childhood
First the grasp, then crawl to talk
and walk then run to school and fun.
The world's a room and mom and dad
are sun and moon.
Children are the last to talk
the twittering sign language of songbirds
squawk, and know the words of fairy tunes
that they'll forget so very soon.

Adolescence
The sprouting shoot hardens
and extends a fuzzy chin,
the tell-tale signs the boy is
ripening on the vine.
The awkward right-angled days begin,
his childhood days were a foolish whim.

Youth
The peak of promise has arrived.
This is the fair and lovely season,
before time and age commit their treasons,
and burrow furrows in the brow.
Danny is now called Dan
This is the year manhood began.
He is a warrior now.

Maturity
It is the center of his life
He's been to war and wed a wife.
He has a kid or maybe two,
and does the work his father did.
He didn't know what else to do.
His days have now become a habit.
He is no more the randy rabbit.
The warrior has now become a worrier.

Middle Age
So this is who he became to be.
Perhaps he should have gone to sea.
It's true he never was the best
and doesn't talk much to his wife.
But it's more or less the life he chose.
He's more or less content.
Perhaps he should have gone to sea.
It's all irrelevant.

Old Age
Pain denies that pleasure
which once was being,
and denies life of all its meaning.
His dear wife has gone ahead.
Old men sleep alone in bed.
How quickly it all came down to this,
A sigh goodbye,
and the memory of a kiss.

LITTLE SYLVESTER THE ADULT MOLESTER

Among one family's progeny there was born a pervert prodigy
by the name of little Sylvester the adult molester. It started
quite innocently when he was only three and gave his aunt
a hickey on her knee which was the height that he could see.
He loved to climb on ladies' laps and then pretend to take
a nap, while fluffying up their breasts like pillows for his
head to rest. When he was four he played with toys upon
the floor and slyly peeked up ladies' skirts to see just
how their plumbing works.
Sylvester invented dirty jokes about grown-up doing funny
things with fairy tale folks like Little Bo Peep and uncle Bill
doing it among the sheep up on the hill. Guests when
visiting Sylvester's home were warned not to be left
with him alone. More than one was heard to squeal,
"I think that kid just copped a feel!"
He wore a raincoat to school each day even when it didn't
rain. He'd flash the teachers in their lounge then run away
till he was found. For punishment he would say, "Please make
me stay after school with Miss O'toole.

"No." said Miss O'toole, "I am not a total fool!"
When he grew up Sylvester found god and became a
religious braggard. He changed his name to
Jimmy Swaggart.

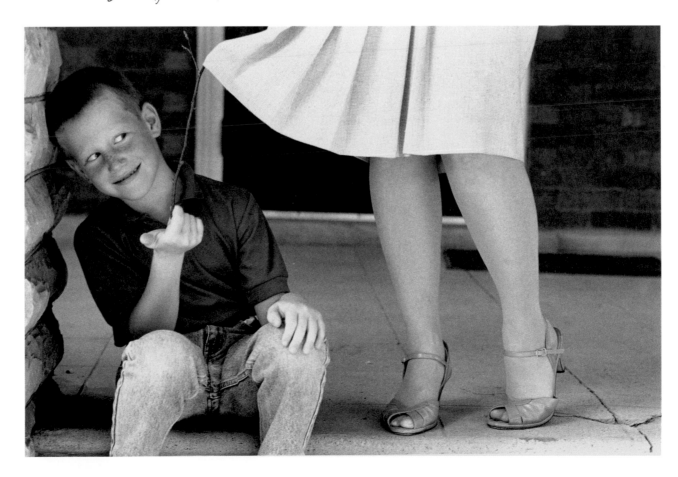

Mortality

The loss of so many young lives to AIDS since the early 1980s, explicitly memorialized in *A Dream of Flowers*, has heightened the sense Michals already had as a middle-aged man of his good fortune in simply being alive. As early as 1968, in *Self-Portrait as if I were Dead*, he wistfully contemplated the prospect of his own demise. Though brought up a Catholic, Michals has conspicuously rejected Christianity's morbid fixation on the physical agony of death as a consummation of the trials and tribulations of life. In his introduction to *Real Dreams* in 1976 he admitted a 'compulsive preoccupation with death', but immediately mocked his melancholic tendencies with a childish humour. The prospect of death is neither to be savoured (as an escape from the daily grind) nor feared, but respected as a way of intensifying one's appreciation of the moment. The most useful reason to think about death is that it makes one more conscious of being alive and concentrates one's mind on the urgency of striving now to realize one's potential.

Speculating about the possibility of an afterlife and of the transcendence of the spirit over physical matter, Michals borrowed from Christian iconography for early sequences such as *The Spirit Leaves the Body*, illustrated in the following section. Yet even these works are open to interpretations that go beyond traditional religious teachings. In another early sequence the ascent of a nude man towards heaven, represented as a blinding light into which he ultimately disappears, can initially be taken literally as an illustration of the passage from life through death to an unknown beyond. The image also acts, however, as a metaphor for metaphysical impulses within ourselves and as a way of imagining the eventual elimination of all traces of our physical existence.

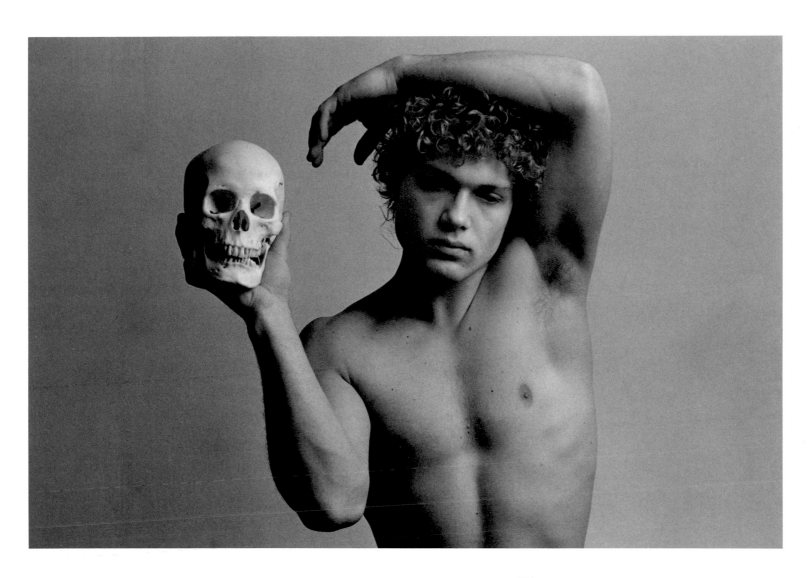

ALL THINGS MELLOW IN THE MIND,
A SLEIGHT OF HAND, A TRICK OF TIME.
AND EVEN OUR GREAT LOVE WILL FADE.
SO WE'LL BE STRANGERS IN THE GRAVE.

THAT'S WHY THIS MOMENT IS SO DEAR.
I KISS YOUR LIPS AND WE ARE HERE.
SO LET'S HOLD TIGHT AND TOUCH AND FEEL.
FOR THIS INSTANT WE ARE REAL.

A MAN GOING TO HEAVEN

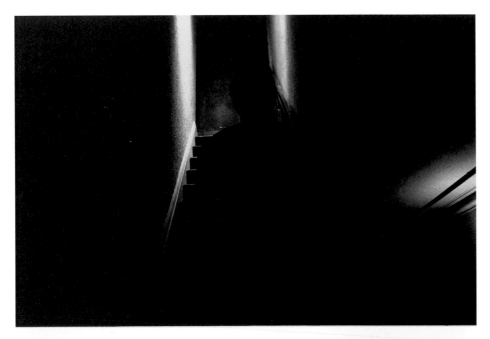

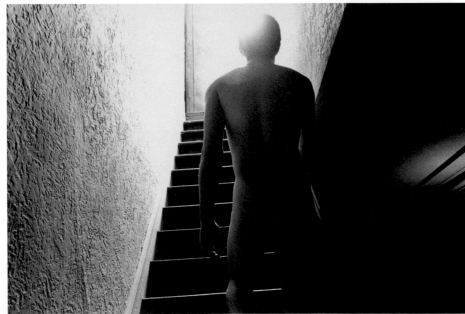

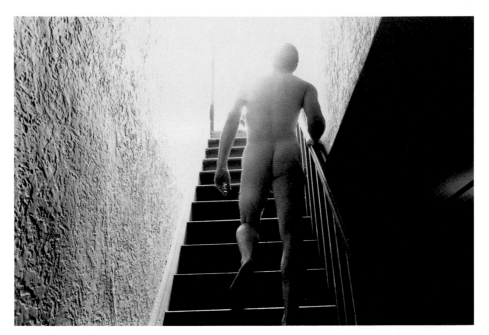

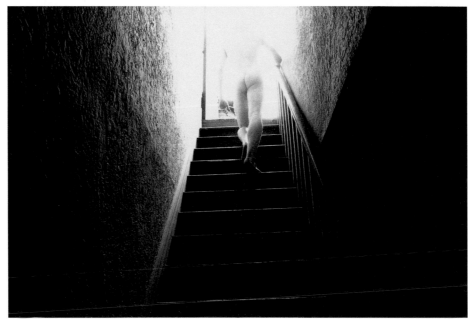

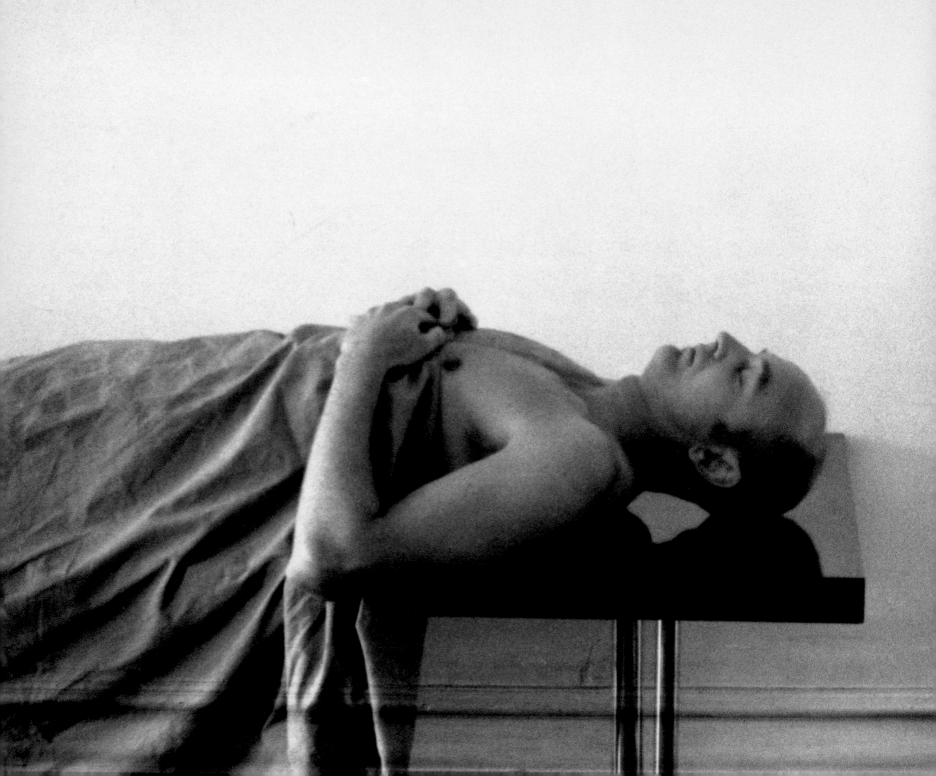

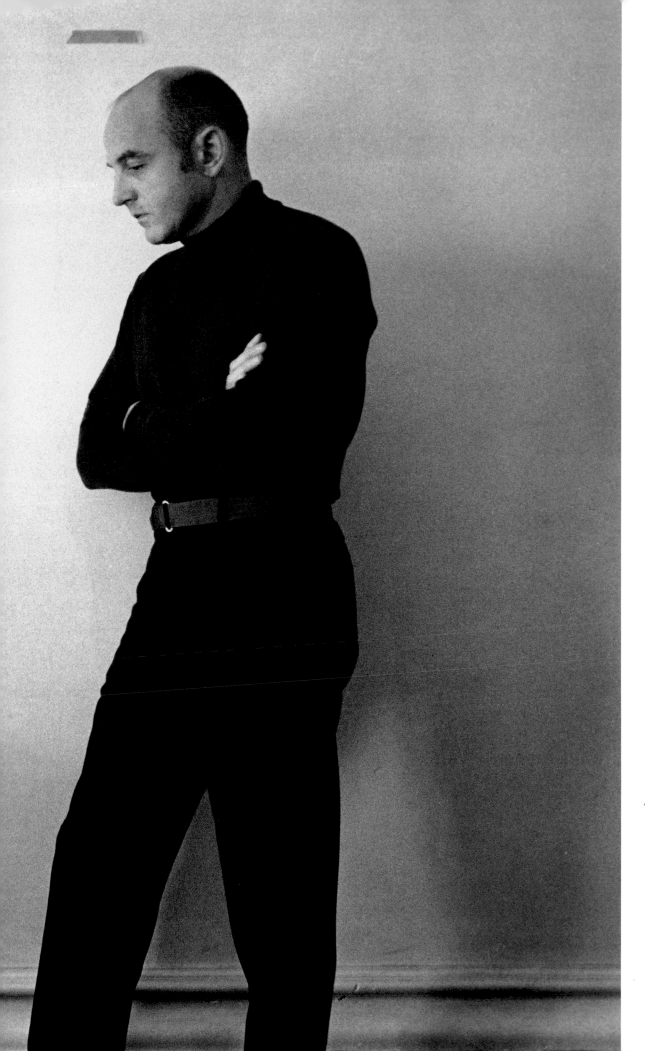

SELF PORTRAIT
AS IF I WERE DEAD

A DREAM OF FLOWERS

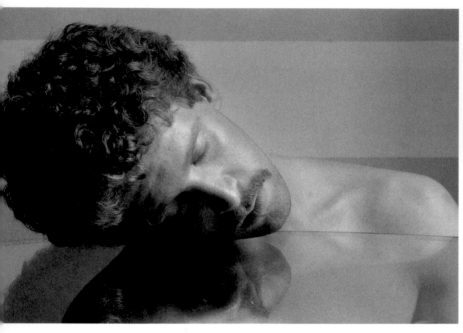 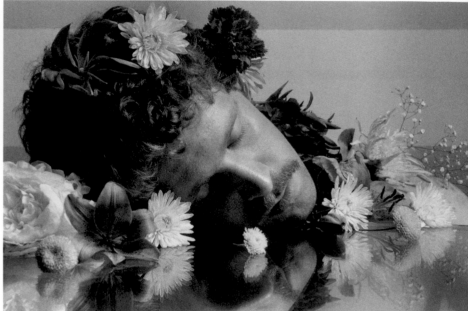

A. I.

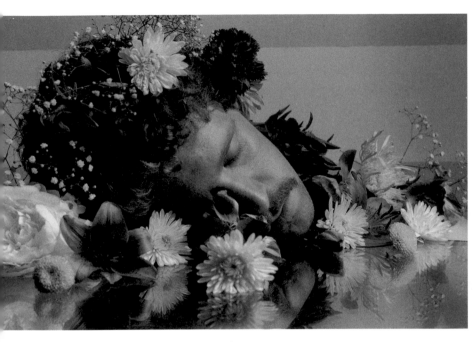

D. S.

How could it be,
That one day I will say goodbye to all of this,
 and miss the lilac spring, the maytimes whistling
on the wing, and the robin's kiss.

 In the summertime,
When days and evenings are in rhyme, you will not find
 me in the grove, among the lilies in repose,
or weeding in the garden path, where scented sedum
 hold on fast.

 When autumn falls
I'll cast no shadow on the wall, or hear the owl's haunted
 hoot,
 high above the rotting root.
When all is orange, russet, red, I not be there
 with you in bed.

 The day the silent snow descends,
 and lulls to sleep all living friends,
I too will slumber in the earth, among the seeds
 and squirrel's birth.

Who will miss me, who will care.
 When I am called and no one's there?

The Spirit

We think we know material reality well enough, and tend to define ourselves through it, but even those who do not subscribe to conventional religious beliefs find it difficult to shake off all notions of the spirit. It is not just that the prospect of a spiritless existence would be too bleak to entertain, but that many recognize within each living thing the life force that animates it as an ineffable quality more complex than the interaction of purely physiological and psychological forces.

Never content to photograph simply what he can perceive with his eyes, Michals has repeatedly sought to find a pictorial form through which to embody his notions of the spirit, which by definition cannot be seen or touched – since it has no material substance – but only sensed. His favoured solution, common to a great range of religious art, has been to represent the spirit as pure light. In *The Human Condition*, a man gradually fades away and then melts into the blinding white light of the universe: one is free to view this in mystical terms or simply as an account of what happens to us when we die. With *The Illuminated Man*, by contrast, the body remains intact while only the head disappears into the brightness of an illumination that can be interpreted metaphorically as a transcendence of the ego into a blissful communion with forces greater than ourselves.

The impossibility of visualizing what is conventionally referred to as the 'soul' – an intangible substance housed within the physical enclosure of one's body – is attested to in *The Spirit Leaves the Body* by the picturing of that person's spirit as a ghostly replica of his material self. The sequence begins and closes with the same image of a recumbent naked man, representing him initially at the moment of death and in the final frame as the mere shell from which his soul has departed. Whatever our beliefs, Michals suggests, we can bear witness only to the material facts and leave the rest to our imagination.

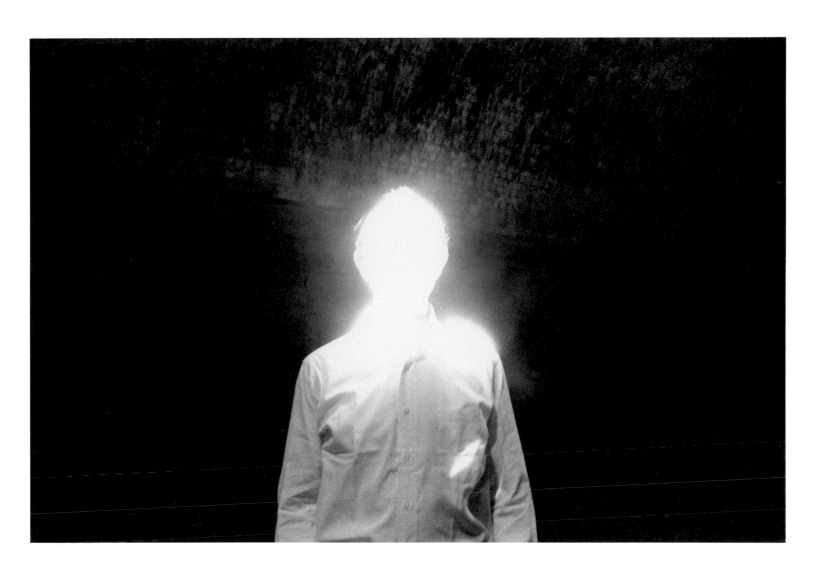

THE ILLUMINATED MAN

THE SPIRIT LEAVES THE BODY

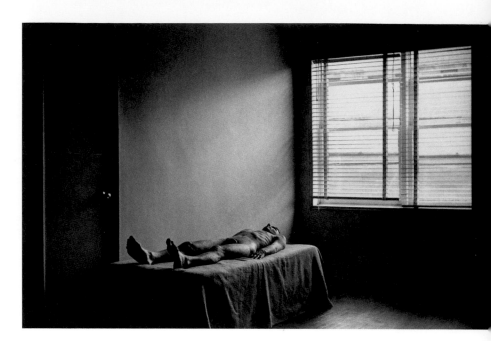

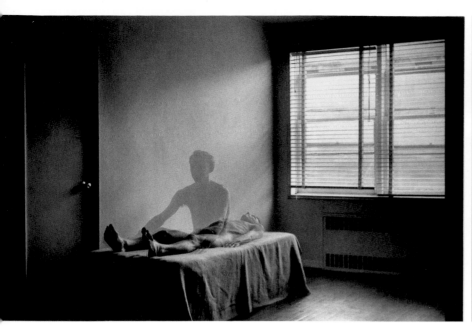 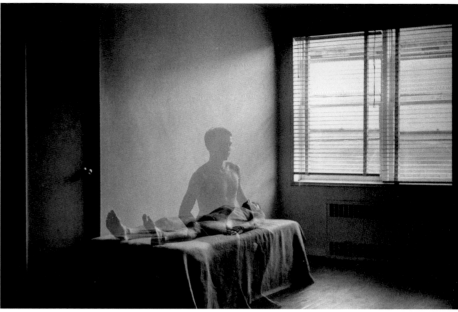

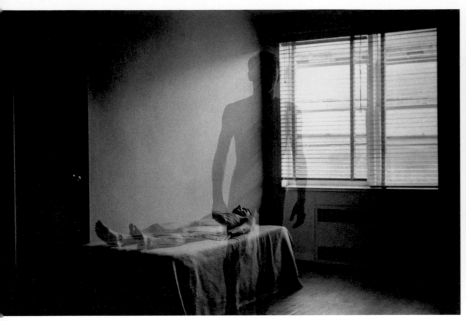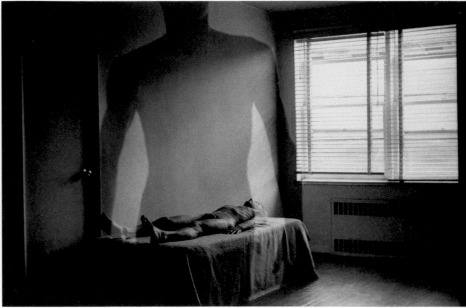

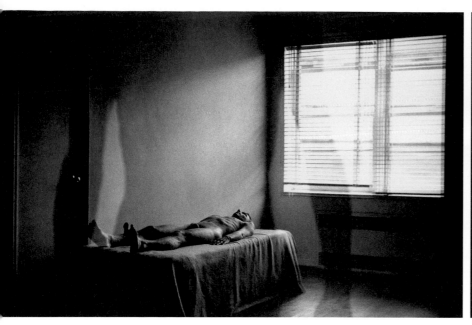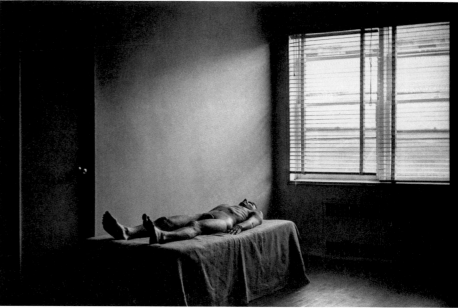

THE HUMAN CONDITION

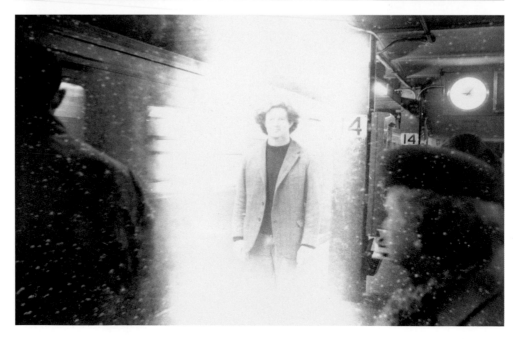

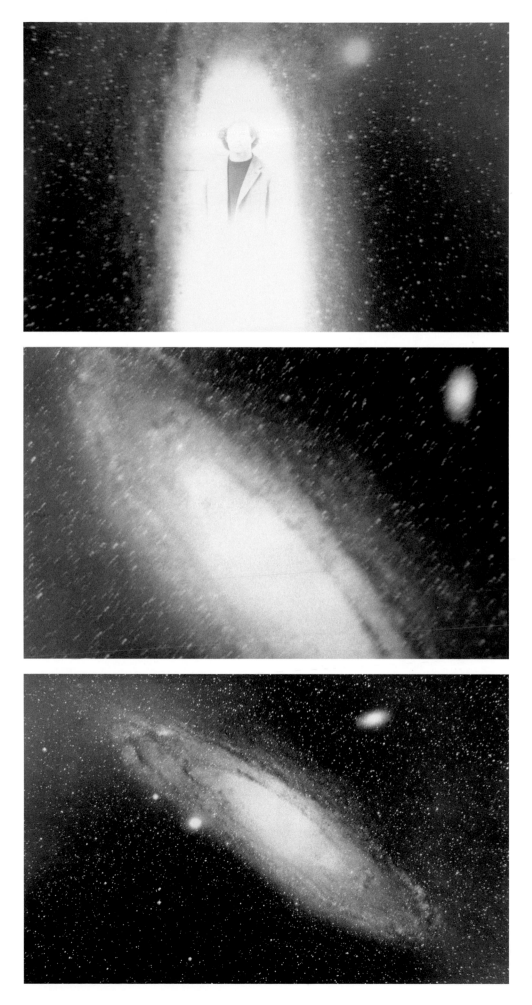

God

Given all the abstract and intangible concepts to which Michals has given pictorial form in his photographs, and considering his Catholic upbringing and his inquisitiveness about the origins and meaning of life, one could be excused for expecting to find in his work at least some images of God. But with the exception of a 1975 photo-sequence called *A Man Talking to God*, in which a nude young man speaks to an image of himself wearing a silly mask, we would search in vain even for lighthearted depictions of the Almighty in human or any other form.

God is presented in Michals's work almost exclusively as a sorrowful absence, the source of profound disappointment and his sense of existential aloneness. It is fitting, therefore, that rather than being directly portrayed He should be referred to in the artist's texts as an unseen force or character who never arrives, like Beckett's Godot, but whose rumoured existence still scratches at his consciousness.

SHOPPING WITH MOTHER

When I was a little boy, my mother often took me shopping with her, and our last stop was always Cox's dress shop. She would set me down in a chair surrounded by our purchases and say, "Sit there. I'll be right back." And off she would vanish into the dress racks. For the first five minutes it was a relief just to be seated, but a terrible anxiety began to grow within me that she would never return.

I had been abandoned! In 1932 God dropped me off on this planet and said, "Sit there, I'll be right back." Well I have sitting here now for forty six years, and the bastard hasn't returned. For all I know he's off in Andromeda trying on dresses and has forgotten all about me. And I know that he is never coming back.

I AM MUCH NICER THAN GOD

It was last thursday, when David finally died, that I realized that I was much nicer than God. I know that I would never had let him suffer all those months. And I never would have invented cancer in the first place. I would never let children fall asleep hungry or old people die alone.

But if it is true that I am nicer than God, with my vanity and petty greed, then I am in despair.

The Unknown

'I seem to know too many wrong things and not enough right things,' Michals wrote in his introduction to his book *Merveilles d'Egypte*, published in 1978. 'I don't even know what the proper questions are that one should ask. What should I want? What are the things of value that I should devote the last twenty or thirty years of my life toward doing? […] How best should I live?'

With admirable alacrity and lack of embarrassment, Michals has become more daring as he grows older in asking the big questions most usually posed by us as children but kept increasingly to ourselves as we come to realize that we shall never get to the bottom of them. 'What is the Universe?' 'What is Life?' 'What is Time?' 'What is Memory?' These are among the conundrums posed by Michals to himself in a series of photographs with text which he conceived in 1994 with the intention of producing a book called *Questions without Answers*. Such enormous issues called for considered answers, so it is hardly surprising that the photographs are almost swamped by his longest handwritten texts to date. The apparent shrinking of the photograph may look funny, and it was certainly intended to offend the same sensibilities that would have been shocked by his assertion in *Merveilles d'Egypte* that 'Photographs are useless', but it has the function also of conveying the individual's insignificance relative to the universe and the weight of these unfathomable mysteries bearing down on us.

An early photo-sequence, *The Bogeyman*, explores the ways in which childhood curiosity about the unknown is tainted by an irrational fear of the very things it seeks to disclose or uncover. In constantly presenting such metaphysical questions, Michals invites the viewer to consider the extent to which adults consciously avoid asking them of themselves, because the possibilities remain as unfathomable and frightening as ever.

WHAT IS THE UNIVERSE ?

What are Dreams?

Dreams are the midnight movies of the mind,
where the sphinx recites his riddles to the blind,
And as our daydreams sleep, our night dreams come awake.
phantom visions float as we in reverie recline.
On this slumbering plain, a zephir fans the embers
of lost dreams to flames,
that pantomime their shadows on our brains,
where things look familiar, yet not at all the same.
In this chimeria's hallucinations,
the strange become the ordinary without surprise.
and desire and terror thrive side by side.
I wander down the Passage Vivienne,
and see in its windows displayed
what might have been, and I commit my sins again.
In lucid dreams the dreamer comes awake
and sees that what he thought real was fake.
As I write I now know too that the universe
is a great dream room imagined by our senses
in its womb.

As I write I now know too,
that the universe is a great dream room,
imagined by our senses in its womb.
It is our enigmatic fate that we must dream
in time and wait.

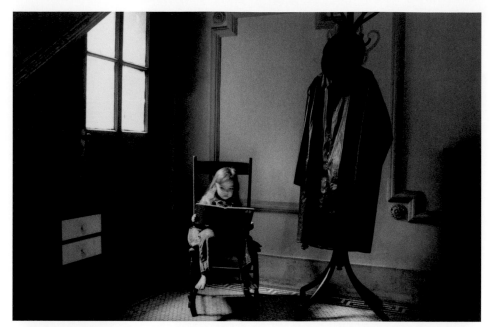

THE BOGEYMAN

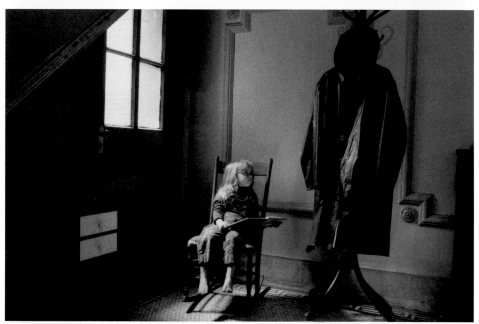

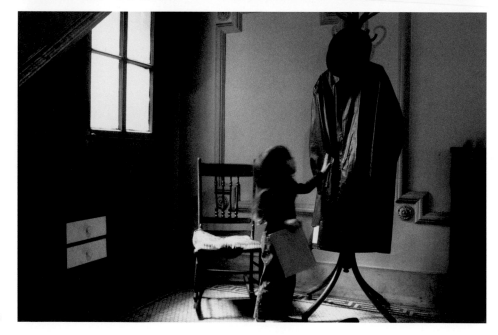

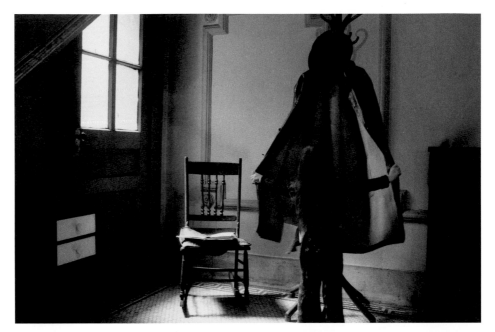

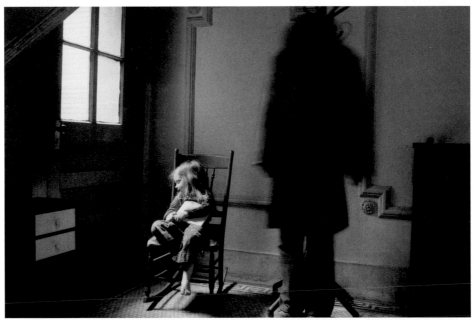

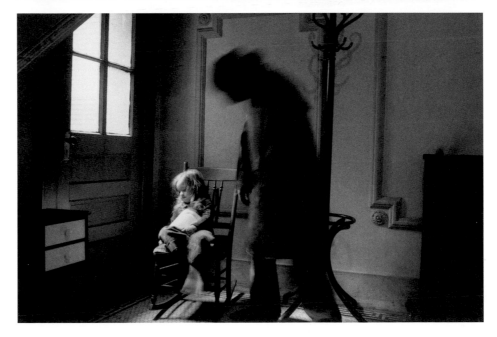

Politics

Anger is rarely heard in Michals's own voice, though he has sometimes taken the emotion as a subject for his work. The things that do provoke him, however, and which have led him on occasion to produce pointedly political diatribes, are most often linked to the efforts made by certain groups in society to deny to others the right to their own individuality. Repression can of course take many forms, but what most disturbs Michals in contemporary America is the attempt of the so-called Moral Majority, the religious right, to impose their views and way of life on everyone else. *Salvation*, as he succinctly notes in his photograph of that title, is presented by such bigots not as a subtle theological matter of choice but as a threat, a gun pointed at our heads to warn of the untimely end we are likely to meet if we do not conform.

In works such as *C.L.E.A.N.* and *Pat Buchanan*, Michals veers towards satire as a way of disarming his opponents, but there is by no means a uniform tone or a single line of attack to his political statements. The photo-sequence *Christ in New York* is a bleak and sorrowful fantasy in which he contemplates the prospect of the Messiah's return in an era of vicious random violence, hypocrisy and callousness. His response to the hatred espoused by others, including the self-appointed representatives of religion, is finally to call upon the conveniently forgotten or obscured messages of Christ himself: to demonstrate compassion, acceptance and love.

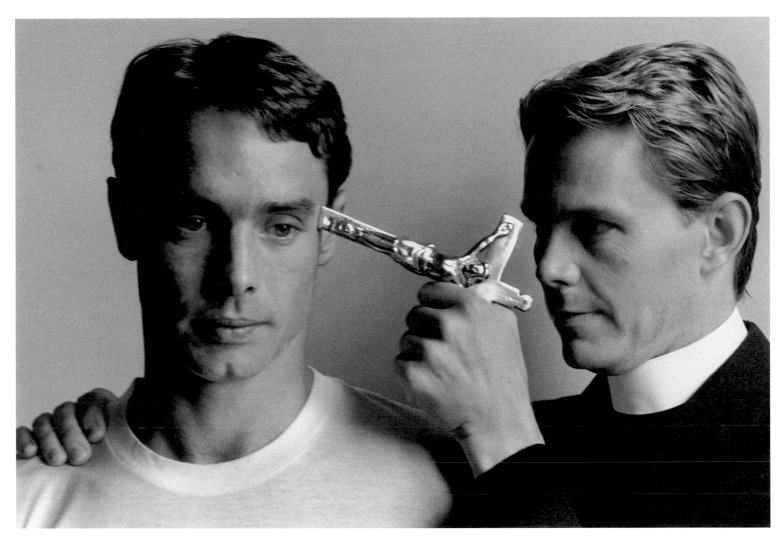

S A L V A T I O N

No american citizen has the right to impose his private morality
on any other american citizen, which is exactly the political
agenda of some organized religions today.
Millions of women have been victims of these churches intrusion
into their most private and painful decision, whether to have or not
have an abortion.
Millions of gays and lesbians have been victims of these churches
assaults on gay rights legislation, which would simply
protect them from housing and job discrimination, rights
assumed by all heterosexual citizens.
If one does not have the freedom to make his most intimate
choices without fear, one does not have any freedom at all.

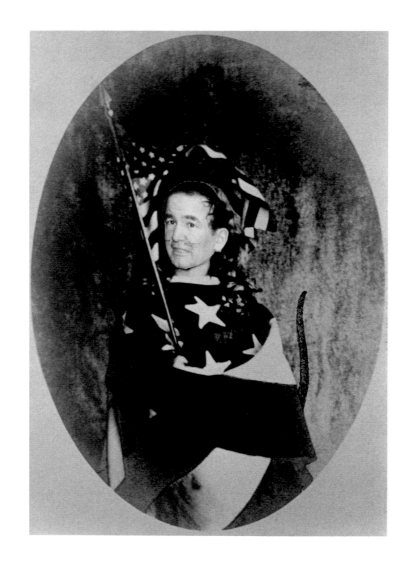

RAT BUCHANAN

C. L. E. A. N.

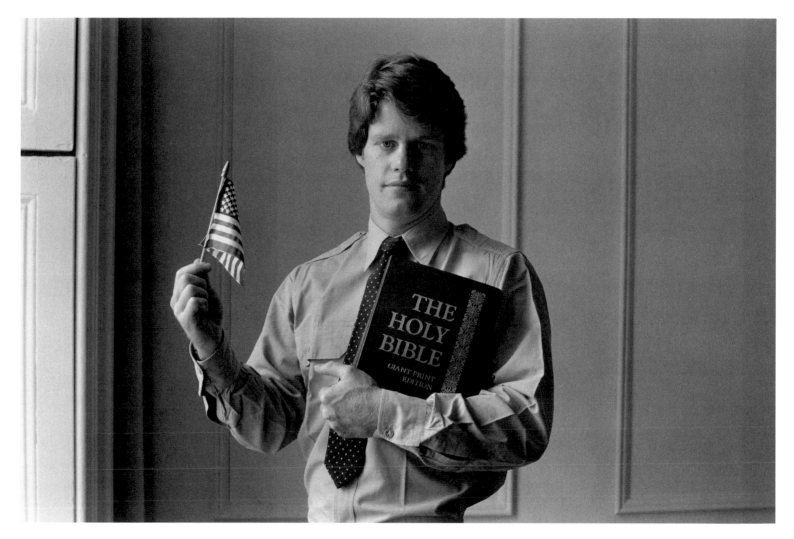

No one was surprised by the large majority that the Christian League for Education and Neutralization candidate had won the 1988 election for president considering the ecological tragedies and economic disasters that had taken place in the United States in that decade. There was a fundamental need for stability. The C.L.E.A.N. candidate immediately made good his platform promises. The women's movement was effectively destroyed by the new marriage laws. The unpopular homosexuals were immediately round up by the Morality Squads and vanished. Creationism was declared the official state science, and only appropriate family books could now be published. All music was banned except for religious hymns. Any abortion was a capital offence. Now the country was mobilizing for a Christian holy war against satanic Russia. God's will had finally come to America.

CHRIST IN

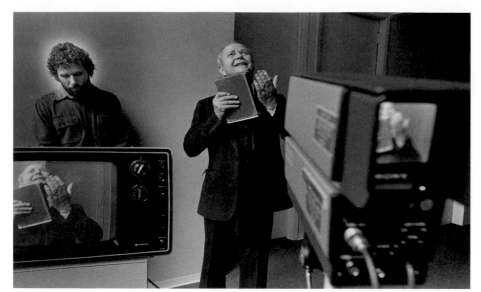

Christ is sold on television by a religious hypocrite.

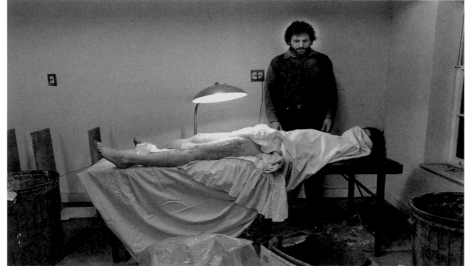

Christ cries when he sees a young woman
who has died during an illegal abortion.

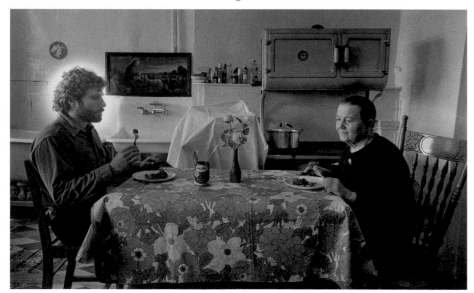

Christ eats dog food with an old Ukrainian lady in Brooklyn

NEW YORK

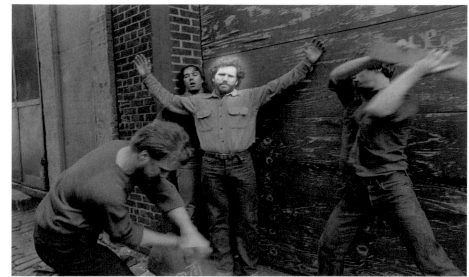

Christ is beaten defending a homosexual

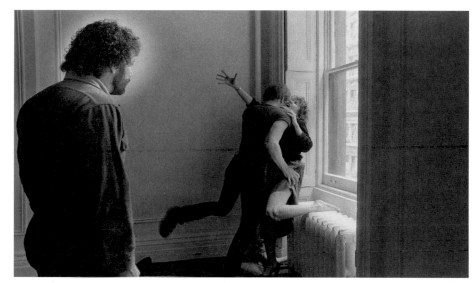

Christ sees a young woman being attacked

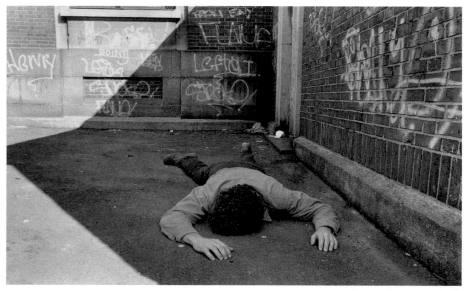

Christ is killed by a mugger with a hand gun.
The second coming had occurred and no one noticed.

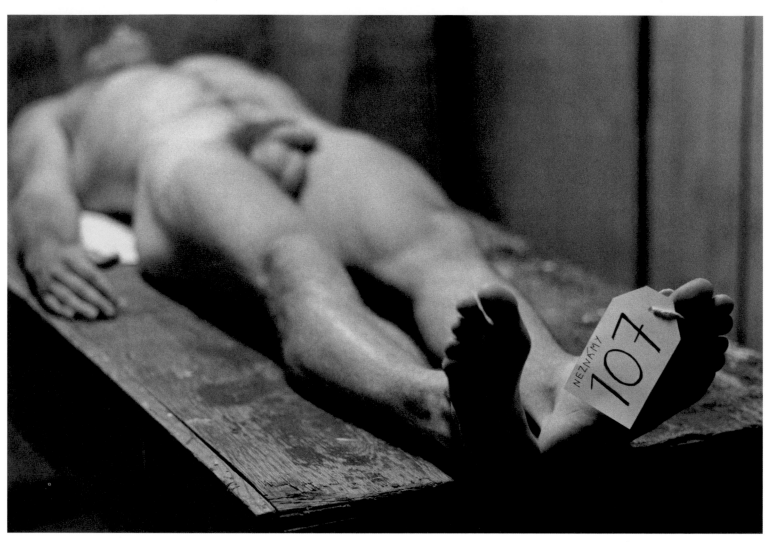

SARAJEVO

In Sarajevo there's a mountain of meat,
 Made of dead people unfit to eat.
With each hour this mountain grows higher,
 And as it towers towards the sun,
It casts its shadow on everyone,
 Not just those whose lives are done.
For all who cower in this grim shade,
 Dread descends when daylight fades.
Now where children once played their games,
 Only their sad shadows remain.
Innocence soon learns there is no defense
 against its foes and our faux concerns.
When prayers fail there is no heaven only hell
 When the Savage self prevails,
 Hope rots in the carcass of the city
Why should we care with our polite pity,
 Since we are here and they are there.

Desire

The Nature of Desire entranced Michals long before he published a book of that title in 1986. 'The camera's caress', as he noted in a text for that publication, can be an eloquent expression of the pleasure experienced in looking at someone one finds attractive; the sensation is all the more intense for being kept in an indefinite state of suspension of exquisitely unfulfilled longing. The play of light over a face or body is revealed not just as the means by which other people are made available to scrutiny, but as a metaphor for the act of touching or even – as in *The Flashlight* – of penetrating them.

It is in this erogenous zone of his work, naturally enough, that Michals has most explicitly revealed himself as a gay man. Long before he publicly identified himself as such, notably with the *Homage to Cavafy* book of 1978, Michals had alluded obliquely in works such as *Chance Meeting* (1970) and *The Unfortunate Man* (1976) to experiences especially familiar to homosexuals. Yet his more direct images of homosexual desire do not conform to the expectations created by pornography or to the stereotypes of leather-clad masculinity popularized in the drawings of Tom of Finland or in the photography of Michals's younger contemporary, Robert Mapplethorpe. It is not just, as he says, that he is 'a victim of the Greek ideal', or that his acute sensitivity about his own physical imperfections has heightened his awareness of the lengths to which we will go in pursuit of the beautiful or of the wounding powers inflicted on ourselves by unreciprocated lust. His images of men are generally tender, concerned not with the sexual act but with themes of male bonding and companionship. His true kinship is with poets such as Constantine Cavafy and Walt Whitman, to both of whom he has paid homage in separate books. Loath to segregate himself as part of an enclosed community, he celebrates the beauty of both sexes and the multiplicity of forms in which love and sexual desire can be expressed, dwelling not on differences but on shared needs and impulses.

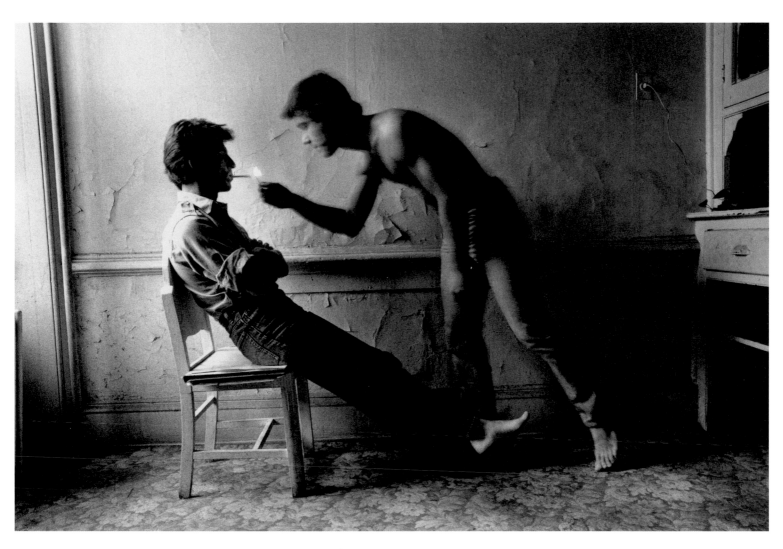

Just to light his cigarette was a pleasure.

Watching George drink a cup of Coffee.

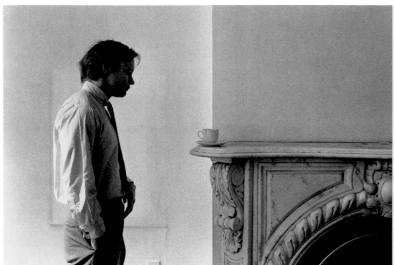

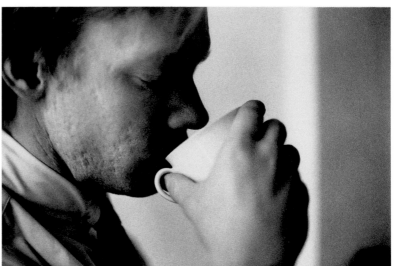

She never thought of him. And although she saw him almost every day, she never really thought about him. He was always there. He might have been a chair.

There was one thing she had noticed though. It was his habit of closing his eyes as he slowly sipped his ~~hot~~ coffee. He almost always did it. He seemed to be dreaming that he was drinking coffee, she thought.

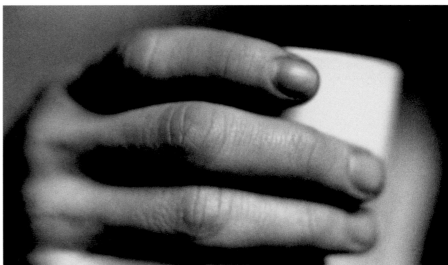

Men's hands were different from women's. They were fat and had hair and sometimes dirty finger-nails. She thought his hands looked strong.

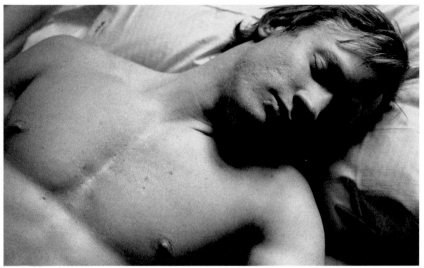

~~She saw him asleep before but never like this.~~
She saw him asleep.

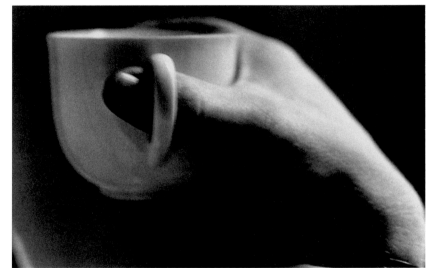

She realized that she was staring at his thumb.

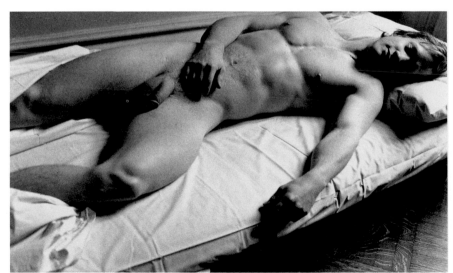

She never thought of him as having a body. She only thought of him as a head. Now she thought of his body.

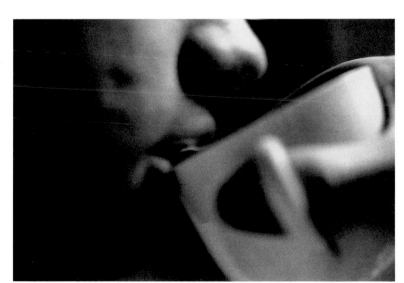

The edge of the cup felt hard against her lips as he sipped.

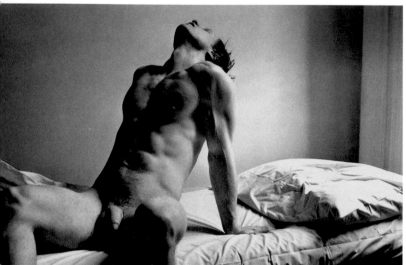

She wondered what he would look like when he awoke in the morning.

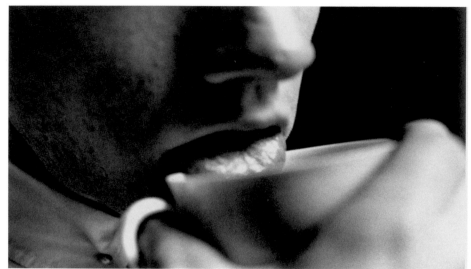

Then he did something very strange. ~~As the~~ He slowly began to touch his tongue to the edge of the cup, and ~~tongue~~ very deliberately he started to rub the rim of the cup.

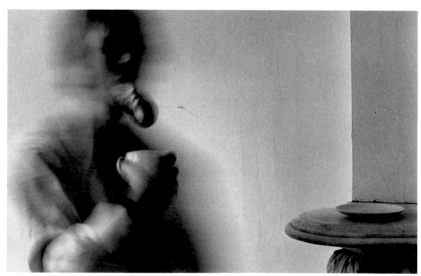

until she couldn't believe her eyes.

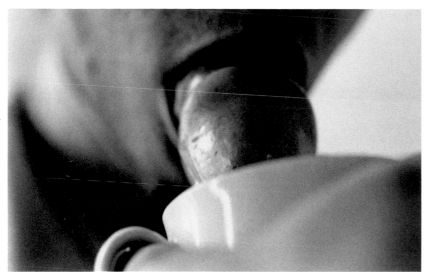

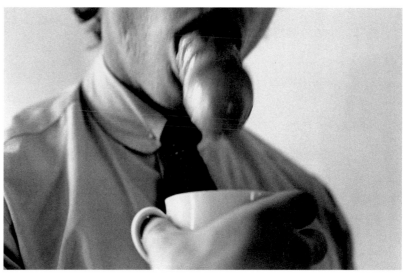

His tongue began to grow beyond the cup.

and became larger and larger

He was laughing!

He Knew!

GILLES

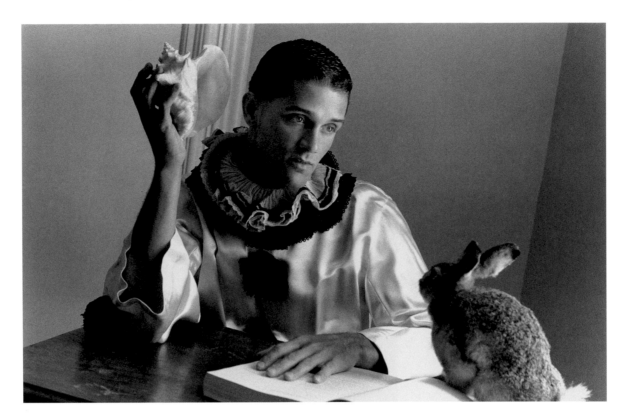

Gilles receives a sea shell from Colombine.
When he puts it to his ear, he hears her say,
"I love you".

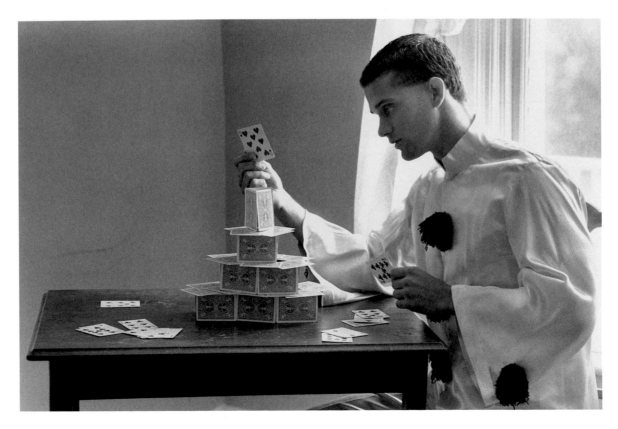

Gilles builds a house of cards
to share with Colombine.

160

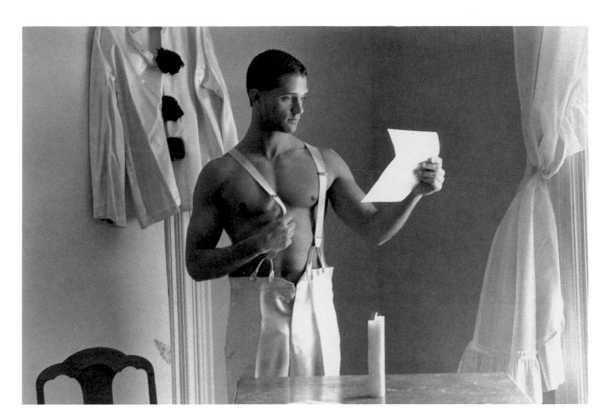

*Gilles receives a letter announcing
the marriage of Colombine to Harlequin.*

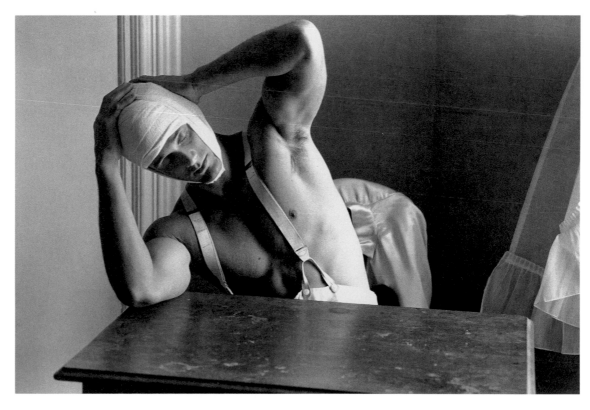

Wounded by grief, Gilles dies of melancholy.

Something happened when I took your picture.
I became enchanted by the sight of you,
Standing there, looking at the book.
Perfect in that gentle light
I took the photograph, over and over
Again and again, compulsively,
Knowing that when I stopped. And set
The camera down, the moment would be lost,
As the dream dies when one awakens
And I could not bear to let it go.

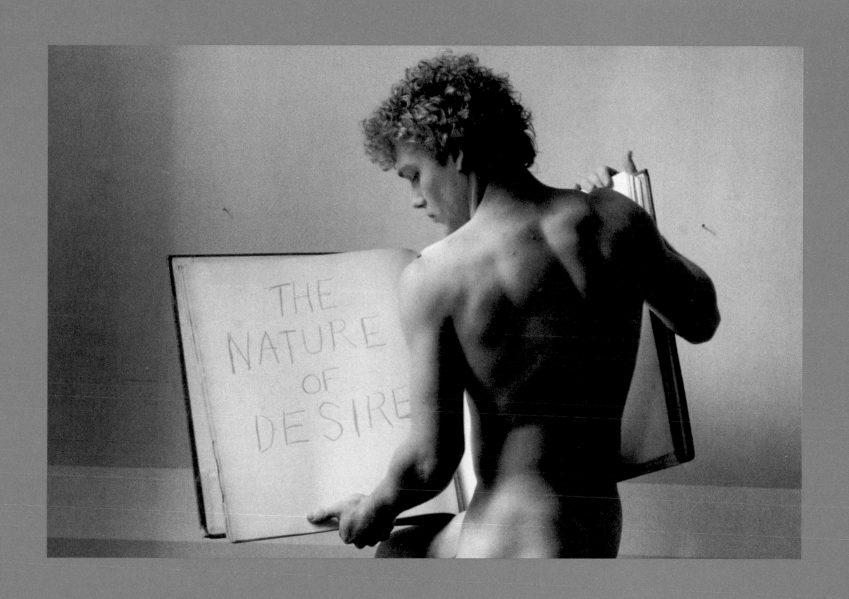

The Camera's Caress

Whoever you are,

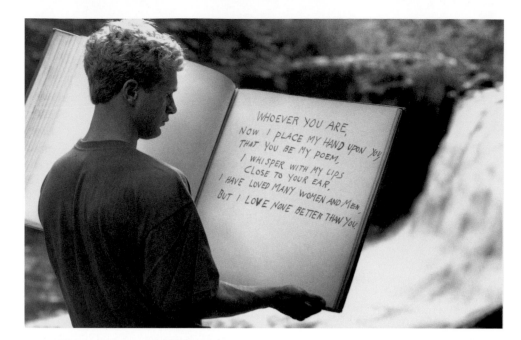

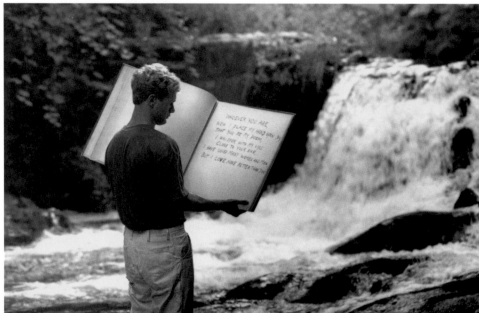

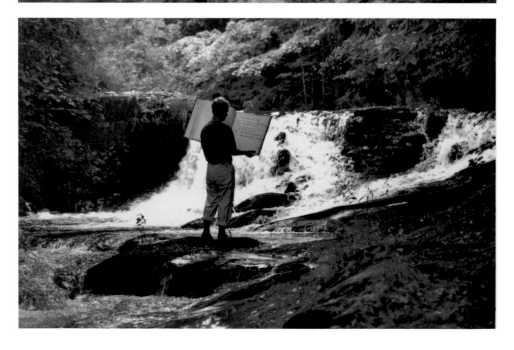

Self-Image

The shedding and adoption of various identities has been a constant theme in Michals's work. The idea of an alter ego has long fascinated him as a way of gaining an understanding of oneself, one's life and our common humanity. His mother named him Duane after her employer's son, whom he hardly knew and who committed suicide for reasons unknown while at university; his own family name was anglicized from the Slovak, leaving him (like others of immigrant origin) acutely conscious of his sense of otherness. Reverting to that original surname and using the Slovak spelling of his middle name, Michals invented a character called Stefan Mihal, who has appeared occasionally in his work and even been credited as the publisher of one of his books. This sense of the power to reinvent oneself helps account for the images of the Doppelgänger and of exchanged identity that appear in Michals's art, as evidence both of the fluidity of the self and the almost mystical search for compatibility that underlies relationships. In the book *Homage to Cavafy*, a haunting image of male twins stripped to the waist is accompanied by the caption 'There was something between them which they had always sensed, but it would remain unspoken.'

We rarely see ourselves as others do, not only because we lack the necessary objectivity to scrutinize ourselves dispassionately but because we may internalize aspects of our identity that we choose not to express publicly. In an early photo-sequence, *The Mirror*, an ordinary and weary-looking man catches glimpses of the more glamorous, feminine self he imagines himself to be as he gazes at his reflection. Others are shown as tragically prey to self-loathing, feeling they have been punished in life for the colour of their skin or because of the inappropriateness of their sexual desire. Michals presents himself in one photo as endowed with both male and female attributes, and in another is shown sadly contemplating the son he never had, grieving at his sense of loss of a reflected image that could have preserved a fragment of his identity.

In my dream I saw the face of my unborn son,
and he was fair and called me father.

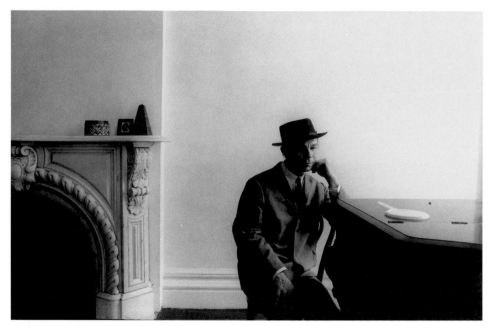

THE MIRROR

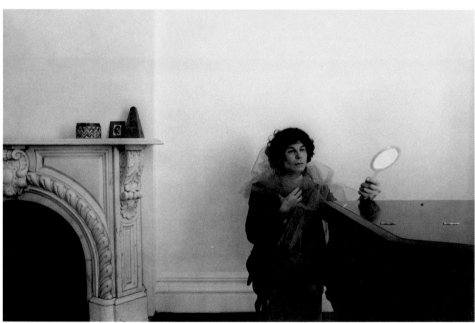

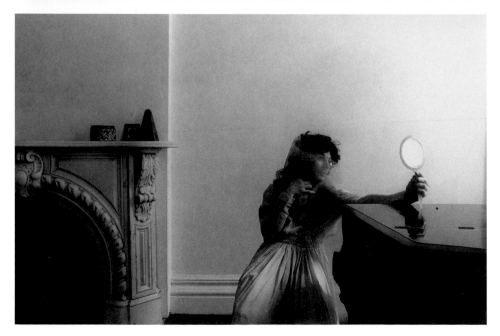

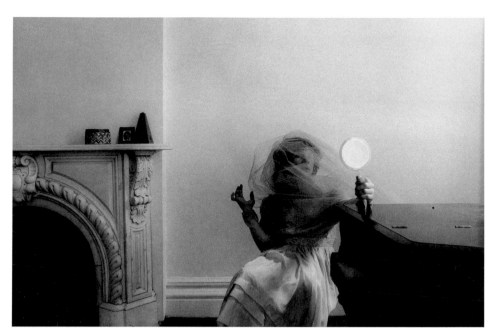

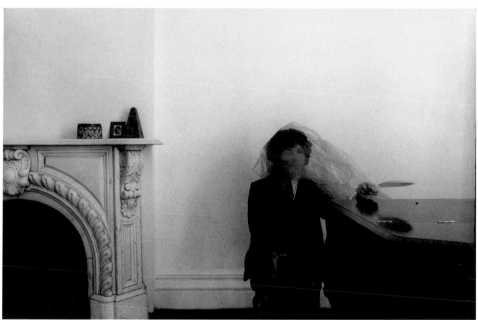

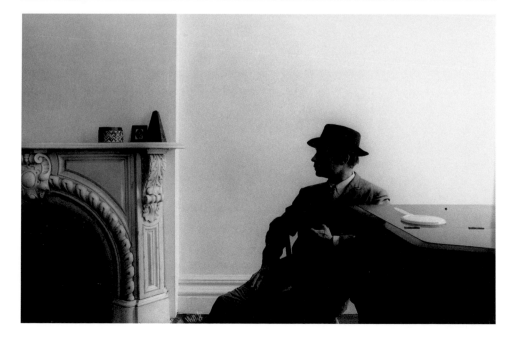

BLACK IS UGLY

All his life he believed all the lies white men had told him. He believed that black was ugly and a punishment from God (although he could not guess what his sin must have been). So he spent his entire life being cold when white men were warm, and he was hungry when white men were fed. It seemed to him to be the natural order of things (although he could not guess why he should be punished). And when I told him it was not true, he would not believe me. It was too late.

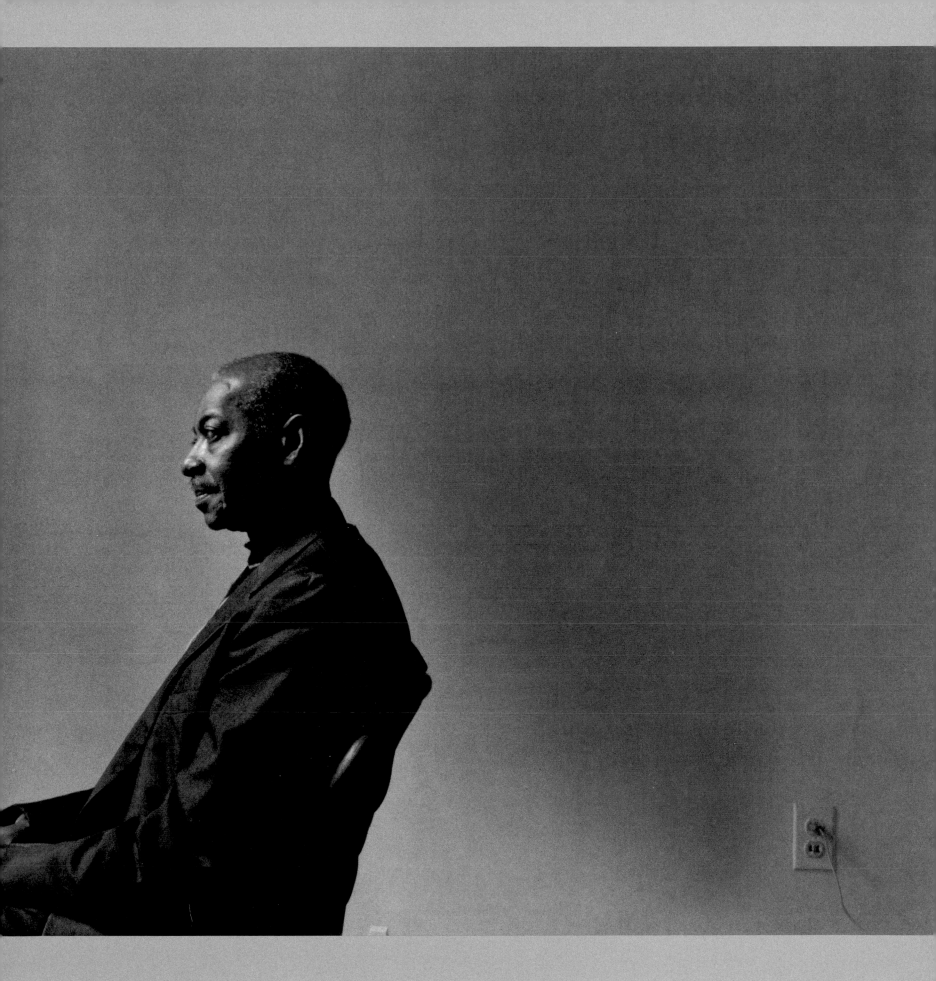

THE UNFORTUATE MAN

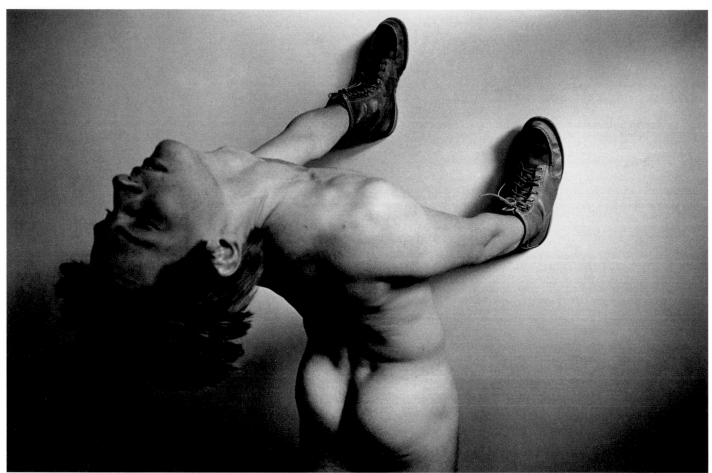

The unfortunate man could not touch the one he loved. It had been declared illegal by the law. Slowly, his fingers became toes and his hands gradually became feet. He began to wear shoes on his hands to disguise his pain. It never occurred to him to break the law.

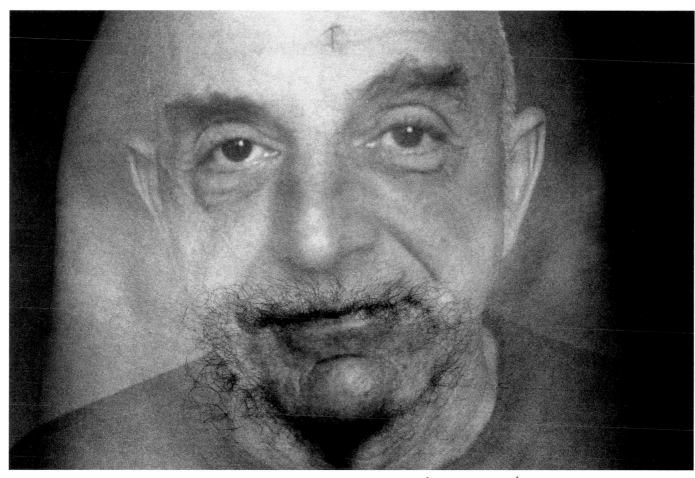

self portrait with Feminine beard

I am what is being experienced, the universe focused in the eye of the beholder. There is a quality of sensation felt as myself which like the "I" of the hurricane is a calm center of the storm of awareness. The exact point of myself in this calm is held as it were a black hole, where my purest reality cannot escape itself, the absolute. I am tethered to the absolute by the cord of consciousness. Again and again I gaze hard at my reflection in the looking glass. Then blink without acknowledgement for my stare reveals no one is there. All descriptions of me are like barnacles attached to me. Nothing is really mine. My name is a word like any other sound, which when repeated blurs to babble. My pride enjoys the false luxury of vanity, a cosmetic decoration that casts me into the furthest ring of self-delusion. I distract myself with novelties. But they are not me. I identify with follies. But they are not me. I am an accomplice to my own ignorance. Under the magnifying glass of my attention my personality has the permanence of fog. I communicate with myself in monologue. My questions echo in my mind. All this thinking exhausts me and I must rest. But who falls asleep and dreams

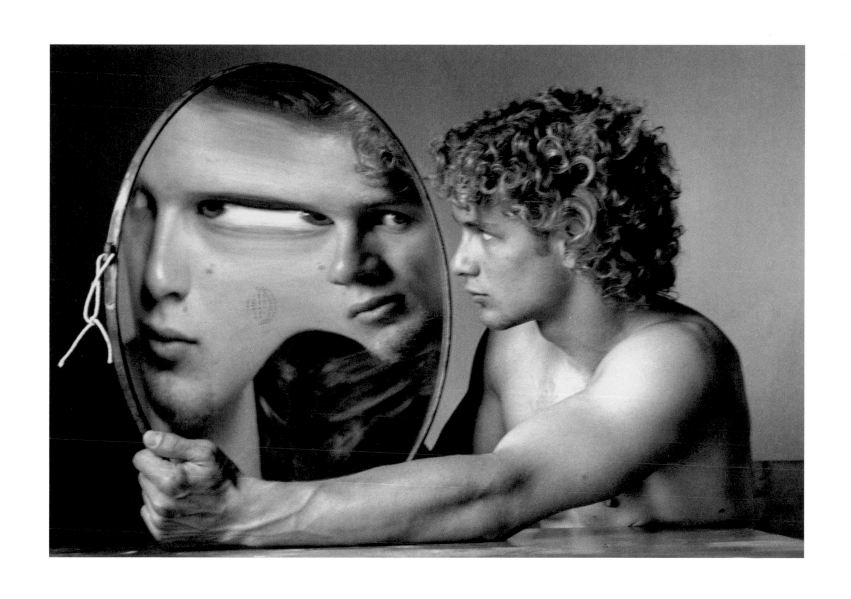

WHO AM I ?

Colour Photographs and Commercial Work

To many 'art' photographers, the idea of using their medium to produce 'commercial' work for magazines or advertising campaigns is anathema. Michals, far from judging some commissions to be compromising, sees them as enabling him in his art – which he modestly refers to as his 'personal' work – to produce the work he needs to make free of any pressures to sell it. In any case, he sensibly points out that anyone earning his or her living from photography can be described as a commercial photographer. He also keeps his operation simple for all his work, whether for himself or for clients. He has no studio, apart from a room occasionally reserved for that purpose in the basement of his house; minimum lighting paraphernalia, as he usually limits himself to available light; no darkroom, since he sends out all his films to a highly skilled printer who knows his exact requirements; no assistants in the conventional sense, since he has no cumbersome equipment to handle and would only occasionally require someone else on hand to snap the shutter; and no need for an agent, given that he is listed in the Manhattan telephone directory and is comfortable fielding enquiries himself.

Michals enjoys the versatility offered by commissions and is aware that because clients come to him wanting something different from the norm, they will generally give him great flexibility in responding to their demands. While it is a relief to have some respite from the expectations of constant invention that he places on himself, he has also found that a situation engineered to conform to someone else's needs can also suit his own purpose. The photograph used for *Black is Ugly*, reproduced in the preceding section, is not alone among his personal works in having started life as part of an advertising campaign. Apart from the fact that his commercial photography is often unsigned, as is the custom, what most distinguishes it from his private work is its use of colour. For his art, where all can be conveyed in tones of black, any other hue would be a distraction.

THE FOUR SEASONS
OF OUR GARDEN

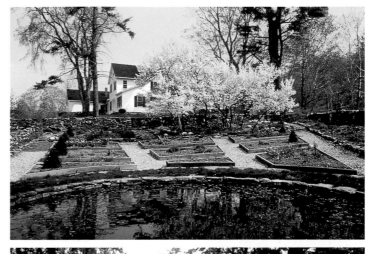

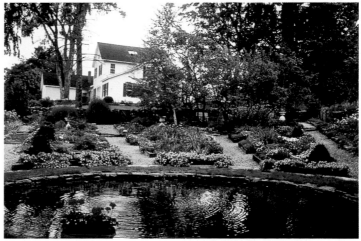

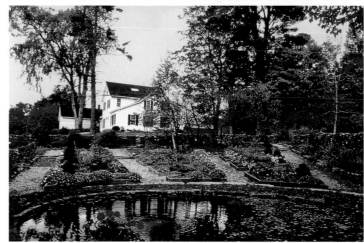

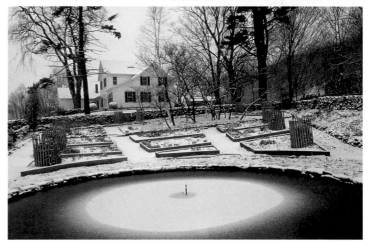

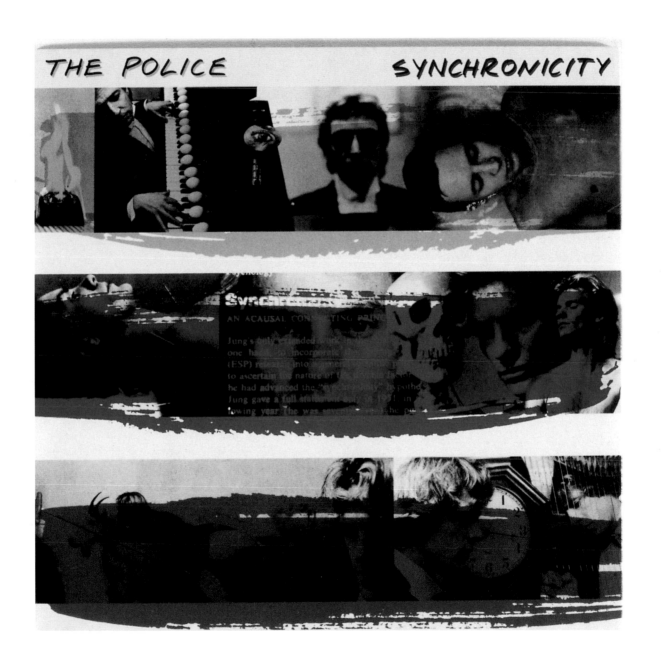

Synchronicity, The Police, 1983

Y S L
YVES SAINT LAURENT

Au Metropolitan Museum of Art de New York s'ouvre le 14 décembre et jusqu'en août 1984 une rétrospective de la mode haute couture créée par Yves Saint Laurent depuis l'ouverture de sa maison en 1961. Evénement unique, sous l'égide de Diana Vreeland, honorant un couturier de son vivant.

DIANA VREELAND PARLE DE YSL

Il y a chez Yves Saint Laurent, un printemps éternel. Chez lui, tout est neuf, jeune, porteur d'avenir. Lorsque j'ai passé en revue ses vingt cinq ans de créations, au rythme de quatre collections l'an, pour choisir ce que cette exposition présentera, je me suis aperçue qu'on pouvait parfaitement mettre n'importe quel vêtement de n'importe quelle année depuis la robe la plus extravagante jusqu'au mini kate en prêt à porter, sans courir le risque de dater. Il serait impossible de dire "Ceci date de telle année" car ceci c'est toujours maintenant. C'est toujours aujourd'hui, et son imagination romantique est éternelle. Et comment cela est-il possible? Yves Saint Laurent voit toujours la femme de "maintenant", à n'importe quel moment. Voilà son secret.

Volontairement ou non, la jeune fille française est l'idéal d'Yves. La jeune Française charmante, courageuse et fière, un peu Jeanne d'Arc, un peu midinette, qui se rend à son travail sous la pluie ou sous le soleil printanier, simplement vêtue d'une chemise et d'un pantalon. Là est son inspiration.

Et puis il y a d'autres types de femmes : celles qui veulent paraître, que ce soit pour recevoir chez elles ou se rendre au bal ; celles qui veulent se montrer extravagantes, cotirées et même un rien absurdes, ou alors plus secrètes et plus posées.

Yves est sur les cinq continents, et des femmes qui pensent jeune, ont l'air jeune et sont jeunes, quel que soit leur l'âge. L'âge a si peu à voir avec l'apparence. C'est une question de port, de silhouette, d'expression, toutes choses essentielles. Yves applique la perfection de la couture aux meilleurs uniformes — pilote, soldat, marin, homme d'église, boulanger, postier — et les rend à la mode. Son choix merveilleux de pantalons, de cabans, de chemises, de boléros, de pull overs, de coupe vent, de vêtements de travail a été porté dans le monde entier, dans les aéroports, pour faire du vélo, sur des femmes de toutes les nationalités, de tous les statuts sociaux, de tous les âges, de toutes les races et de tous les modes de vie.

Yves est tout en contrastes. J'ai été charmée par l'emportement de sa prose, dans les quelques textes que j'ai pu lire de lui, mais dans la conversation, il est parfaitement simple, il s'exprime avec concentration et retenu. Et il y a autant de contraste entre son discours et l'embrasement glorieux de ce qu'il écrit qu'il y a en a entre ses créations pour la nue et le luxe élégant et extrêmement maîtrisé de ses modèles pour le salon. Il est la vie, il est la pierre de touche de toute la mode aujourd'hui. Il est totalement dénué de suffisance, couturier absolument parisien, il apporte au monde la magie et l'émerveillement de la plus belle ville du monde.

(Traduit de l'américain par Philippe Mikriammos)

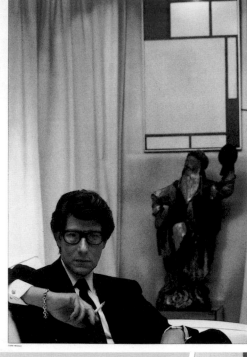

YVES SAINT LAURENT
PAR DUANE MICHALS, À DR.
LA TOUTE
PREMIÈRE ROBE CRÉÉE
PAR YVES SAINT
LAURENT, CI-DESSUS,
POUR SA PREMIÈRE
COLLECTION EN 1961.

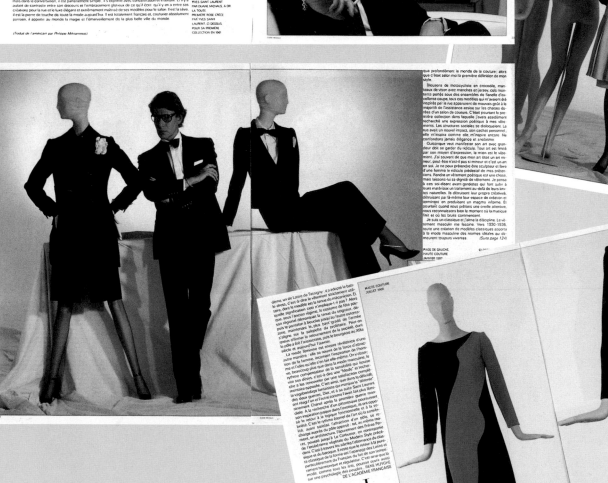

French *Vogue*
December 1983

180

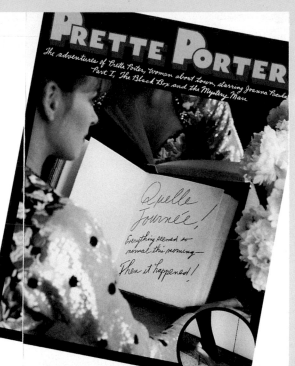

CLOTHES CALLS

Quick—what's the right thing to wear when receiving a note from a mysterious stranger? Or when following a trail of clues through the paranoia-producing streets of New York City? When waiting in a dark boîte facing who knows what? On the next five pages, Joanna Pacula is Prette Porter, our Holly Golightly-esque heroine whose life is one clothes call after another, and whose adventures—sartorial and otherwise— are going to be chronicled in Mirabella's own [cont]inuing comic strip. The words and pictures are by Duane [Micha]ls, concept and art direction by Angelo Bucarelli, [with M]artin Charnin consulting. You've heard of mystery [rea]ds—think of this as a mystery wardrobe.

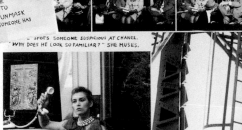

Ungaro, Prette's great designer friend, has shocking news. Sneak, the scandal magazine has dispatched a spy to the Paris collections to write an exposé discrediting the couture. Would Prette unmask the spy from Sneak? "Yes, yes, yes!" Unbeknownst to them, someone has bugged the candy and taped their conversation.

... spots someone suspicious at Chanel. "Why does he look so familiar?" she muses.

While investigating Chanel's Rue Cambon apartment, Prette finds a copy of Sneak. Someone has just been there!

Prette goes underground at the Versace show, disguised as a mannequin. Dazzled by the clothes, she forgets to look for clues.

"Wonderful, wonderful, wonderful," beams Prette, as she looks into a mirror at a Lacroix fitting.

Meanwhile, [Pre]tte's black book [is] stolen.

At that moment, the spy steals Lacroix's sketches.

Mirabella
August and November 1990

181

Uncle Duane's curious Christmas list, a sensible collection of bizarre confections and real gifts for imaginary friends.

From left: Bumblebee, $39. At Evolution, 120 Spring Street. Santa ornament, $33. At Bergdorf Goodman. Silver watch, $28. At Warehouse of London, 583 Broadway. One-of-a-kind blue topaz necklace with sterling silver setting and chain, by Stephen Dweck, about $7,832. Through special order at Bergdorf Goodman. Snowball ornament, $33. At Bergdorf Goodman.

Photographs by Duane Michals
With Sheva Fruitman

Text by Duane Michals

*Recently my cat told me that she had been my wife, once upon a time ago in another life.
Then she said when we were wed that I had been a mouse, and that her name had been Babette, and they called me Klaus.
Suspiciously I asked for proof. Was this a cunning pussy spoof?
Then she recalled a secret just the two of us had shared.
She said my favorite Christmas gift was always Camembert.
Suddenly, epiphany and I could see Babette
And how I loved her long ago and how I love her yet.*

From left: Bellerton Camembert cheese, $6.50. At Balducci's, 424 Avenue of the Americas. Hologram shoe, $171, by Dennis Comeau at Showroom 7. At Nordstrom, select stores. Clip-on bird ornament, $4. At Lord & Taylor. Brooch, $1,245, from Chanel. At Chanel Boutique, 15 East 57th Street.

I know le cadeau parfait for my favorite aunt, the faux Clairvoyant who writes poetry when she can't. She could use a full-time muse and a Judith Leiber purse to help perfect her meter and improve her vapid verse.

From left: Hand mirror, $22. At Gallery 91, 91 Grand Street. Evening bag, $2,132, by Judith Leiber. At Bergdorf Goodman. Glasses for 3-D viewing, $6. At Little Rickie, 49½ First Avenue. Venus candle, $22. At Artmarket, 73 Grand Street.

How do you disguise a Christmas surprise
from your guardian angel, who is always at your side?
Ask him to play hide-and-seek,
close his eyes and count to ten.
Then float a feather in the air above his head,
he'll not look there.
And as it falls upon his nose,
it will tickle his fancy from head to toes.

From left: Crystal pitcher, $90. At MOMA Design Store, 44 West 53d Street. Bag, $39 to $59 (depending on size). At Freemans, 120 Spring Street. Silver bracelets, $215 each. At Charivari, 18 West 57th Street. Ostrich feather, $1.25. At Eskay Novelty, 34 West 38th Street. Kaleidoscope, $3.50. At Artismarket. Italian hand-bound leather books, $30 to $44 each. At Troy, 138 Greene Street.

I'll give a lump of coal to my doppelgänger double,
who casts his shadow on my soul
and always gets me into trouble.
But I'm not as mean as I may seem.
Shadows have an appetite for anthracite.
They find it delicious.
I'm told it's what they love to eat
as candy treats for Christmas.

From left: Swirl coaster $4. At Artismarket, 79 Grand Street. Cracked-glass vase, $210, by Jene Rauter. At Michael Dawkins, 33 East 65th Street. Children's ruby slipper, $22 a pair. At F.A.O. Schwarz. Antique brass microscope, $1,210, by C. Collins. By appointment at E. Buk, 151 Spring Street, (212) 226-6893. Antique moon ornament, $65. At Grey Gardens, 461 Broome Street. Toy tin art student (limited edition), $39. At F.A.O. Schwarz.

Because I already know,
I never ask my uncle Joe
what he wants for Christmas.
Remember him,
the retired clochard
who practices Zen
in his backyard?
He always wants
enlightenment.
But instead I'll present him
with a fountain pen,
the next best thing to the eternal delight
of being in the great white light.

From left: Bronze Buddha, $150. At Sing Ken Ken, 405 Washington Street. Fountain pen, $275, by Omas. At MOMA Design Store. Stopwatch, $75, from Georg Jensen. At Bergdorf Goodman. Miniature metal tree, $500 for a set of 15. At Troy, 138 Greene Street. Relaxation oil, $15. At Sing Ken Ken. Giant marble, $3.50. At F.A.O. Schwarz. Lamp, $615, by Ingo Maurer. At Moss, 146 Greene Street.

NARRATIVE.
It's how you forge
a context by
linking
what seems
unrelated.

for individuals
who reach
conclusions
all their
own.

GAP

The Gap, 1993

The first photographs taken by Michals, as a tourist visiting Russia in 1958 with a borrowed camera, demonstrate how natural he found it to ask complete strangers to present themselves to the scrutiny of his lens. These portraits have a candid directness, reminiscent of nineteenth-century photographs, for which no professional training could have prepared him. He simply did what he had seen his mother do in photographing the family when he was young: line everyone up and ask them to face the camera.

Throughout his life Michals has produced many portraits, often on commission. He has no aversion to working with a 'real' situation, using a model and often a setting that he has not chosen himself. Rather than pretending, however, that it is possible to achieve an instant and profound psychological understanding by concentrating on the geography of the face or by having the subjects fix their stare onto the camera, he prefers to engage the sitters in a kind of play, so that the true subject of the photograph is a person in the act of having his or her picture taken.

The commissions that Michals accepts, and the photos of sitters he has sought out himself, are often of people who have a strong self-consciousness about their own image and identity, such as actors and artists, and who are thus perfect candidates as participants in these little enactments. In such cases Michals has also brought to bear his previous knowledge of their work, much as he brings his understanding of friends and family members to the photographs he has taken of them. The results, while not intended as evidence that would help a psychiatrist to decode someone's personality, are certainly more illuminating in their casual intimacy than the conventionally flattering glamour shots favoured in much photojournalism. Asked to photograph a celebrity, Michals always comes back with something more: an image of a human being.

Portraits

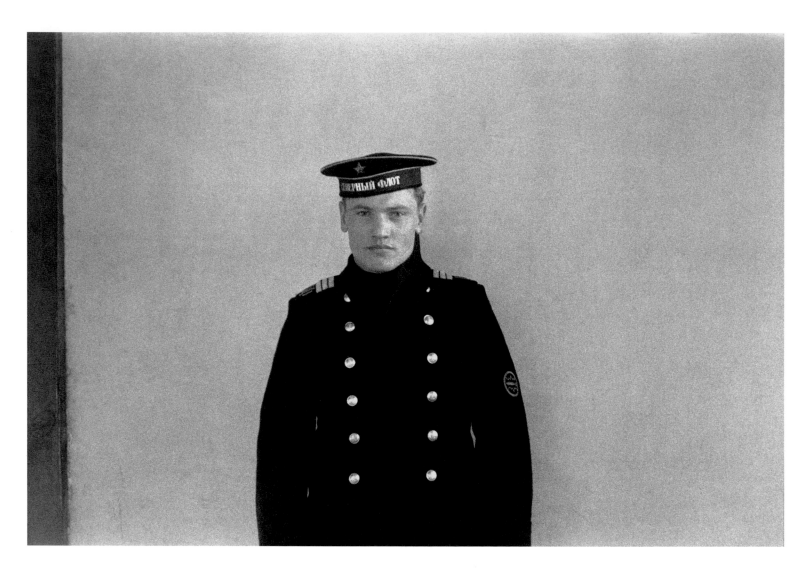

SAILOR IN MINSK

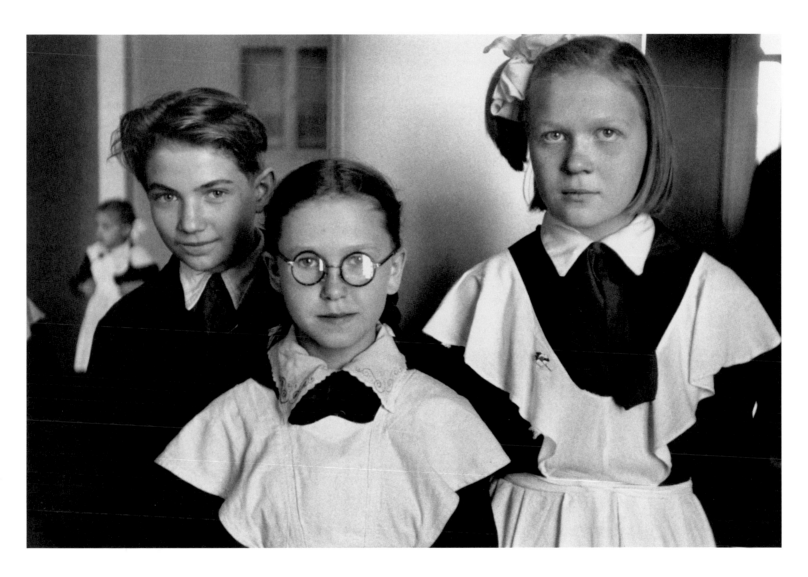

CHILDREN IN LENINGRAD

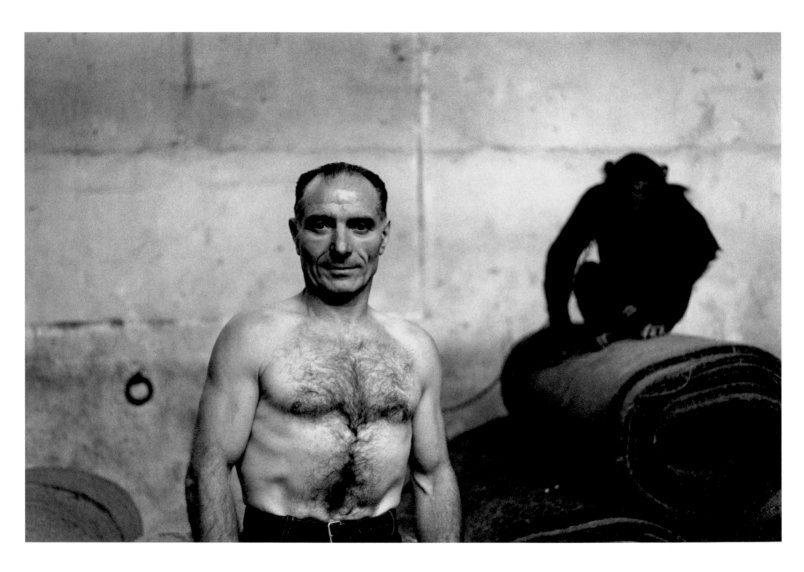

ANIMAL TRAINER AND MONKEY

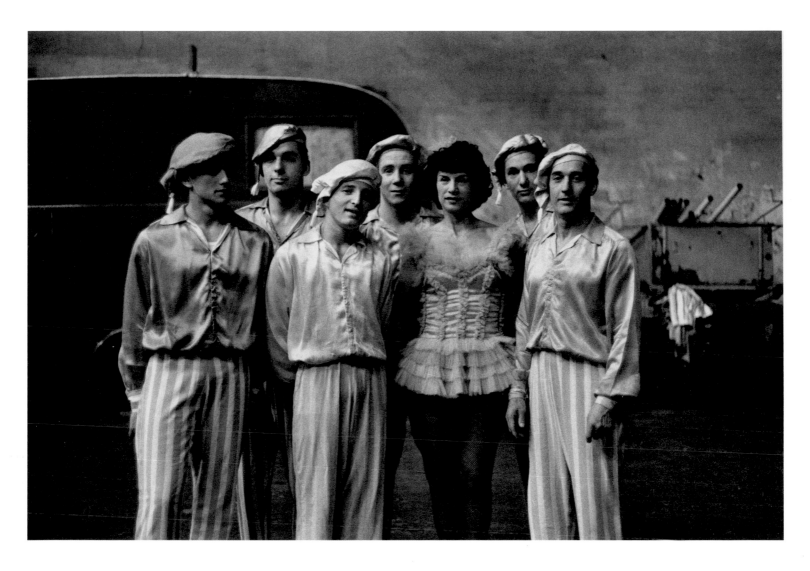

LE CIRQUE D'HIVER, 1962

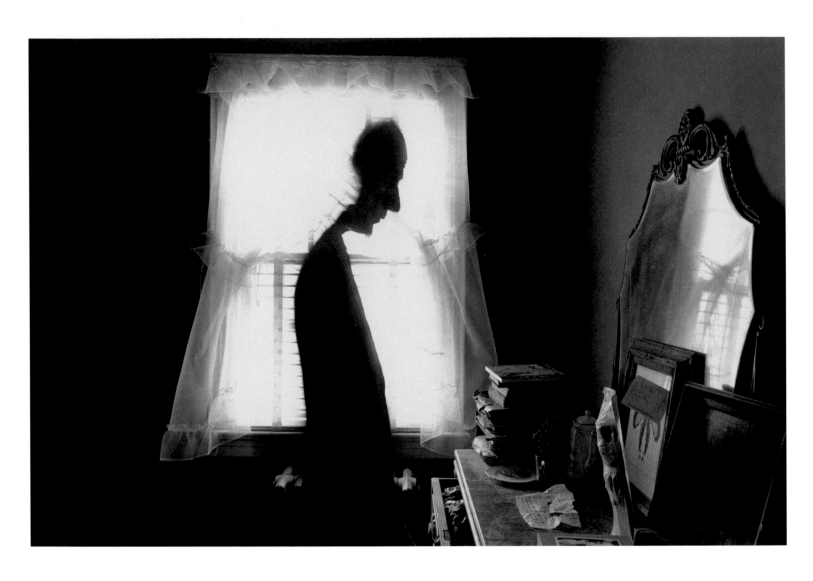

JOSEPH CORNELL

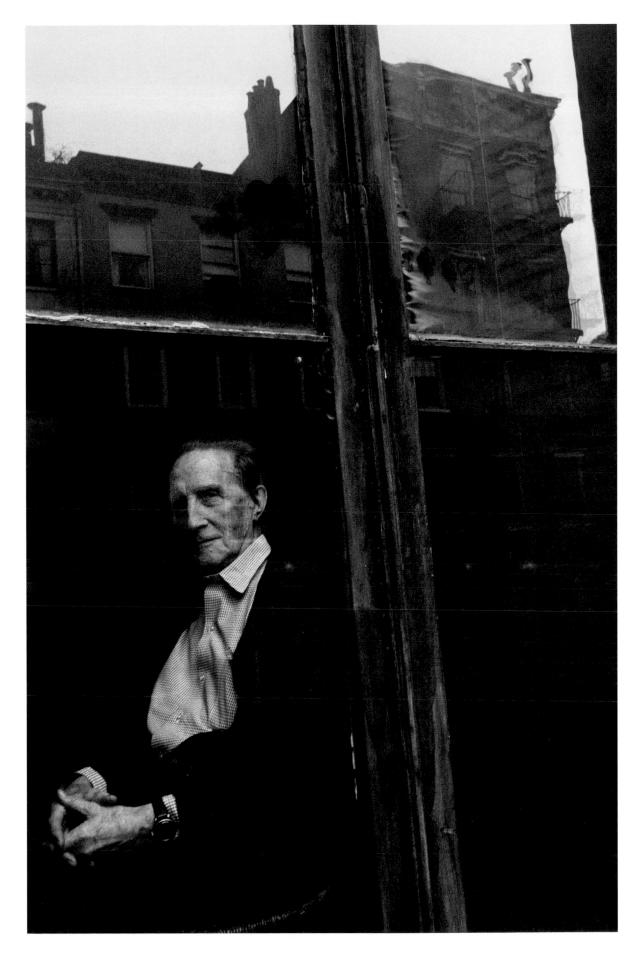

MARCEL DUCHAMP

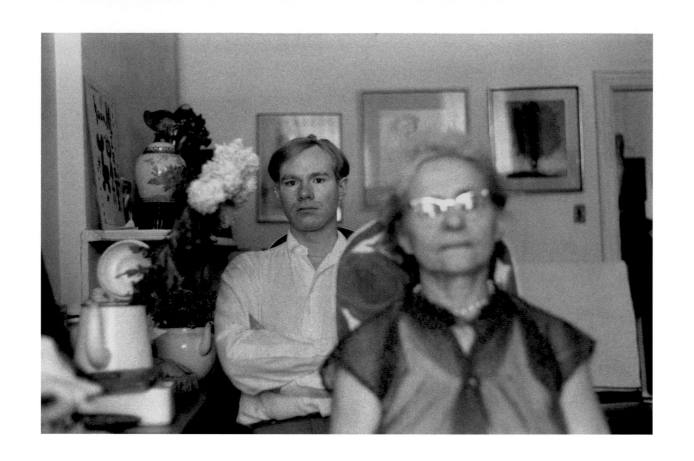

ANDY WARHOL AND JULIA WARHOLA

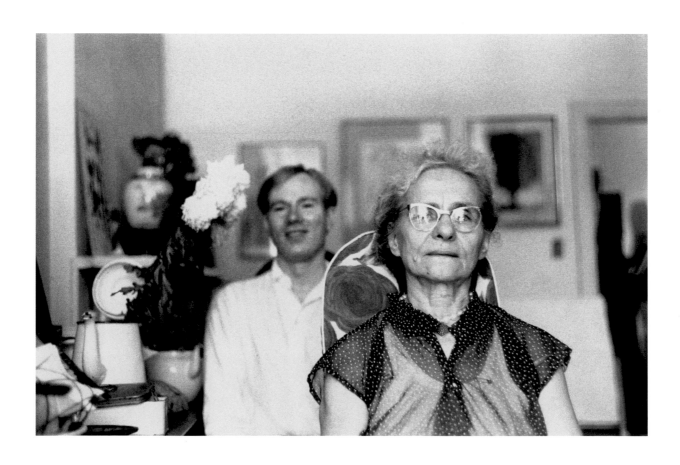

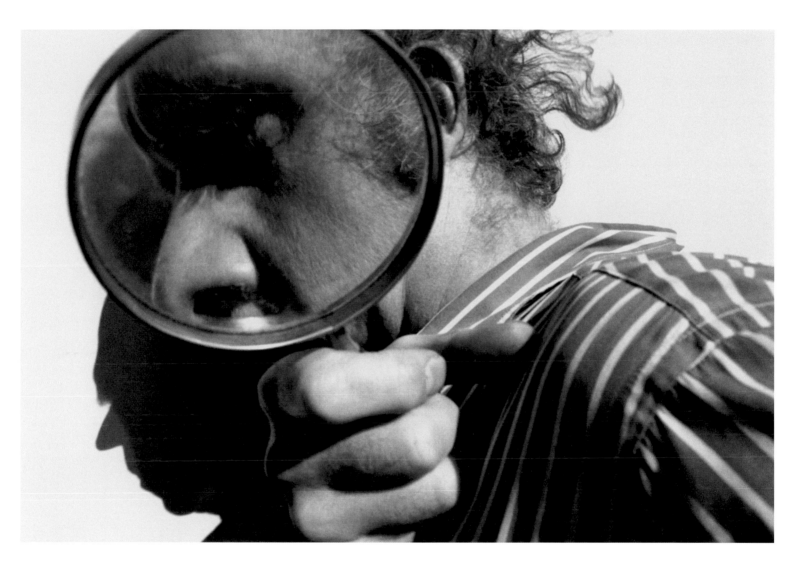

CLAES OLDENBURG

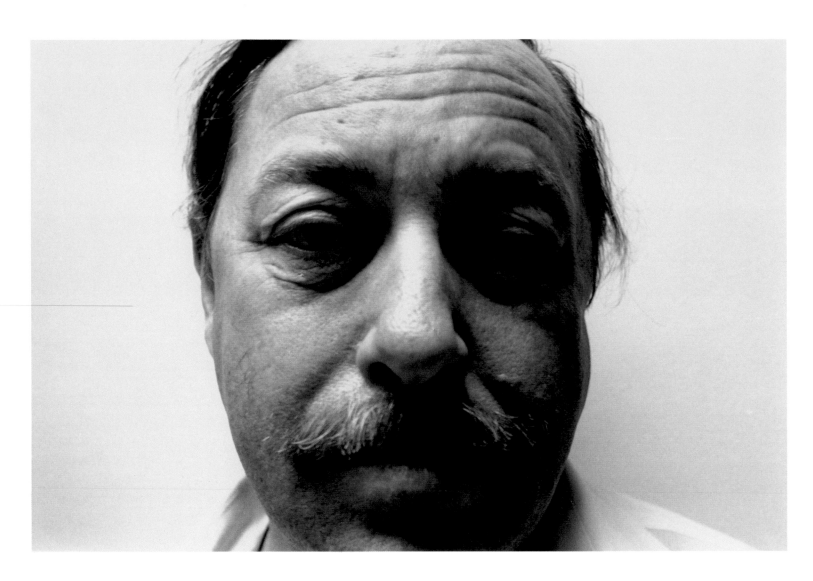

TENNESSEE WILLIAMS

DE KOONING

ROBERT DUVALL

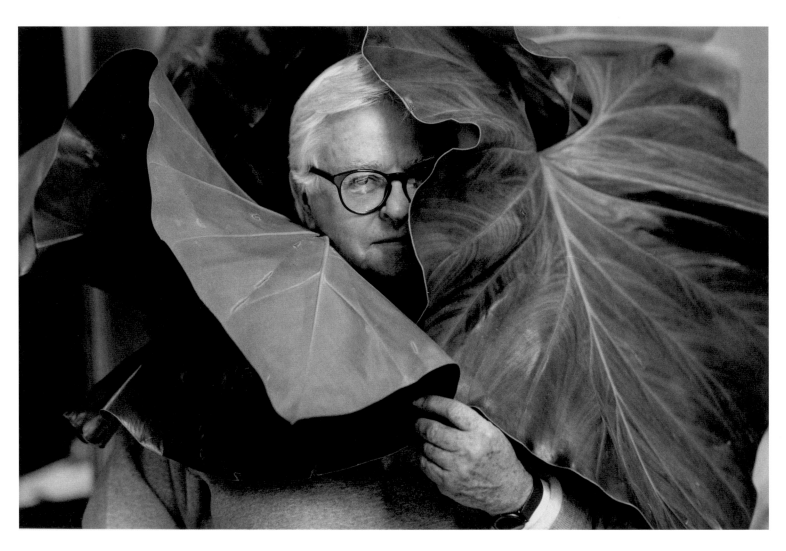

GEOFFREY BEENE

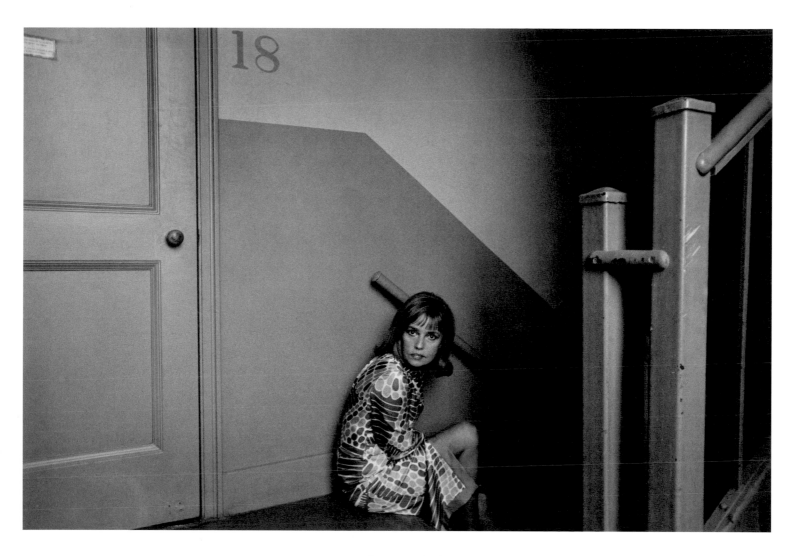

JEANNE MOREAU

Verifying Reality

Recognizing early in his career that he was not destined to follow in the foot-steps of Henri Cartier-Bresson – since, by his own admission, he was always too indecisive to capture the 'decisive moment' – Michals was also only too aware that even the most apparently convincing documentary photographs could be faked or staged for the camera. Under the circumstances, it seemed not only more suited to his temperament, but also much more honest, to make it clear that his photo-graphs have been constructed from elements he has chosen, invented or arranged. As early as 1964, in his series of *Empty New York* interiors shot after hours, he understood the dramatic potential of the location as a kind of stage set. The photo stories that followed soon afterwards fleshed out ordinary but often atmospheric sites with human confrontations devised by him. We are left in no doubt that we are being presented with a fiction, but the experience conveyed is no less real than life itself so long as the situations strike us as true and well-observed.

The Surrealist painter René Magritte, a supreme master of artifice whom Michals counts as a major influence, proved particularly adept at the complicit alliance between sitter and photographer when he was visited by his American fan at home in Brussels in 1965. These and later photographs openly exploit the full range of devices that enhance the potential of the camera as a tool for invention rather than as a straightforward recorder of appearances. If Michals concludes, in works such as *A Failed Attempt to Photograph Reality*, that appearances should not be confused with reality, he also accepts the powerful role that the camera can play in our lives. In *This Photograph is My Proof*, a picture of his cousin taken years earlier is joined by a text that conveys the talismanic importance we all attach to family snapshots as repositories of memory and as evidence of the past. It is photographs like these, Michals tells us, that will rightly mean most to us and that give the camera its proper role in verifying reality.

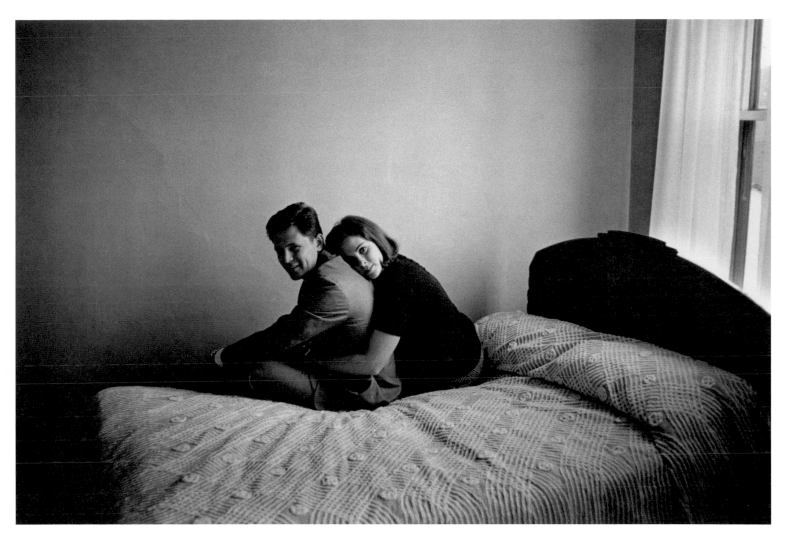

THIS PHOTOGRAPH IS MY PROOF

This photograph is my proof. There was that afternoon,
when things were still good between us, and she embraced
me, and we were so happy. It did happen, She did
love me, Look see for yourself!

Empty New York

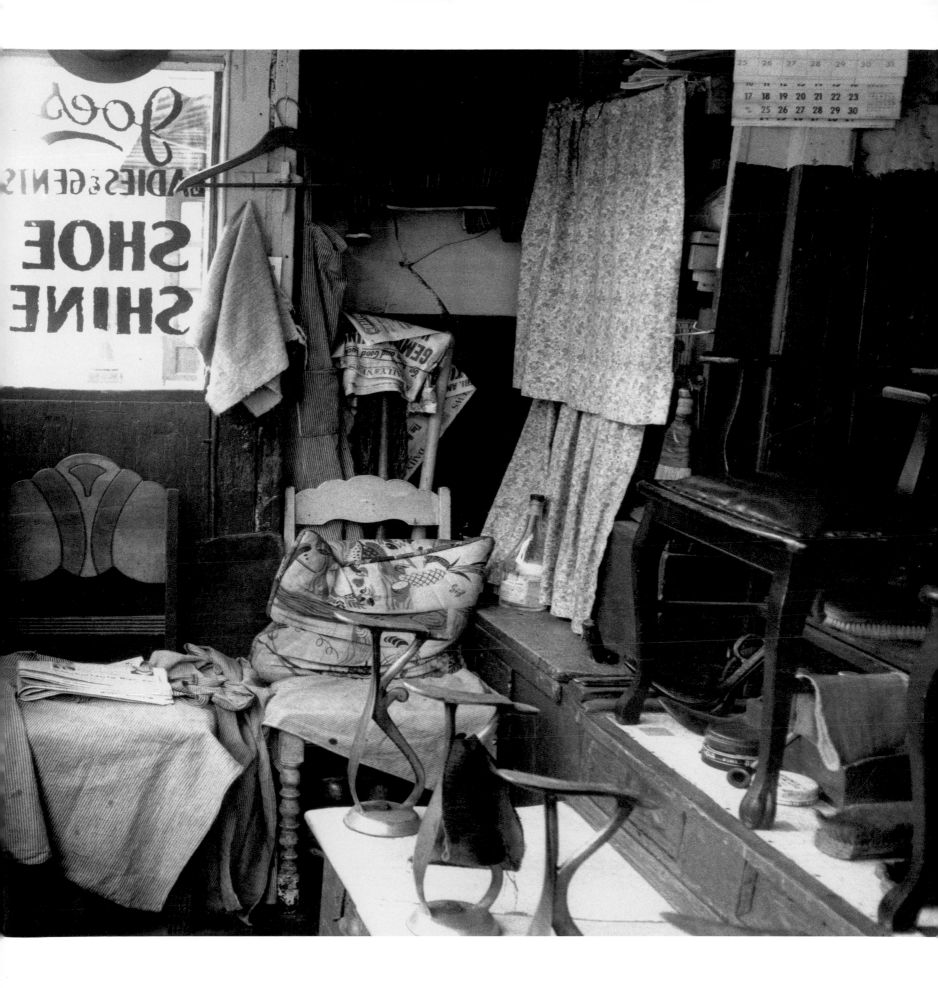

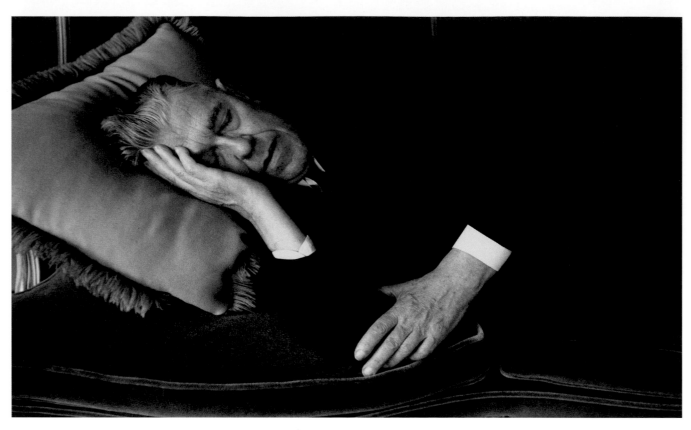

Magritte asleep

Bedroom with nude painting

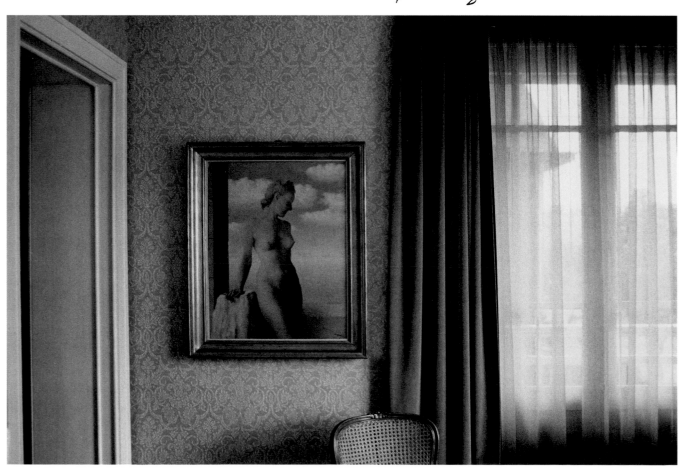

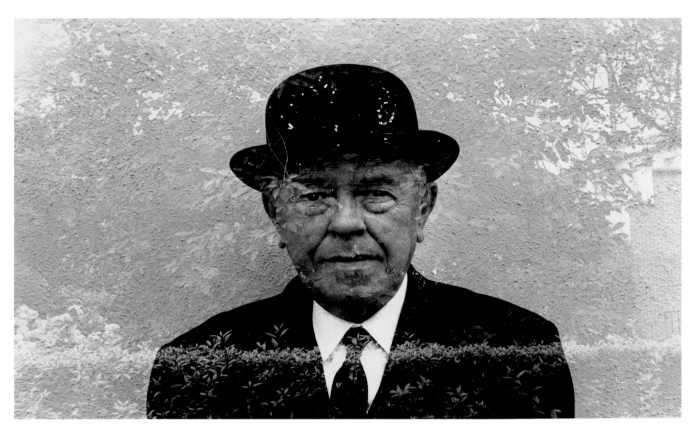

Portrait of Magritte in his garden double-exposed.

Studio

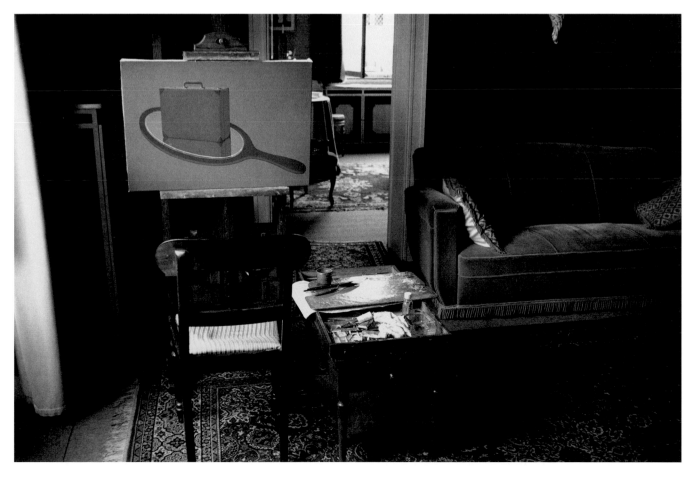

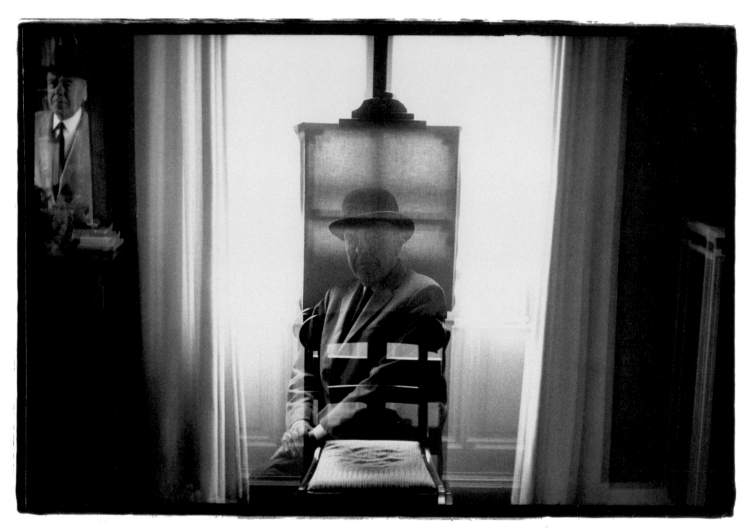

Magritte at his easel

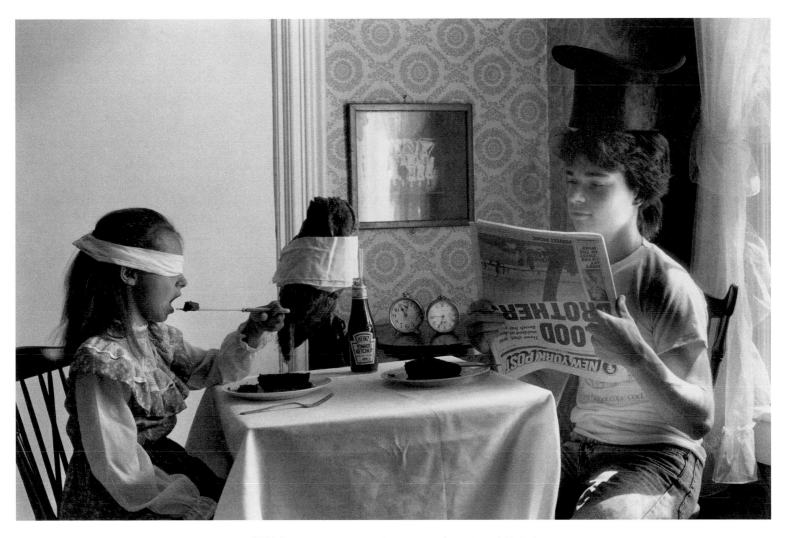

THERE ARE NINE MISTAKES
IN THIS PHOTOGRAPH

Can you find them?

THE SIGHT OF SOUND

A FAILED ATTEMPT TO PHOTOGRAPH REALITY

How foolish of me to believe that it would be that easy.
I had confused the appearances of trees and automobiles,
and people with reality itself, and believed that
a photograph of these appearances to be a photograph
of it. It is a melancholy ~~truth~~ truth that I will
never be able to photograph it and can only fail.
I am a reflection photographing other reflections
within a reflection. To photograph reality
is to photograph nothing.

Biography

Duane Steven Michals was born in McKeesport, Pennsylvania on 18 February 1932, the son of John Ambrose Michals, a steelworker, and Margaret Matik, a housekeeper. As his mother was required to live in with the family for whom she worked, he was raised in his early childhood by his Czechoslovakian grandmother, who had emigrated to America at the turn of the century. The lasting impression made on him by these circumstances and by his foreign background is attested to by his invention in adulthood of an alter ego named Stefan Mihal: a name which not only reverts to the original Slovak spelling but which discards the Christian name given to him by his mother in honour of her employers' son. Stefan Mihal is the person he should have been destined to become: a factory worker married and with children, living modestly on a suburban housing estate, prompting curiosity rather than scorn. He has been credited as both the author and subject of the artist's self-portraits and as the publisher of his book *Take One and See Mt. Fujiyama*.

It was while in high school that Michals first sensed his vocation as an artist, enrolling at the age of fourteen, with the aid of a scholarship, in watercolour painting classes held on Saturdays at the Carnegie Institute in Pittsburgh. His grades helped earn him a further scholarship to the University of Denver, from which he was awarded a B.A. in 1953, but he had decided on leaving school to be 'sensible' and therefore opted not to train as an artist. It was during these years, however, that he developed his abiding interest in a wide range of painting, from the early Renaissance through to Surrealist masters such as de Chirico, Balthus and Magritte.

Immediately following his graduation from university, Michals was drafted into the American army, serving as a second lieutenant in the armoured division in Germany. On his release from the army in 1956 he enrolled at the Parsons School of Design in New York, where he trained as a graphic designer, leaving within a year to become assistant art director for *Dance* magazine. In 1958 he moved on to the publicity department of Time Inc., working as a paste-up artist and designer.

In 1958 Michals seized the opportunity of making a three-week journey to the Soviet Union, recently opened up to tourism, taking with him – as any tourist would do – a camera (a borrowed Argus C3), with no motive other than that of taking some snapshots. The portraits made during that trip were of the utmost simplicity and directness, successful (as he was the first to recognize) precisely because he was not setting out to be a photographer. As soon as he saw the results, he realized that they were worth making public and that he had found his real *métier*. Armed with this 'instant portfolio', he took part in his first group exhibition in 1959 at the tiny Image Gallery in New York, in the company of Garry Winogrand among others. Having decided to concentrate all his energies on photography, he rapidly mastered matters of technique, thanks in no small measure to advice from a photographer friend, Daniel Entin, who also offered him the use of his studio at weekends; it was there that Michals began photographing friends and acquaintances using only natural light, as was to be the case with all his subsequent work.

By 1960 Michals was earning his living as a commercial photographer, without, however, succumbing to the temptation of acquiring a studio or the other trappings generally associated with being a 'professional'. His first commission was to produce publicity stills for a Broadway musical revue, *The Fantasticks*, which thanks to a long run and cast changes supplied him with a steady stream of work. Within months he was working for glossy magazines such as *Esquire*, *Mademoiselle* and *Show* and later on for *Vogue*, *The New York Times*, *Horizon* and *Scientific American*. Michals has earned considerable respect for his commercial work, which he enjoys and which gives him the financial security to pursue the private work which is his fundamental concern.

Michals has published numerous books of his photographs and texts, and he has had work exhibited widely on an international scale, including retrospectives in France, Great Britain and the United States. He continues to live and work in New York City.

Awards

1975	CAPS Grant
1976	National Endowment for the Arts Grant
1978	Pennsylvania Council of the Arts
1979	Carnegie Foundation Photography Fellow, Cooper Union
1982	Médaille de Vermeil de la Ville de Paris
1989–90	The Meadows Distinguished Visiting Professor, SMU, Dallas
1991	International Center of Photography Infinity Award for Art
	Nissan International Fellow
1992	Honorary Fellowship, Royal Photographic Society, Bath, England
1993	Officier dans l'Ordre des Arts et des Lettres, France
	The Century Award, The Museum of Photographic Arts, San Diego
	Youth Friends Award, School Art League of New York City
	Honorary Doctorate of Fine Arts, The Art Institute of Boston
1994	Gold Medal for Photography, The National Arts Club, New York
1997	Art Start for Children, Solomon R. Guggenheim Museum, New York

Public Collections

USA

Akron Art Institute, Akron, OH
Art Institute of Chicago, Chicago, IL
Birmingham Museum of Art, Birmingham, AL
Boston Museum of Fine Arts, Boston, MA
Exchange Bank of Chicago, Chicago, IL
High Museum of Art, Atlanta, GA
Honolulu Academy of Art, Honolulu, HI
International Museum of Photography,
 George Eastman House, Rochester, NY
Lowe Art Museum, University of Miami, Miami, FL
Emily Lowe Gallery, Hofstra University, Hempstead,
 NY
Memphis Brooks Museum of Art, Memphis, TN
Metropolitan Museum of Art, New York, NY
Museum of Fine Arts, Houston, TX
Museum of Modern Art, New York, NY
Nelson-Atkins Museum of Art, Kansas City, MO
New Orleans Museum of Art, New Orleans, LA
Norton Simon Museum, Pasadena, CA
Ohio State University Collection, Athens, OH
Philadelphia Museum of Art, Philadelphia, PA
Philadelphia Library, Philadelphia, PA
Princeton University Art Museum, Princeton, NJ
Rhode Island School of Design, Providence, RI
San Francisco Museum of Modern Art,
 San Francisco, CA
Smithsonian Institution, Washington, D.C.
University of Delaware, Wilmington, DE
University of California at Los Angeles,
 Los Angeles, CA
University of Maryland, Baltimore, MD
University of Massachusetts, Boston, MA
University of New Mexico, Albuquerque, NM
Vassar College, Poughkeepsie, NY
Wesleyan University Collection, Middletown, CT
Worcester Art Museum, Worcester, MA
Yale University Art Gallery, New Haven, CT

OUTSIDE USA

Australian National Gallery of Art, Canberra,
 Australia
Bibliothèque Nationale, Paris, France
Commune de Gibellina, Gibellina, Sicily, Italy
Espace Niçois d'Art et de Culture, Nice, France
Fonds Régional d'Art Contemporain Basse-
 Normandie, France
Fonds Régional d'Art Contemporain, Limousin,
 France
Fonds Régional d'Art Contemporain, Lorraine,
 France
Fonds Régional d'Art Contemporain Nord,
 Pas de Calais, France
Museum für Kunst und Gewerbe, Hamburg,
 Germany

Institute of Polytechnic, College of Photography,
 Japan
Israel Museum, Jerusalem, Israel
Louisiana, Denmark
Kunsthaus Zürich, Zürich, Switzerland
Moderna Museet, Stockholm, Sweden
Montreal Museum of Fine Arts, Montreal, Canada
Musée d'Art Moderne de la Ville de Paris, Paris,
 France
Musée d'Art Moderne et Contemporain, Strasbourg,
 France
Musée Cantini, Marseille, France
Musée de Nîmes, Nîmes, France
Museu Calouste Gulbenkian, Lisbon, Portugal
Museum Ludwig, Gruber Collection, Cologne,
 Germany
National Museum of Modern Art, Kyoto, Japan
National Museums on Merseyside, Walker Art Gallery,
 Liverpool, England
National Gallery of Canada, Ottawa, Canada
National Art Gallery, Wellington, New Zealand
Repubblica di San Marino, Italy
Stedelijk Museum of Modern Art, Amsterdam,
 Holland
Vancouver Art Gallery, Vancouver, Canada

Exhibitions

SOLO EXHIBITIONS

1963
Underground Gallery, New York, NY

1965
Underground Gallery, New York, NY

1968
Underground Gallery, New York, NY
Art Institute of Chicago, Chicago, IL

1970
Museum of Modern Art, New York, NY

1971
George Eastman House, Rochester, NY

1972
Museum of New Mexico, Albuquerque, NM
San Francisco Art Institute, San Francisco, CA

1973
Galerie Delpire, Paris, France
International Cultural Center, Antwerp, Belgium
Kölnischer Kunstverein, Cologne, West Germany

1974
Frankfurter Kunstverein, Frankfurt, West Germany
Galerie 291, Milan, Italy
Documenta, Turin, Italy
School of Visual Arts, New York, NY
Light Gallery, New York, NY

1975
Light Gallery, New York, NY
Broxton Gallery, Los Angeles, CA

1976
Jacques Bosser, Paris, France
Sidney Janis Gallery, New York, NY
Galerie Die Brücke, Vienna, Austria
Texas Center for Photographic Studies, Dallas, TX
Contemporary Arts Center, Cincinnati, OH
Ohio State University, Columbus, OH
Felix Handschin Galerie, Basel, Switzerland
Douglas Drake Gallery, Kansas City, KS

1977
Galerie Breiting, Berlin, West Germany
Paul Maenz, Cologne, West Germany
G. Ray Hawkins Gallery, Los Angeles, CA
Philadelphia College of Art, Philadelphia, PA
Focus Gallery, San Francisco, CA

1978
Douglas Drake Gallery, Kansas City, KS
The Collection at 24, Miami, FL
Camera Obscura, Stockholm, Sweden
Galerie Fiolet, Amsterdam, Netherlands
Galerie Wilde, Cologne, West Germany
Akron Art Institute, Akron, OH

Sidney Janis Gallery, New York, NY
Galerie L'Oeil 2000, Chateauroux, France

1979
La Remise du Parc, Paris, France
Canon Photo Gallery, Geneva, Switzerland
The Collection at 24, Miami, FL
Art Gallery, The University of Denver, CO
Galerie Wilde, Cologne, West Germany
Galerie Nouvelles Images, The Hague, Netherlands
Nova Gallery, Vancouver, British Columbia, Canada

1980
Carl Solway Gallery, Cincinnati, OH
Galerie Nouvelles Images, The Hague, Netherlands
Susan Spiritus Gallery, Seattle, WA
Art Gallery, University of Pittsburgh, PA
Silver Image Gallery, Seattle, WA
Museo de Arte Moderno, Bogotá, Colombia
Sidney Janis Gallery, New York, NY

1981
Galerie Fiolet, Amsterdam, Netherlands
Gemeentemuseum, Apeldoorn, Netherlands
Halstead Gallery, Birmingham, MI
Swarthmore College, Swarthmore, PA
The Atlanta Gallery of Photography, Atlanta, GA
The Huntsville Museum of Art, Huntsville, AL
Work Galerie, Zurich, Switzerland
Colorado Photo Arts Center, Denver, CO
Philadelphia College of Art, Philadelphia, PA
Centres Culturel Graslin, Nantes, France

1982
Columbia Museum of Art & Science, Columbia, SC
University of Rhode Island, Providence, RI
Art 45, Montreal, Quebec, Canada
Photogalerie, The Compagnie, Hamburg,
 West Germany
La Remise du Parc, Paris, France
University of Pittsburgh, Pittsburgh, PA
'Duane Michals: Photographies de 1958 à 1982', Musée
 d'Art Moderne de la Ville de Paris, Paris, France

1983
Galerie Watari, Tokyo, Japan
Miami University, Oxford, OH
Greenville County Museum of Art, Greenville, SC
Rising Sun Media Art Center, Santa Fe, NM
Douglas Drake Gallery, Kansas City, KS
L'Espace Niçois d'Art et de Culture, Nice, France
Sidney Janis Gallery, New York, NY

1984
Wellesley College Art Gallery, Wellesley, MA
Galerie Wilde, Cologne, West Germany
Rochester Institute of Technology, Rochester, NY
The Light Factory, Charlotte, NC

G.H. Dalsheimer, Baltimore, MD
'Duane Michals: Photographs/Sequences/Texts
 1958–1984', Museum of Modern Art, Oxford,
 England; touring to Institute of Contemporary
 Arts, London; Watershed, Bristol; John Hansard
 Gallery, University of Southampton; Bluecoat
 Gallery, Liverpool, and Open Eye Gallery, Liverpool

1985
Sidney Janis Gallery, New York, NY
Clara M. Eagle Gallery, Murray State University,
 Murray, KY
Adam Brown, Amsterdam, Netherlands

1986
Studio 8 Gallery, Kalispell, MO
Dickinson College, Carlisle, PA
Galerie Samia Saouma, Paris, France

1987
Sidney Janis Gallery, New York, NY
Southeast Center for Photographic Studies,
 Dayton Beach Community College, FL
George Ciscle Gallery, Baltimore, MD
Art Center College of Design, Pasadena, CA;
 touring to Brooks Institute of Photographic Art
 and Science, Santa Barbara, CA and Meadows
 Museum and Gallery, Dallas, TX, in conjunction
 with the Eastman Kodak Reedy Memorial Lectures

1988
Fay Gold Gallery, Atlanta, GA
Allen Street Gallery, Dallas, TX
'Someone Left a Message for You: Photographs by
 Duane Michals', Art Institute of Chicago, Chicago, IL
Maine Photographic Workshops, Rockport, ME
'Duane Michals: Two Photographers', Blatant Image/
 Silver Eye, Pittsburgh, PA
Galerie Fiolet, Amsterdam, Netherlands
Ugo Ferranti, Rome, Italy
Forum Gallery, Tarragona, Spain
'Duane Michals: Photographies', Fonds Régional
 d'Art Contemporain Aquitaine, Bordeaux, France
Artoteque de Caen, Caen, France
Oregon Art Institute, Portland, OR

1989
'Duane Michals Photographien 1958–1988',
 Museum für Kunst und Gewerbe, Hamburg,
 West Germany; touring to: Museum de Beikerd,
 Breda, Netherlands; Château d'Eau, Toulouse,
 France; Musée de l'Elysée, Lausanne, Switzerland;
 Museum voor Fotografie, Antwerp, Belgium
Photographic Image Gallery, Portland, OR
Southern Alleghenies Museum of Art, Loretto, PA
Art Kane Photo Workshop, Cape May, NJ
'Upside Down, Inside Out and Backwards',
 Sidney Janis Gallery, New York, NY

Galerie John A. Schweitzer, Montreal, Canada
'Duane Michals: Portraits', Salt Lake Art Center,
 Salt Lake City, UT
Galerie Samia Saouma, Paris, France
Spectrum Gallery, Light Impressions, Rochester, NY

1990
Modern Art Center, Calouse Gulbenkian Foundation,
 Lisbon, Portugal
A Gallery for Fine Photography, New Orleans, LA
Cumberland Gallery, Nashville, TN
Andrew Smith Gallery, Santa Fe, NM
Fahey/Klein Gallery, Los Angeles, CA
Fay Gold Gallery, Atlanta, GA
'Vrais Rêves', Institut de la Communication,
 Université Lumière, Lyon, France
'The Duane Michals Show', Museum of Photographic
 Arts, San Diego, CA; touring to: Honolulu
 Academy of Arts, Honolulu, HI; San Francisco
 Museum of Modern Art, San Francisco, CA;
 International Museum of Photography at the
 George Eastman House, Rochester, NY; The
 Museum of Contemporary Photography,
 Columbia College, Chicago, IL; Milwaukee Art
 Museum, Milwaukee, WI; Boca Raton Museum
 of Art, Boca Raton, FL; International Center of
 Photography, New York, NY; North Dakota
 Museum of Art, Grand Forks, ND
'Duane Michals: Portraits', Butler Institute of
 American Art, Youngstown, OH; touring to: Olin
 Gallery, Kenyon College, Gambier, OH; Fresno
 Art Museum, Fresno, CA; Moody Gallery of Art,
 Tuscaloosa, AL
Parco Gallery, Tokyo, Japan

1991
Galerie Bodo Niemann, Berlin, Germany
Aspen Art Museum, Aspen, Colorado
'Poetry and Tales', Sidney Janis Gallery, New York, NY
Robert Koch Gallery, San Francisco, CA
Photograum Fleetinsel, Hamburg, Germany
Busche Galerie, Cologne, Germany

1992
Lynn Goode Gallery, Houston, TX
Elke Droscher, Fotoram Fleetinsel, Berlin, Germany
Espace Photographique de Paris, Paris, France
Portfolio Gallery, Edinburgh, Scotland
'Paris Stories and Other Follies', Sidney Janis Gallery,
 New York, NY
Montgomery Glasoe Fine Art, Minneapolis, MN
Beam Gallery, Tokyo, Japan

1993
Ehlers Caudill Gallery, Chicago, IL
Fahey/Klein Gallery, Los Angeles, CA
Irish Gallery of Photography, Dublin, Ireland

Temple Bar Gallery, Dublin, Ireland
Galeria USW, Bratislava, Slovakia
Sala Parpallo, Valencia, Spain
University of North Florida, Jacksonville, FL

1994
Lynn Goode Gallery, Houston, TX
'Duane Michals', Louisiana Museum, Humlebaek,
 Denmark
'Questions Without Answers', Sidney Janis Gallery,
 New York, NY

1995
'Duane Michals', Right Gallery, Kamakura, Japan
'Questions Without Answers', Hamiltons, London,
 England
'Questions Without Answers', Robert Koch Gallery,
 San Francisco, CA
'Questions Without Answers', Hartwick College,
 Oneonta, NY
'Questions Without Answers', Norderlight,
 Groningen, Netherlands
'Duane Michals', Photographic Center, Atlanta, GA
'Duane Michals', Braunschweig Photomuseum,
 Braunschweig, Germany

1996
'Duane Michals Photographs', Miami Dade
 Community College, Kendall Campus Art
 Gallery, Miami, FL
'Questions without Answers', Lynn Goode Gallery,
 Houston, TX

1997
'Salute, Walt Whitman', Sidney Janis Gallery,
 New York, NY

GROUP EXHIBITIONS
1959
Image Gallery, New York, NY

1966
'American Photography: The 60's', University of
 Nebraska, Lincoln, NB
'Contemporary Photographers since 1950',
 George Eastman House, Rochester, NY
'Towards a Social Landscape', George Eastman
 House, Rochester, NY

1967
'Twelve Photographers of the American Social
 Landscape', Brandeis University, Waltham, MA

1968
'Recent Acquisitions', Worcester Art Museum,
 Worcester, MA
'The City', Smithsonian Institution, Washington, D.C.
'Personal Images by 21 Photographers',
 N.W. Ayers Gallery, Philadelphia, PA

1969
'Contemporary Photographers', University of
 California at Los Angeles Art Galleries,
 Los Angeles, CA
Witkin Gallery, New York, NY
'Portraits', Museum of Modern Art, New York, NY

1970
'12 x 12', Rhode Island School of Design,
 Providence, RI
American Pavilion, Expo 70, Osaka, Japan
'Being Without Clothes', Massachusetts Institute of
 Technology, Cambridge, MA

1971
'Photographs of Woman', Museum of Modern Art,
 New York, NY

1972
Fotogalerie Wilde, Cologne, West Germany
'Sammlung L. Fritz Gruber: Fotografien 1900–1970',
 Kölnischer Kunstverein, Cologne, West Germany

1973
'Das Technische Bild und Dokumentationsmittel
 Fotografie', Museum Folkwang, Essen, West
 Germany
'Combattimento per un immagine – Fotografi e
 Pittori', Stadt Museum, Turin, Italy
Festival International d'Art Contemporain, Royan,
 France

1974
'Photography in America', Whitney Museum of
 American Art, New York, NY
Contemporanea, Rome, Italy
'Zwei Amerikanische Fotografen', Städtisches
 Kunstmuseum, Haus an der Redorite, Bonn,
 West Germany

1975
'(Photo) (Photo)2 (Photo)n', University of Maryland,
 Baltimore, MD

1976
Wadsworth Atheneum, Hartford, CT
Arles Festival, Arles, France
Musée Galliera, Fondation Nationale de la
 Photographie, Paris, France
University of Wisconsin Gallery, Milwaukee, WI
'Real, Unreal, Surreal', San Diego State University,
 San Diego, CA

1977
Hamburg Kunstverein, Hamburg, Germany
Whitney Biennial, Whitney Museum of American
 Art, New York, NY
Stedelijk Museum, Amsterdam, Netherlands
'Location in Time', George Eastman House,
 Rochester, NY

'La Photo Comme Photographie', Centre d'Arts Plastiques Contemporains de Bordeaux, Bordeaux, France

Documenta, Kassel, France

'Kunsterphotoghen in XX Jahrhundert', Kestner-Gesellschaft, Hanover, West Germany

'Group Show', Santa Barbara Museum of Art, Santa Barbara, CA

'American Narrative/Story Art', Contemporary Arts Museum, Houston, TX

'40 American Photographers', E.B. Crocker Art Gallery, Sacramento, CA

'Photography – 4 Stylistic Approaches', Katonah Gallery, Katonah, NY

C Space, New York, NY

Cranbrook Academy of Art Museum, Bloomfield Hills, MI

'Time', Philadelphia College of Art, Philadelphia, PA

'Contemporary Figuration', The New Gallery, Cleveland, OH

Annual Exhibition, San Francisco Art Institute, San Francisco, CA

'Magic', Museum of Modern Art, New York, NY

'New Aspects of Self in American Photography', Johnson Museum, Cornell University, Ithaca, NY

1978

'One Thousand and One Photographs', Moderna Museet, Stockholm, Sweden

'Narration', Institute of Contemporary Art, Boston, MA

'Additional Information', University of Maryland, College Park, MD

'Images of Women', Summit Art Center, NJ

'23 Photographers – 23 Directions', The Kirklands International Photographic Exhibition, Walker Art Gallery, Liverpool, England

'Manipulative Photography', Virginia Commonwealth University, Richmond, VA

'Art About Art', Whitney Museum of American Art, New York, NY

'Story Telling in Art', American Foundation for the Arts, Miami, FL

'Duane Michals & Nicholas Africano', Nancy Lurie Gallery, Chicago, IL

'Man to Man', Robert Samuel Gallery, New York, NY

1979

'Images of Self', Hampshire College, Amherst, MA

'The Great American Foot Returns', San Francisco Museum of Modern Art

Visions Gallery, Boston, MA

'Attitudes: Photography in the 70's', Santa Barbara Museum of Art, Santa Barbara, CA

'American Photography in the 70's', Art Institute of Chicago, IL

'Voice and Vision', Creative Photography Lab,

Massachusetts Institute of Technology, Cambridge, MA

'American Portraits of the 60's and 70's', Aspen Center for the Visual Arts, Aspen, CO

'The Altered Photograph', P.S. 1, Long Island City, NY

'The Hand Colored Photograph', Philadelphia College of Art, Philadelphia, PA

'Narrative Art', Dartmouth College, Hanover, NH

'Photographs', National Arts Club, New York, NY

'Photographic Surrealism', The New Gallery, Cleveland, OH; touring to: Dayton Art Institute, Dayton, OH; Brooklyn Museum, Brooklyn, NY

'Eastside–Westside: New York Photography', Roanoke College, VA

'Artists by Artists', Whitney Museum Downtown, New York, NY

'Self As Subject', University of New Hampshire, NH

'Nude: Theory', Witkin Gallery, New York, NY

'Artemisia Gentileschi', Galerie Yvon Lambert, Paris, France

1980

'Word, Object, Image', Rosa Esman Gallery, New York, NY

'Presences', Albright College, Reading, PA

'First Person Singular: Recent Self Portraiture', Pratt Institute, New York, NY

'Words & Numbers', Summit Art Center, Summit, NJ

'Fashion Photography', Hastings/Rinhart Galleries, New York, NY

'Around Picasso', Museum of Modern Art Lending Service, New York, NY

'Déjà Vu: Updated Masterpieces', Western Association of Art Museums, San Francisco, CA (touring)

Viviane Esders Rudzinoff Gallery, Paris, France

'A Century of Photography', C.W. Post College, Long Island University, NY

1981

'Inside Spaces', Museum of Modern Art Lending Service, New York, NY

Biennial Exhibition, Whitney Museum of American Art, New York, NY

Group Show, Robert Samuel Gallery, New York, NY

'Messages', Albright College, Reading, PA

'New York in Photographs, Prints & Drawings', Witkin Gallery, New York, NY

'Aspects de l'art d'aujourd'hui 1970–1980', Les Musées d'Art et d'Histoire et l'Association Musées d'Art Moderne, Geneva, Switzerland

'Edge of Night', Yves Arman Gallery, New York, NY

'Black and White', Bertha Urdang Gallery, New York, NY

Alternative Museum, New York, NY

1982

'American Photography 1900–1980', Hood Museum, Hanover, NH

'Sweet Art Show', Ronald Feldman Gallery, New York, NY

'The Nude by Fashion Photographers', Staley Wise Gallery, New York, NY

'E.R.A.', Zabriskie Gallery, New York, NY

'Erotik in der Kunst Heute', Bonner Kunstverein, Bonn, West Germany

'Photographs from Chicago Collections', Art Institute of Chicago, Chicago, IL

'In Sequence', Museum of Fine Arts, Houston, TX

Photography Gallery, Yarrow, Australia

'The Renaissance Revisited', Tyler School of Art, Philadelphia, PA

'New Portraits: Behind Faces', Dayton Art Institute, OH

1983

'Men of Style', Staley Wise Gallery, New York, NY

'Surrealism', Isetan Museum of Art, Tokyo, Japan

'Contemporary Self-Portraiture in Photography', Massachusetts Institute of Technology, Cambridge, MA

'Peindre et photographier', L'Espace Niçois d'Art et de Culture, Nice, France

'Photography in America 1910–1983', Tampa Museum, Tampa, FL

'Invention & Allegory', Daniel Wolf Gallery, New York, NY

'From Inner & Outer Space', The Floating Foundation, New York, NY

'AIPAD', Staley Wise Gallery, New York, NY

'High Light: The Mountain in Photography 1840 to the Present', International Center of Photography, New York, NY

'Words and Pictures', Visions Gallery, Boston, MA

'L'Ambigue', Ecole Régionale des Arts Plastiques, Lille, France

1984

'Content: A Contemporary Focus, 1971–1984', Hirshhorn Museum & Sculpture Garden, Washington, D.C.

'Painter and Photography/Photographers and Painting', Thorpe Intermedia Gallery, Sparkhill, NY

'Words(=/=)Pictures', The Bronx Museum of the Arts, New York, NY

'Hand Colored Photography', Jayne H. Baum Gallery, New York, NY

'The One & Only: Unique Photographs Since the Daguerreotype', Laurence Miller Gallery, New York, NY

Photographic Resource Center, Boston, MA

'Writing and Photography', Galerie Samia Saouma, Paris, France

'La Narrativa internacional de hoy', Museo Tamayo, Mexico City, Mexico

1985

'Flowers: An Exhibition of Photographs', Monique Knowlton Gallery, New York, NY

'L'Autoportrait a l'Age de la Photographie', Musée Cantonal des Beaux-Arts, Lausanne, Switzerland

'Portraits of Artists', San Francisco Museum of Modern Art, San Francisco, CA

'The Subway Show', Lehman College, Bronx, NY

'American Images: Photographs 1945–1980', Barbican Art Gallery, London, England

'Still Space and Time: Balanchine and Photography', Museum of Fine Arts, Houston, TX

'Images of Men and Women', Elliot Smith Gallery, St. Louis, MO

Catskill Center for Photography, Woodstock, NY

'Tribute to Lee Witkin', Photo Center Gallery, Tisch School of Arts, New York University, New York, NY

'Art and Language', Lawrence Gallery, Rosemont College, PA

Southwest Craft Center, San Antonio, TX

'Landscape Perspectives: Photographic Studies', Jean S. Tucker Gallery, University of Missouri, St. Louis, MO

'Self-Portrait', Museum of Modern Art, New York, NY

'Le Temps: Regards sur la quatrième dimension', Nouveau Musée, Villeurbanne, France

'Le Photographe et le réel', College de Piégut-Pluviers, Fonds Régional d'Art Contemporain Aquitaine, France

'Photographs from the Collection', Museum of New Mexico, Santa Fe, NM

'Das Self Portrait in Zeit Alter der Photographie', Academie der Kunst, Berlin, West Germany

'The Hand-Altered Photograph', Panhandle Plains Historical Museum, Canyon, TX

1986

'Theater of Realities', Metz Pour la Photographie, Metz, France

'Sadness', Simon Cerigo Gallery, New York, NY

'Staging the Self: Self-Portrait Photography 1840–1985', National Portrait Gallery, London, and Plymouth Arts Centre, England

'Landscape Perspectives: Photographic Studies', Gallery 210, University of Missouri, St. Louis, MO

Exhibition in conjunction with 'Robert Frank: New York to Nova Scotia', Museum of Fine Arts, Houston, TX

'Artists Choose Artists', CDS Gallery, New York, NY

'Intimate/Intimate', Truman Gallery, Indiana State University, Terre Haute, IN

'Phantastic Photographs', Gallery 400, College of Art, Architecture and Urban Planning, University of Illinois at Chicago, Chicago, IL

'The Sacred & The Sacrilegious: Iconographic Images in Photography', Photographic Resource Center at Boston University, Boston, MA

'Structured Vision: Collaged and Sequential Photography', Boise Gallery of Art, Boise, ID (touring)

'Apparitions & Allusions: Photographs of the Unseen', San Diego State University Gallery of Art, San Diego, CA

'The Expression of Creative Discovery in Contemporary Photography', Calvin College Art Gallery, Grand Rapids, MI

'Männer seinem Männer', Galerie Hans Christian Hoschek, Graz, Austria

'Midtown Review: A Look at Photography Books of 1986', International Center of Photography/ Midtown, New York, NY

'Des Photographies et le cardigan pression', Galerie du Jour, Paris, France

'Faces', University of Texas at El Paso, El Paso, TX

'Aging', Les Petits Frères des Pauvres, Paris, France

'Photofictions – Subjective-Setups', The Fotogallery, Cardiff, Wales

1987

'Arrangements for the Camera: A View on Contemporary Photography', Baltimore Museum of Art, Baltimore, MD

'1974: A Year in Review', Light Gallery, New York, NY

'Art Circles: Portrait Photographs from *ARTnews* 1905–1986', International Center of Photography, New York, NY

'Photographie von 1945 bis 1985', Museum für Kunst und Gewerbe, Hamburg, West Germany

'Information, USA', toured Russia, 1987, organized by the United States Information Agency

Foto Galerie Wien, Vienna, Austria

'Photography and Art', Los Angeles County Museum of Art, Los Angeles, CA

'The Flower in 20th Century American Art', Southern Alleghenies Museum of Art, Loretto, PA

'Portrait: Faces of the 80's', Virginia Museum of Fine Arts, Richmond, VA

'Contemporary American Figurative Photography', Center for the Fine Arts, Miami, FL

'28th Midwestern: Face to Face', Rourke Gallery, Moorhead, MN

'Photography for Advertising: The History of a Modern Art Form', George Eastman House, Rochester, NY

'Exposed and Enveloped', Laurence Miller Gallery, New York, NY

'Passions et jardins et secrets des photographes', Château de Bagatelle, Paris, France

'28 Great Photographers of the World in Tokyo', Printemps Ginza, Tokyo, Japan

'The New Who's Who', Hoffman Borman Gallery, Santa Monica, CA

'Similia/Dissimilia', Städtische Kunsthalle, Düsseldorf, West Germany; Columbia University, New York, NY

'Photographic Works from 1975–1987', Douglas Drake Gallery, New York, NY

'Stations', Centre International d'Art Contemporain de Montréal, Montreal, Quebec, Canada

'L'art contre le Sida', Galerie Yvon Lambert, Paris, France

'Poetic Injury: The Surrealist Legacy in Postmodern Photography', Alternative Museum, New York, NY

'The Alternative Image III: Visual Paradox', John Michael Kohler Arts Center, Sheboygan, WI

'Amsterdam International Portrait Exhibition', Canon Photo Gallery and Pulitzer Art Gallery, Amsterdam, Netherlands

1988

'First Person Singular: Self-Portrait Photography, 1840–1986', The High Museum at Georgia-Pacific Center, Atlanta, GA

'Black in the Light', Genovese Graphics, Boston, MA

'Art of Persuasion', International Center of Photography, New York, NY

'Men on Men', Catherine Edelman Gallery, Chicago, IL

'Fabrications: Staged, Altered and Appropriated Photographs', Carpenter Center for the Visual Arts, Harvard University, Cambridge, MA

'New Approaches to the Photographic Marketplace', Art Institute of Boston, Boston, MA

'Language and Photography', California Museum of Art, Luther Burbank Center, Santa Rosa, CA

'A Kiss is Just a Kiss', Twining Gallery, New York, NY

Laight Gallery, New York, NY

'Les Photographes en campagne', Espace J.F. Guyot, Paris, France

'Splendeurs et misères du corps', Musée d'Art Moderne de la Ville de Paris, Paris, France

'Popular and Preferential Imagery', Boca Raton Museum of Art, Boca Raton, FL

'Influence Show', College of Fine Arts, University of Florida, Gainesville, FL

'Creative Camera', Dayton Art Institute, Dayton, OH

'50th Anniversary Exhibition', The Contemporary Arts Center, Cincinnati, OH

'Identity: Representations of the Self', Whitney Museum of American Art, Downtown at Federal Reserve Plaza, New York, NY

1989

'A Garden Walk', Twining Gallery, New York, NY

'Photography and Language', Sheppard Gallery, University of Nevada-Reno, Reno, NV

'Fictive Strategies', Squibb Gallery, Princeton, NJ

'Flash Point', Art on the Tracks Gallery, Pensacola, FL

'Fantasies, Fables & Fabrications: Photoworks of the 1980's', Herter Art Gallery, University of Massachusetts at Amherst, Amherst, MA

'Mystery', Procter Art Center, Bard College, Annandale-on-Hudson, NY

'Clichés les choix des sens', Centre Culturel de la Communauté Française, Wallonie-Bruxelles le Botanique (touring)

'Das Porträt in der Zeitgenossischen Photographie', Frankfurter Kunstverein, Frankfurt, West Germany; touring to: Kulturzentrum, Mainz, Germany, and Galerie Fotohof, Salzburg, Austria

'Positive I.D.', Southern Alleghenies Museum of Art, Loretto, PA

'Selected Themes: 150 Years of American History by American Photographers', Pelham Art Center, Pelham, NY

'Invention and Continuity in Contemporary Photography', Metropolitan Museum of Art, New York, NY

'Six Ideas in Photography', Grand Rapids Art Museum, Grand Rapids, MI

'The Cherished Image: Portraits from 150 Years of Photography', National Gallery of Canada, Ottawa, Canada

'Object as Subject', Turman Gallery, Indiana State University, Terre Haute, ID 'Fotoritratto – Il Ritratto nella Fotographia Contemporanea', Pinacoteca Comunale Logetta Lombardesca, Ravenna, Italy

'Capturing the Image: Collecting 100 Years of Photography', Fogg Museum, Harvard University, Cambridge, MA

'Acquisitions du F.R.A.C. Basse-Normandie', Musée de Coutances, France

'Das Portrait in der Zeitgenossichen Photographie', Galerie Krinzinger, Innsbruck, Austria

'Arrangements – Part I', May 36 Galerie, Luzerne, Switzerland

'Vanishing Presence', Walker Art Center, Minneapolis, MN, touring to: Detroit Institute of Arts, Detroit, MI; Winnipeg Art Center, Winnipeg, Manitoba, Canada; High Museum of Art, Atlanta, GA; Herbert F. Johnson Museum of Art, Cornell University, Ithaca, NY; Virginia Museum of Fine Arts, Richmond, VA

1990

'New York, New York: The City in Photographs', Worcester Art Museum, Worcester, MA

'The Indomitable Spirit', International Center of Photography/Midtown, New York, NY; touring to: Lorence Monk Gallery, New York; Pace-MacGill Gallery, New York; Fraenkel Gallery, San Francisco, CA; Rhona Hoffman Gallery, Chicago, IL; Blum Helman Gallery, Santa Monica, CA; Los Angeles

Municipal Art Gallery, Los Angeles, CA; AIPAD Special Exhibition at Basel Art Fair, Basel, Switzerland; A Gallery for Fine Photography, New Orleans, LA; and Fay Gold Gallery, Atlanta, GA

'De la Photographie mise en scène', Musée de Marseille, Centre de la Ville Charité, France

'Word as Image: American Art 1960–1990', Milwaukee Art Museum, Milwaukee, WI

'Identities: Portraiture in Contemporary Photography', Philadelphia Art Alliance, Philadelphia, PA

'Chroniques des apparences', Fonds Régional d'Art Contemporain de Basse et Haute Normandie, Abbaye-aux-Dames, Caen, France

'Modèles Déposés – 1', Fonds Régional d'Art Contemporain du Limousin, Limoges, France

'Influences 5/Photography', Birke Art Gallery, Huntington, WV

'Regarding Art: Artworks About Art', John Michael Kohler Arts Center, Sheboygan, WI

'Personal/Mechanical: Photographs as Support', Graham Modern Gallery, New York, NY

'Stated Upon Eternity', Musée Reattu, Arles, France

'Femmes', Galerie Maeght, Paris, France

'Children Should Be Seen and Not Heard', Robert Klein Gallery, Boston, MA

'AIDS Timeline 1990', Wadsworth Atheneum, Hartford, CT

1991

'Motion and Document – Sequence and Time: Eadweard Muybridge and Contemporary American Photography', National Museum of American Art; touring to: Addison Gallery of American Art, Phillips Academy, Andover, MA; International Center of Photography–Midtown, New York, NY; Long Beach Museum of Art, Long Beach, CA; Presentation House Gallery, North Vancouver, B.C., Canada; Henry Art Gallery, University of Washington, Seattle, WA

'Extrait d'Une Collection', Centre d'Art Contemporain de Basse-Normandie, Hérouville, France

'Der Fotografierte Schatten', Galerie Rudolf Kicken, Cologne, Germany

1992

'Voyeurism', Jayne H. Baum Gallery, New York, NY

'From Media to Metaphor: Art About Aids', organized by ICI, New York, NY; touring to: Emerson Gallery, Hamilton College, Clinton, NY; Center of Contemporary Art, Seattle, WA; Sharadin Art Gallery, Kutztown, PA; Musée d'Art Contemporain de Montréal, Montreal, Quebec, Canada; Grey Art Gallery and Study Center, New York University, NY

'8 Collections of Photographs', Fotografiska Museet, Moderna Museet, Stockholm, Sweden

'House without Walls', Buhl Family Foundation, New York, NY

'Something's Out There: Danger in Contemporary Photography', National Arts Club, New York, NY

'About Face: Photographic Portraits from the International Center of Photography Permanent Collection, 1900–1991', International Center of Photography, New York, NY

'Interpretazioni', Eos Arte Contemporanea, Milan, Italy

'Fragmente der Erinnerung: Photographie und Reisen', Heidi Reckermann Photographie, Cologne, Germany

'Sprung in die Zeit', Berlinische Galerie, Berlin, Germany

'Flora Photographica', Vancouver Art Gallery, B.C., Canada; touring to: New York Public Library, New York City; Royal Ontario Museum, Toronto, Canada; Montreal Museum of Modern Art, Quebec, Canada

'Recent Acquisitions', Fonds Régional d'Art Contemporain de Basse-Normandie, France

1993

'Exploring Scale in Contemporary Art', Laguna Gloria Art Museum, Austin, TX

'Here's Looking At Me', Art Contemporain Lyon, France

'The Art of Diamonds', Tatistcheff Gallery, New York, NY

'The Artist as Subject: Paul Cadmus', Midtown Payson, New York, NY

'Self-Portrait: The Changing Self', New Jersey Center for the Visual Arts, Summit, NJ

'The Alternative Eye: Photo Art for the 90's', Southern Alleghenies Museum of Art, Loretto, PA

'A La Recherche du Père', L'Espace Photographique de Paris, Paris, France

'Recent Acquisitions', Ecole Maternelle Jacques Prévert, Argentan, France

'Multiple Images: Photographs Since 1965 in the Collection', Museum of Modern Art, New York, NY

1994

'American Photography: A History in Pictures', San Antonio Museum of Art, San Antonio, TX

'Images Fixed by Light', Jansen-Perez Gallery, San Antonio, TX

'New Acquisitions/New Work/New Directions 2: Photography from the Collection', Los Angeles County Museum of Art, Los Angeles, CA

'The August Group Show', Montgomery Glasoe, Minneapolis, MN

'The Camera i – Photographic Self-Portraits', from the Audrey and Sidney Irmas Collection, Los Angeles County Museum of Art, Los Angeles, CA

'AIDS', Galeries Photo, Levallois, France

'Art in the Age of Aids', National Gallery of Australia, Canberra, Australia

Bibliography Published books, exhibition catalogues and films by or about Duane Michals

'Targeting Images: Objects & Ideas', Museum of Contemporary Photography, Columbia College, Chicago, IL

1995

'Magic and Mystery', Laguna Gloria Art Museum, Austin, TX

'Face à face', Centre Photographique d'Ile de France, Pontault-Combault, France

'Making Faces: The American Portrait', Hudson River Museum, Yonkers, NY

'Leurs illusions particulières', Le Printemps de Cahors, Boulogne, France

'Prodigal Son Narratives: 1480–1980', Yale University Art Gallery, New Haven, CT; touring to Davison Art Center, Wellesley College, Wellesley, MA

'1968', National Gallery of Australia, Canberra

'Whitman's Sampler', Photographs Do Not Bend, Dallas, TX

'Magicians of Light: Photographs from the Collection of The National Gallery of Canada', National Gallery of Canada, Ottawa, Ontario, Canada

'Unscharse', Galerie Objectiv, Berlin, Germany

Ryerson Lecture Exhibition, Stephen Bulger Gallery, Toronto, Ontario, Canada

'Targeting Images, Objects, and Ideas', Museum of Contemporary Photography, Columbia College, Chicago, IL

'The Three Great Egyptian Ladies – The Giza Pyramids Through the History of Photography', Musée de la Photographie, Charleroi, Belgium

'Blind Spot', Nancy Richardson, New York, NY

1996

'Wedding Days: Images of Matrimony in Photography', Japanese touring exhibition: Osaka Takashimaya, Osaka; Laforet Harajuku, Tokyo; Nihonbashi Mitsukoshi, Tokyo; Fukushima Nakagou, Fukushima; Nagoya Matsusakaya, Aichi; Aomori Virre, Aomori; Takamatsu Mitsukoshi, Kagawa

'The Sixties', Ehlers Caudill Gallery Ltd, Chicago, IL

'American Masters of Photography: A 100 Year Survey', Southern Alleghenies Museum of Art, Saint Francis College, Loretto, PA

'Cardigan pression Agnès B', Centre Georges Pompidou, Paris, France

'Une Contemporaine: La photographie 1955–95', Maison Européene de la Photographie, Paris, France

'L'Ubo Stacho Susiaren', Muzeum voj Techa Lofflera, Slovakia

'First Anniversary Show', Photographs Do Not Bend, Dallas, TX

'Some Grids', Los Angeles County Museum of Art, Los Angeles, CA

'Foto Szenen/Photo Stories', Altes Rathaus, Göttingen, Germany

1970

Sequences. New York: Doubleday & Co.

Sequenze. Milan: Forum Editoriale.

1971

The Journey of the Spirit after Death. New York: Winter House.

1973

Things Are Queer. Cologne: Fotogalerie Wilde.

Chance Meeting. Cologne: Fotogalerie Wilde.

Paradise Regained. Cologne: FFC Antwerpen/Fotogalerie Wilde.

1975

The Photographic Illusion: Duane Michals. Los Angeles: Alskog. Text by Ronald H. Bailey, with the editors of Alskog, Inc.

1976

Take One and See Mt. Fujiyama. New York: Stefan Mihal.

Real Dreams: Photostories by Duane Michals. Danbury, NH: Addison House. Introduction, 'Real Dreams', by Duane Michals.

1977

Vrais Rêves. Paris: Editions Chêne.

1978

Merveilles d'Egypte. Paris: Editions Denoël-Filipacchi E.P.I. Preface by Pierre de Fenoyl; introduction, 'Journal', by Duane Michals [In French only].

Homage to Cavafy: Ten Poems by Constantine Cavafy, Ten Photographs by Duane Michals. Danbury, NH: Addison House. Preface by Duane Michals.

Duane Michals (1932–1997), (film), Checkerboard Foundation. Edgar Howard, Theodore R. Haimes.

1981

Duane Michals: Photographs with Written Text. Apeldoorn, Netherlands: Municipal Van Reekummuseum of Modern Art.

Changements. Paris: Editions Herscher. Introduction, 'Maintenant et alors', by Duane Michals [in French only].

A Visit with Magritte. Providence, RI: Matrix. Introduction by Duane Michals.

1982

Duane Michals Photographies de 1958 à 1982. Paris: Musée d'Art Moderne de la Ville de Paris. 'La Pensée, l'émotion'/'Thought and Emotion', by Michel Foucault.

1983

Duane Michals. Paris: Centre National de la Photographie, Photo Poche. Introduction, 'L'Ombre d'un double', by Renaud Camus

[in French only]. English language versions published 1986 and 1990.

1984

Sleep and Dream. New York: Lustrum Press.

Duane Michals: Photographs/Sequences/Texts 1958–1984. Oxford: Museum of Modern Art. Introduction, 'Certain things must be said', and interview, 'A Meeting with Duane Michals', by Marco Livingstone.

1986

Duane Michals. New York: Pantheon Books. Introduction, 'The Shadow of a Double', by Renaud Camus. Translation from French monograph published in 1983.

The Nature of Desire. Pasadena, CA: Twelvetrees Press.

1988

Album: The Portraits of Duane Michals 1958–1988. Pasadena, CA: Twelvetrees Press. Introduction, 'I am much nicer than my face and other thoughts about portraiture', by Duane Michals.

1989

Duane Michals: Photographien 1958–1988. Hamburg: Museum für Kunst und Gewerbe. Texts in German only. Foreword by Wilhelm Hornbostel; 'There's Something I Must Tell You' by L. Fritz Gruber (reprinted from *Frankfurter Allgemeine Magazin*, February 20, 1987); 'Duane Michals und die zeitgenössische amerikanische Photographie' by Julia Scully; and 'Duane Michals: Photographie als Idee' by Rüdiger Joppien.

1990

Duane Michals. London: Thames and Hudson, Photofile series. Introduction, 'The Shadow of a Double', by Renaud Camus. Translation from French monograph published in 1983.

Duane Michals: Now Becoming Then. Altadena, CA: Twin Palms Publishers. Text by Max Kozloff. [to accompany the touring exhibition 'The Duane Michals Show']

1992

Eros & Thanatos. Santa Fe, NM: Twin Palm Publishers.

Duane Michals. Paris: Espace Photographique de Paris. Introduction, 'La ville vue de l'esprit'/ 'Cityscapes of the Mind', by Shelley Rice. [Paris sequences]

1993

Duane Michals: Fotografías 1958–1990. Valencia, Spain: Edicions Alfons El Magnamín – IVEI.

Upside Down Inside Out and Backwards. [New York:] A Sonny Boy Book.

1996
Salute, Walt Whitman. Santa Fe, New Mexico:
 Twin Palms.

1997
The Essential Duane Michals. London: Thames and
 Hudson; Boston, MA: Bulfinch Press. Edited and
 with texts by Marco Livingstone.

Articles and Published Photographs
1964
du (Switzerland), February.
Contemporary Photographer, Spring.
Infinity, June.

1965
Contemporary Photographer, Horizon House.

1966
'People and Places', Martin Fox, *Print*, March/April.

1967
'The Empty Environment', *Art in America*, June.

1968
'The Beautiful People of Duane Michals', *Art Scene*,
 June.

1969
'Sequences', *Camera*, July.
Creative Camera, October.

1970
Album, August.
'Series Photographs, More is More', *Print*, October.
Camera, October.

1971
Modern Photography, January.
Kodak International Photography, January.
Popular Photography, February.
The Photo Image, Spring.
'Sequences Duane Michals', *Image*, August.
Camera 35, October.
Prisma (Germany), November.
'Duane Michals: How do you photograph chance?',
 Popular Photography, December.
Life Library of Photography: *The Camera*;
 The Print; *Great Themes*; *The Art of Photography*.
 Time/Life Inc.
Image, George Eastman House.
Photo (Paris), Nos. 53, 58, 61, 64, 66.

1972
'New Photography', Douglas Davis, *Newsweek*,
 April 3.
Camera Mainichi (Tokyo), May.
'Duane Michals', Guy Jamas, *Foto* (Sweden), August.
Vogue, December.
Camera 35, December.

1973
Modern Photography, February.
Le Figaro (Paris), February 19.
'Der Alltag Wird zum Sprechen gebracht',
 Wilfred Wiegan, *Frankfurter Allgemeine Zeitung*,
 February 25.
Elle, March.
Esquire, April.
Duane Michals interview by Ethy Bejar, *L'Officiel*
 (France), May/June.
'Mastarttavlan: Vinnarbilderna Duane Michals',
 Nya Sekvensar, *Foto* (Sweden), August.
'Les Séquences de Duane Michals', J.D. Gautrand,
 Photo-Ciné Revue (France), September.
'Most portraits are lies', J.M. Kinzer,
 Popular Photography, November.
Photo World, December.

1974
'Le sequenze di Duane Michals', Daniella Palazzoli,
 Domus (Milan), January.
'Duane Michals', Attilio Colombo,
 Progresso Fotografico (Milan), January.
'Von Bruno zum Paradies', Eduardo Beaucamp,
 Frankfurter Allgemeine Zeitung, February 26.
'The Portraits of Duane Michals', *Photo World*, June.
Nueva Lente (Madrid), June.
Extra (Cologne), July.
'Photography', Douglas Davis, *Newsweek*, October 21.
'Duane Michals is different from you and me',
 Lois Greenfield, *The Boston Phoenix*, October 31.
'The Sequential Imagination of Duane Michals',
 Sy Johnson, *Changes*, October.
The Paris Review, Winter.
Popular Photography Annual.
A Joseph Cornell Album, Dore Ashton, New York:
 Viking Press.

1975
'Duane Michals/Light Gallery', Robert Pincus-Witten,
 Artforum, January.
Camera (Switzerland), May.
'Duane Michals at Light', Andy Grundberg,
 Art in America, May/June.
'Duane Michals', Carter Ratcliff, *The Print Collector's
 Newsletter*, September/October.
'Public Faces', Carol Stevens, *Print*, October.
'Art as Photography as Art', Lee Battaglia;
 'The Photographer's Choice', Kelly Wise; *Horizon*,
 No. 10.
'This is a Real Dream', interview by William Jenkins,
 in *The Photographers' Choice: A Book of portfolios
 and critical opinion*, ed. by Kelly Wise, Danbury,
 NH: Addison House.
The Magic Image, Cecil Beaton, London:
 Weidenfeld & Nicolson.

1976
'Photographie als Kunstlerische Medium',
 Willy Rotzler, *du* (Switzerland), February.
'Photos within Photographs', Max Kozloff, *Artforum*,
 February (reprinted in *Photography and
 Fascination*, Danbury, NH: Addison House, 1979).
'Seeing in Sequence', *Art and Man*, Vol. 6, No. 6,
 National Gallery of Art, April/May.
Photo (France), No. 106, July.
Foto File, Vol. 3, Fall.
Creative Camera (London), October.
'Duane Michals, Master of Sequential Photography',
 Casey Allen, *Camera 35*, October.
'De l'autre côté du miroir, Duane Michals',
 Carole Naggar, *Zoom*, October.
'Duane Michals; un "aveugle de génie"',
 Jean-Claude Loiseau, *L'Express* (Edition
 Internationale), No. 1320, 25/31 October.
'Festival d'Arles', interview by Monelle Hayot, *L'Oeil*
 (Paris/Lausanne), October.
'Creating Photographs', Peggy Sealfon,
 New York Times, 10 October.
'Festival d'Automne: Kites and American
 Photographers', Andrea Perera, *The Paris Metro*,
 October 13.
'Two Visionaries', Douglas Davis, *Newsweek*,
 October 18.
Interview with Duane Michals by Martine Voyeux,
 Festival d'Automne, Paris, exhibition catalogue.
'Duane Michals says it is no accident you are reading
 this', Shelley Rice, *The Village Voice*, 8 November.
'Duane Michals', Jonathan Crary, *Arts Magazine*,
 December.
Review, Allen Ellenzweig, *Arts Magazine*, December.
The Darkroom, Ralph Gibson, New York:
 Lustrum Press.
Andy Warhol, das Zeichnerische Werk, Reiner Crone,
 Wurttembergischer Kunstverein, Stuttgart,
 exhibition catalogue.
Theater of the Mind: Arthur Tress, preface, 'Tress'
 Vaudeville', by Duane Michals, Dobbs Ferry, NY:
 Morgan & Morgan.
Kunstforum International (Cologne), Vol. 18,
 4th quarter.

1977
'Duane Michals', Jeff Perrone, *Artforum*, January.
'Setting the World on Fire', *Soho Weekly News*,
 March 3.
Le Nouvel Observateur, numéro spécial photo
 (Paris), No. 1, June.
'The Strip', Peggy Sealfon and Merrill Roseman,
 35 mm Photograph, Summer.
'Duane Michals', *Sun Valley Center*, Summer.
'Portraits by Duane Michals', *Flightime*, August.
du (Switzerland), August/September.

'Duane Michals: Real Dreams', Frank Joseph, *The Philadelphia Photo Review*, September.
'How Duane Michals Makes Those Mystical Photographs', *Popular Photography*, October.
'Duane Michals', Tokija Manniskorar, *Foto* (Sweden).
Le Nouvel Observateur, numéro spécial photo (Paris), No. 2, November.
'Real Dreams', Vicki Goldberg, *Photograph*, Vol. 3.
Die Geschichte der 77. Fotografie im 20 Jahrhundert, Peter Tausk, Cologne: Dumont (issued in English as *Photography in the 20th Century*, London: Focal Press, 1980).

1978
'Histoires photographiques de Duane Michals: la nécessité du contact', Hervé Guebert, *Le Monde* (Paris), February 9.
'Ways of Working with Light', Marietta Dunn, *Kansas City Star*, February 12.
'Duane Michals: la quête de la totalité', Michel Nuridsany, *Le Figaro* (Paris), April.
Photo, June.
'Duane Michals in Egypt', Dan Laskin, *Horizon*, August.
'Fotogalerie', Duane Michals, *Zeit Magazin* (Hamburg), December.
'Poets of the Ineffable', Richard Whelan, *Christopher Street*, December.
'Duane Michals Recent Photographs', *Creative Camera Collection 5* (London).

1979
'Homage to Cavafy: The Kindred Spirit of Duane Michals', A.D. Coleman, *Camera 35*, March.
'Duane Michals: The Sequences and Beyond', Julia Scully and Andy Grundberg, *Modern Photography*, March.
'Duane Michals: Things are Not the Way they Seem', Andrew Scott, *Georgia Straight*, March 23–29.
'Flash: A New Pyramid For an Old Giza', *American Photographer*, April.
'Your Personal Signal', *Vogue*, May.
'Homage to Cavafy', Don Fike, *Photographer's Forum*, August.
'Novels with a Lens', Ronald Hoffmann, *Kansas City Star*, September 30.
'Duane Michals' work hits universal nerves', Irene Clurman, *Rocky Mountain News*, November 4.
'Conversation with Duane Michals', Elizabeth Labar, *Photographer's Forum*, Vol. 12, No. 1, November/December.
'The Forgotten Dream: A Fable by Duane Michals', *Avenue*, December.
'Duane Michals', *Nueva Lenta* (Madrid), No. 28.
Photography Between the Covers, Thomas Dugan, New York: Light Impressions.
Light Readings, A.D. Coleman, New York: Oxford University Press.

Nude: Theory, ed. Jain Kelly, New York: Lustrum Press.

1980
'A Duane Michals Interview', Steve Nero, *Camera Era*, January.
'The Photographer as Illustrated Man', *Pittsburgh*, February.
'Resenas: Duane Michals', *Revista del Arte y la Arquitectura en America Latina*, Vol. 2, No. 5.
'Medellin/Museo de Arte Moderno: Duane Michals', *Sobre Arte*, No. 1, July/August.
'The Homosexual Aesthetic', Allen Ellenzweig, *American Photographer*, August.
Camera 35, December, pp. 28–25, 78.
'The Photograph Assumes a New Artiness', Hilton Kramer, *New York Times*, December, section 2, pp. 1, 33.
'The Manipulation of Duane Michals', Ben Lifson, *The Village Voice*, December 31, p. 65.

1981
'Exhibitions – Duane Michals', Owen Edwards, *American Photographer*, January, pp. 16–18.
'Duane Michals Interview', Sean Kernan, *Camera Arts*, January/February, pp. 32–38, 80–87, 118.
'Van Huskamer Naar Heelal', Rommert Boonstra, *Elseveirs Magazin* (Netherlands), March.
'Erotik in der Kunst Heute', Duane Michals, *Kunst Forum* (Cologne), April.
'Duane Michals', *Flash Art*, Summer.
'Duane Michals ou la photographie? Legendaire American Dreams', Alain Fleig, *Les Cahiers de la Photographie* (France), No. 2, September.
'Duane Michals', Hasse Perrson, *Foto* (Sweden), October, pp. 40–45.
'La Photo aussi Raconte des Histoires', Christian Caujolle, *A Suivre 47* (Paris), December.
'Santa Fe Springs', *Picture*, No. 18.

1982
'Michals' camera lies to tell truths', Robert Beckmann, Jr., *Arts Insight*, January.
'Close Encounters with Duane Michals', Shelly Rice, *On Campus*, February.
'The Camera and the Crush', Douglas Davis, *Newsweek*, February 7.
'Duane Michals Proteste', *Photo* (Paris), April.
'The Double Vision of Duane Michals', *Nikon World*, Summer.
'Cinderella and the Print', Lynn Zelevansky, *Flash Art*, No. 108, Summer.
'Duane Michals et le reexame des apparances', Hervé Guibert, *Le Monde* (Paris), November 17.
'Les jeux de têtes de Duane Michals', Francoise Ayzendri, *Le Matin de Paris*, December 22.
'Les Plaisirs du Gant', Jean Arrouye, *Les Cahiers de la Photographie*, No. 5.

1983
'Tales of a Story Teller', Phil Mezey, *Darkroom Photography*, March/April.
'Duane Michals', a portfolio, *Avenue*, April.
'Christ in New York', *The Philadelphia Photo Review*, Spring.
'I Don't Believe in Seeing', John Sundstrom, *New Life News*, September.
'Going Back', with photo sequence *I Remember Pittsburgh*, *American Photographer*, November.
'Duane Michals', transcript of lecture with illustrations, *Camera Austria*, November/December.
'Yves Saint Laurent: 25 Years of Design', exhibition catalogue photography, Metropolitan Museum of Art, New York.
Currents: Contemporary Directions in the Visual Arts, Howard Smagula, Englewood Cliffs, NJ: Prentice Hall, pp. 204–15.

1984
'Ohioana', Bob McKay, *Ohio Magazine*, February.
'The Camera and the Brush', Douglas Davis, *Newsweek*, February 7, p. 74.
'An Artist's Garden: Robert Motherwell's garden', *Vanity Fair*, August, pp. 78–83.
'Meet the Masters', P. Sealfon, *Petersons Photography Magazine*, October, pp. 18, 19.

1985
'Inspirations', Erta Zwingler, *Connoisseur*, January, p. 82.
'Duane Michals', Emmanuel Cooper, *Gay Times* (London), Issue 77, January, p. 89.
'A Show That Reveals an Artist at the Height of His Powers', Gene Thornton, *New York Times*, January 20.
'Duane Michals', Tim Imrie, *British Journal of Photography*, Vol. 132, Issue 9, March 1, pp. 243–45, 253.
'New York by Duane Michals', N. Canavor, *Popular Photography*, April, p. 77.
'Fine Art vs. Commercial Photography: A Reconciliation', Emily Simson, *Photo Design*, August, Vol. 2, No. 4.
'Full-blown out of Zeus's forehead', interview by Tom Evans, *Art & Artists*, No. 227, August, pp. 12–15.
'Duane Michals', Margherita Abbozzo Heuser, *Progresso Fotografico* (Milan), November, pp. 76–83.
'Sleep and Dream', Geoffrey Young, *San Francisco Camera/Work*, Vol. 12, November, p. 13.
'Reflections Spiegel', *H.Q.* (Munich), Issue 3.
Scopophilia The Love of Looking, ed. Gerard Malanga, New York: Alfred van der Mark Editions.

1986
'Recent Works by Duane Michals', *Asahi Camera*, February.

'Through the Narrative Portal', Max Kozloff, *Artforum*, April, p. 77 (reprinted in *The Privileged Eye*, 1987).

'Duane Michals: Fiction et philosophie', Marie Mandy and Anita Velle, *Clichés* (Brussels), Issue 25, April.

'Duane Michals', interview by John Shown, *Forum*, April/May, pp. 18–19

'Stairway to a Third Image', David Levi-Strauss, *San Francisco Camera/Work*, Vol. 13, Nos. 2–3, Summer/Fall.

'Art and/or Commerce', Carol Squiers, *Village Voice*, September 30.

'Le Héros de lui-même', Patrick Roegiers, *Le Monde* (Paris), October 16.

'Travel Documents', Alice Wingal, *Places* (Massachusetts Institute of Technology), Vol. 3, No. 2.

1987

Popular Photography, January, pp. 76–77.

'The Goodbye Boy: To Dream the Invisible Dream', Duane Michals, *Parenting*, Issue No. 1, February.

'Duane Duck', Petrii Nuutinen, *Valokura*, February.

'Everything Is in the Mind – The Art of Duane Michals', George Stambolian, *Christopher Street*, Issue 107, February 19.

'I Have Something To Tell You – The Photographer of the Unphotographable', L. Fritz Gruber, *Frankfurter Allgemeine Magazin*, February 20, pp. 14–22.

'Duane Michals', John Russell (review), *New York Times*, February 27.

'Duane Michals' (review), *The Village Voice*, March 3.

'Victim of the Greek Ideal', Roland Hagenberg, Margot Mifflin, *Artfinder*, April–June, pp. 78–80.

'Duane Michals', Carol Diehl, *Art & Antiques*, May, pp. 57–58

'Travelers We Meet – Duane Michals', David Magee, *Lufthansa's Germany*, May, p. 55.

'Duane Michals', *L'enchanteur* (Japan), Issue 5, May, pp. 56–57, and Issue 6, June, pp. 56–57.

'Photo-Postale: Duane Michals', *Libération* (Paris), August 10.

'Duane Michals, Private Lives', *Photo District News*, September, p. 67.

'Quick Clicks Alter Reality', Robert L. Pincus, *San Diego Union*, October 19.

The Privileged Eye, Max Kozloff, Albuquerque: University of New Mexico Press, pp. 110–19.

1988

'Theater of the Forbidden: Duane Michals and Joel-Peter Witkin', *Photo Design*, January–February, pp. 68–74.

'Duane Michals: Fotograafen Schrijveræ, Herman Hoeneveld, *Kunstbeeld* (Netherlands), March.

'Echoes of reality in the inner explorations of Duane Michals', Catherine Reeve, *Chicago Tribune*, March 4.

'AT&T: The Whole Tomato', Robert McCarthy, *Photo District News*, May, pp. 82–84.

'Fade to black: Duane Michals's jittery celebrities', V.G., *Vogue*, October.

'Smoking in Bed', Portfolio, *On Seeing*, No. 2, November 19.

'Disappointment in the Picture: Disappointment in the Text', Peter Weirmair, *Camera Austria*, No. 25, pp. 16–18.

1989

'Duane Michals', Richard B. Woodward, *ARTnews*, April, Vol. 88, No. 4, pp. 156–57.

'Joel-Peter Witkin et Duane Michals face à l'interdit', *Artpress* (Paris), 137, June, pp. 42–44.

'Father Figures', Edith Newhall, *New York Magazine*, Vol. 22, June 12, p. 34.

'Duane's World', Andy Grundberg, British *Vogue*, July, pp. 16, 17.

'De Fotograaf die alleen mislukte foto's wilde maken', Max Borka, *De Morgen* (Brussels), 5 August.

'Duane's World', Claire Holt, *Photo District News*, September, p. 86.

'Goings on About Town', *The New Yorker*, September 18, p. 20.

'Human-Spirited Photographs', David Hirsh, *New York Native*, Vol. 9, No. 42, September 23, p. 38.

'Duane Michals – A Picture and a Thousand Words', Paul Lin, *View* in *The Journal of Art*, September/October, pp. 8–11.

'Duane Michals Reale Traume', Wolfgang Kemp, *Nikon News* (Zürich), No. 3, pp. 34–41.

'Duane Michals' Moments', *Ikarus*, October, pp. 70–75.

'Sweet and Scary', Robin Cembalest, *ARTnews*, Vol. 88, No. 9, p. 30.

'Das Unsichteare Sichthar Machen Duane Michals', Henriette Bach-Hinz, *Photographie* (Schafthausen, West Germany), Vol. 6, No. 89.

'A Dream Photographic Narrative by Duane Michals', Thomas Southall, *The Register of the Spencer Museum of Art*, University of Kansas, Vol. 6, No. 5.

'Le Héros de lui-même', *Ecoutez–voir*, Patric Roegier, Paris Audio-Visuel, pp. 30–36.

'Duane Michals: A Whirl of Unfettered Imagination', Michelle Bogre, *Rangefinder*, November, pp. 44–47.

Review, Peggy Cyphers, *Arts Magazine*, December, Vol. 64, No. 4, p. 97.

1990

'Duane Michals' Recent Work', John H. Lawrence, *The New Orleans Art Review*, January/February, Vol. VIII, No. 3, pp. 24–25.

'Photographer travels back to childhood', Roger Green, *The Times-Picayune*, February 4, section F12.

'Duane Michals at Sidney Janis', John Ash, *Art in America*, March, Vol. 78, No. 3, pp. 207–208.

'A Imagen Viografica', Antonio Cerviera Pinto, *O Independente* (Lisbon, Portugal), April 27.

'Michals Speaks', L.S., *RISD Views*, May.

'Storytelling with photos and paintings', Angela Wibking, *Nashville Business Journal*, May 14–18.

'Michals Reveals Magic Behind His Imagery', Michael Hochanadel, *The Daily Gazette*, Friday, May 25, Section D, pp. 1, 5.

'Duane Michals', *The Sun*, July, No. 348, p. 81.

'Personal/Mechanical: Photographs as Support', Andy Grundberg, *New York Times*, July 20.

'Prette Porter: The Black Box and the Mysterious Man', *Mirabella*, September.

'Duane Michals: Beyond Appearances', Benoit Prieur, *Photo Digest*, September–October, Vol. 1, No. 1, pp. 21–24.

'Prette Porter: Hooray for Hollywood', *Mirabella*, October.

'Prette Porter: The Spy from SNEAK', *Mirabella*, November.

'La Galerie Vrais Rêve présente Duane Michals', Natalia Luyer, *Vis à Vis* (Paris), November, pp. 60–67.

'Photographs tell stories that read like a dream', Christian Walker, *The Atlanta Journal and Constitution*, November 23, D2.

'Camera on the Soul', Mark-Elliot Lugo, *San Diego Magazine*, December, Vol. 43, No. 2, pp. 156–60.

'Photos From Serious to the Comic', Susan Freudenheim, *Los Angeles Times*, December 15, Section F, pp. F1, F6.

'Pluralism since 1960', Marco Livingstone, p. 387, in *Modern Art*, ed. David Britt, London: Thames and Hudson.

1991

Untitled in 'In a Moon Mood', a portfolio, *Interview*, January, p. 88.

'The Duane Michals Show', Carol Khewhok, *Calendar News* (Honolulu Academy of Arts), March, p. 4.

'A feel for the surreal', Ronn Ronck, *The Honolulu Advertiser*, March 14, Section B, pp. 1–2.

'Duane's World', Amy Fine Collins, *Vanity Fair*, July, Vol. 54, No. 7, p. 68.

'Duane Michals', *Foto Práctica* (Milan), August.

'Dossier', Giuliana Scime, *Progresso Fotografico* (Milan), September.

'The Eyes of Duane Michals', Ron Netsky, *Democrat and Chronicle* (Rochester, NY), September 19, Section C, pp. 1, 3.

'Image and reality', Elizabeth Forbes, *Times-Union* (Rochester, NY), September 19, Section C, p. 3.

'Now becoming then', *City Newspaper*, September 19, p. 8.

'Personal photography', Ron Netsky, *Democrat and Chronicle* (Rochester, NY), September 29.

'Bolstering Narrative Qualities With Whimsy', Charles Hagen, *New York Times*, October 18, C32.

'Michals Recria a Narrativa Fotografica', Bernardo Barvalho, *Folha de São Paulo* (São Paulo, Brazil), October 19.

'Being Alive', David Hirsh, *New York Native*, November 4, No. 446, p. 33.

'There's something I must tell you', *Tageszeitung* (Berlin), November 6.

'First U.S. retrospective traces career of Duane Michals', Larry Thall, *Chicago Tribune*, November 8, Section 7.

'Kleine Dialoge mit Gott und Welt', Julia Mummenhoff, *Tageszeitung* (Berlin), November 15.

'Merry Christmouse', *New York Times*, December 22, p. 35 (repro.).

1992

'Duane Michals/Sidney Janis', B.B.S., *ARTnews*, January, pp. 122–24.

'Reading between the Lines', Leo Nash, *Psychic Reader*, February.

'The Visual Art Worker: The Duane Michals Show', Alan Singer, *The Bookpress*, March, Vol. 2, No. 2, p. 13.

"The French Guy in Goggles' & Other Favorite Photographs', Paul Gardner, *ARTnews*, March, Vol. 91, No. 3, pp. 102–07.

'Michals' photographs capture states of mind', Janice T. Paine, *Milwaukee Sentinel*, March 6.

'Photography & The Sin of Voyeurism', Vicki Goldberg, *New York Times*, March 8, section 2, pp. 1, 37.

'A brilliant retrospective at Boca Museum', Helen Kohen, *The Miami Herald*, May 16, p. 8E.

'Poetry and Tales, Duane Michals', *Portfolio Magazine* (Scotland), No. 14, Summer, pp. 19–25.

'Bringing It All Back Home', David Lee, *The Sunday Observer* (London), August 2, p. 48.

'Faking It', Richard McClure, *Creative Camera*, August–September, pp. 14–19.

'Gallery Go 'Round', Victoria Pedersen, *Paper*, September, p. 12.

'Camera', *American Photographer*, September, p. 12.

'Duane Michals à Paris', interview by Pierre Borhan; 'Duane Michals, d'illusion en désillusion', Portfolio, *Photographies*, No. 44, September, pp. 36–45.

'Duane Michals Spins Tales of Love and Death', Vicki Goldberg, *New York Magazine*, Fall Preview Issue, September 14.

'The Talking Picture Show' (Michals retrospective at the Royal Photographic Society, Bath), Andrew Palmer, *The Independent* (London), September 16.

'Storytelling with a Deceptive Simplicity', Charles Hagen, *New York Times*, September 25, C28.

'Serious Whimsy', Tim Cavanaugh, *Manhattan Spirit*, October 27, p. 19.

'Michals' Three-Decade Career (No Map Provided)', A.D. Coleman, *The New York Observer*, November 2, p. 22.

'Letter From: New York, No. 38', A.D. Coleman, *Photo Metro*, December 1992/January 1993, pp. 24–25.

'The View From the Mirror' (photographs with text), *Subjective Reasoning 3*, published by Champion Paper, 16 pp.

Det iscenesatte Fotografi, Mette Sandbye, Denmark: Raevens Sorte Biblioteque.

The Homoerotic Photograph, Allen Ellenzweig, New York: Columbia University Press.

1993

'The Man Who Put the Lie Behind the Lens', John M. Farrell, *The Sunday Press*, February 7.

'Picture Stories of Passion and Feeling', David Lee, *The Irish Times*, February 12.

'Duane Michals: Whimsical, Sweet, Absurd in One Mix', Susan Kandel, *Los Angeles Times*, March 12, Section F.

'Picture Imperfect', Kristine McKenna, *Los Angeles Times*, March 14, Calendar, pp. 8, 63.

'Duane Michals' new work is "serious and also silly"', Abigail Foerstner, *Chicago Tribune*, March 12, Section 7.

'Duane Michals', Jody Zellen, *Art Issues*, May/June, No. 28, p. 45.

'Map – Das Papier', *Photo Essay* (Zürich/New York), Summer.

'Esquire', *Photo Essay*, October, p. 34.

'Duane Michals', A.D. Coleman, *Camera and Darkroom*, November, pp. 22–31.

'Duane Michals', Jo Leggett, *Photo Metro*, December/January, Vol. 11, Issue 114, pp. 3–25, cover.

1994

'Duane Michals Interviewed by Robert Birnbaum', *Stuff*, Issue 133, February, pp. 26–39.

'Sequential Photographs: Duane Michals offers a bit of philosophy with his photography', Ted Weeks, *Folio Weekly* (Jacksonville, FL), February 1.

'Response to AIDS Gains in Subtlety', Roberta Smith, *New York Times*, February 18, p. C28.

'Past Tense' (poem), *Blind Spot*, Issue 3.

'Grandpa Goes to Heaven' (photograph), *Harper's*, Vol. 22, No. 1728, May, p. 41.

'Salute Robert Frank', *Blind Spot*, Issue 4.

'Christ in New York', *The Witness*, August/September, Vol. 7, pp. 22–24.

'An Interview with Duane Michals', Paul Karabinis, University Gallery, University of North Florida, Jacksonville, FL.

1995

'Alice's Mirror: Die Bildgeschichten des Fotografen Duane Michals', Aktuell, *Das Magazin der Deutschen AIDS-Hilfe*, No. 9, February, p. 14.

'Hi, If That's Duane Michals He's Not Here', interview by Claude Grunitzkey, *Dazed*, No. 11, pp. 66–69.

'Duane Michals; Out of the Box', *Art Access*, September, pp. 4–5.

Prodigal Son Narratives: 1480–1980, Yale University Art Center, catalogue essay by Ellen G. D'Oench, pp. 26–29.

1996

'Photographie', Ulrike Lahmann, *Living Photography*, January, pp. 36–37.

'The Photo Session', interview by Ryan Brookhart, *Provocateur*, Vol. 1, Issue 3, pp. 12–23.

'Kissing Manual', Jennifer Scruby, *American Photographer*, January–February, pp. 94–95.

'Tête-Bêche', interview by Elisabeth Lortic, *La Revue des Livres pour Enfant*, April 1996, pp. 91–92.

'Revolution in black and white', Abigail Foerstner, *Chicago Tribune*, June 2, Section 7, p. 5.

'Uncle Duane's Curious Christmas List', Duane Michals, *New York Times Sunday Magazine*, December 8.

'Upside Down Inside Out and Backwards', Riccarda Hoft, *Schwarzweiss*, No. 9, July/August, cover and pp. 4–13.

'For the Time Being: Duane Michals 240796', *D&AD* (London), November [transcript of lecture delivered by Michals at Royal Geographical Society, London, 24 July 1996].

'Things are Queer', Jonathan Weinberg, *Art Journal*, Vol. 55, No. 4, winter.

Foto Szenen/Photo Stories, Altes Rathaus, Göttingen, Germany, catalogue essay and section on Michals, pp. 48–51, by Manfried Schmalriecke.

1997

'Making Art Out of Whitman's Stirring Words', Martin Filler, *New York Times*, January 5, section H, p. 39.

'Duane's World', Deidre Stein Greben, *ARTnews*, January, pp. 106–10.

Index of Titles

Photographic credits